ROBERT ADAMS

TO MAKE IT HOME
PHOTOGRAPHS OF THE AMERICAN WEST

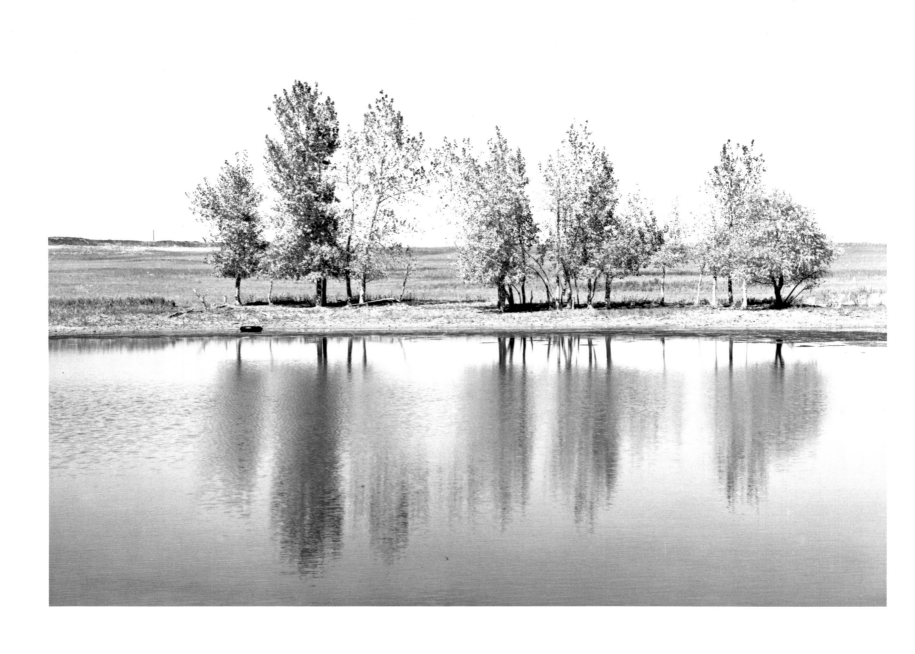

ROBERT ADAMS

TO MAKE IT HOME
PHOTOGRAPHS OF THE
AMERICAN WEST

AN APERTURE BOOK

THIS PUBLICATION IS MADE POSSIBLE
THROUGH THE GENEROUS SUPPORT OF
THE FOLLOWING PATRONS

CAROL J. ANDREAE
 AND JAMES P. GARLAND

ARTHUR M. BULLOWA

SHIRLEY C. BURDEN

MR. AND MRS. JACK M. FRIEDLAND

SONDRA GILMAN
 AND CELSO GONZALEZ-FALLA

LYNNE AND HAROLD HONICKMAN

MR. AND MRS. BERTON E. KORMAN

MR. AND MRS. DAVID N. PINCUS

D. ROBERT YARNALL, JR.

THE NATIONAL ENDOWMENT
 FOR THE ARTS

THE EXHIBITION, ROBERT ADAMS: TO MAKE IT
HOME—PHOTOGRAPHS OF THE AMERICAN
WEST, 1965–1986, WAS MADE POSSIBLE BY GRANTS
FROM THE PEW CHARITABLE TRUST AND
THE NATIONAL ENDOWMENT FOR THE ARTS, A
FEDERAL AGENCY.

TO MAKE IT HOME—PHOTOGRAPHS OF
THE AMERICAN WEST, 1965–1986
IS PUBLISHED TO ACCOMPANY A MAJOR
RETROSPECTIVE EXHIBITION
PRESENTED BY THE
PHILADELPHIA MUSEUM OF ART
FEBRUARY 19 TO APRIL 16, 1989,
AND TRAVELING FROM THERE TO THE
THE LOS ANGELES COUNTY MUSEUM OF ART,
MAY 4 TO JULY 16, 1989;
CORCORAN GALLERY OF ART,
WASHINGTON, D.C.,
AUGUST 5 TO OCTOBER 1, 1989;
THE AMON CARTER MUSEUM, FORT WORTH,
JANUARY 20 TO MARCH 18, 1990;
THE COLORADO HISTORY MUSEUM, DENVER,
MAY 12 TO JULY 8, 1990;
AND TO OTHER INSTITUTIONS

THOSE WITH WHOM I WORKED

Kerstin has been the editor I have trusted most, because the country has been ours together.

Michael Hoffman, who founded the Alfred Stieglitz Center at the Philadelphia Museum of Art in 1969, and who serves there now as Adjunct Curator, conceived of this book and the exhibition it accompanies, and directed plans for both. I am grateful to him, too, for his efforts, always self-effacing, to help us survive financially, and for his passionate discrimination, evident here in the ordering of the pictures. As was said of Stieglitz, he cares. When we have had differences they have not been decisive because, I think, we both loved the West as young men, and we both believe now, in Michael's words, that "photography isn't itself the important thing."

John Szarkowski was the first person beyond my family to understand what I hoped to do, and the first to exhibit my photographs prominently and to write about them. John Schwartz taught me publishing, and directed production of the first books. The friendship of both men remains a formative honor in my life.

I would like to acknowledge as well, among those who have helped me find an audience, the varied kindnesses of Renato Danese, Kathy Gauss, Peter Bunnell, Carole Kismaric, Charles Mikolaycak, Marvin Heiferman, the late Toiny Castelli, Jeffrey Fraenkel, Frish Brandt, Joyce and Edward Strauss, Martha Chahroudi, James Alinder, Susan Kismaric, Judith Ross, Manfred Willmann, Christine Frisinghelli, Anne Tucker, Dianne Vanderlip, Peter Galassi, and Sylviane DeDecker Heftler.

Mark Holborn shared insights that became fundamental to the organization of the book, Robert Hennessey made negatives of the highest quality for the plates, Lisa Rosset painstakingly untangled problems with the text, and Steve Baron braved a German winter to supervise the printing.

Wendy Byrne not only designed the interior of the book but coordinated, with great tact and kindness, everyone's efforts on the publication. None of us could imagine the book without her.

I am indebted to Anne D'Harnoncourt, director of the Philadelphia Museum of Art, for her belief in the value of the work, to the members of the Committee for Prints, Drawings, and Photographs and to the Friends of the Philadelphia Museum of Art for their purchases for the collection, to Marie Carpo for her skills as a print spotter, to Laura Griffith for her supervision of final exhibition preparations, and—not least—to Francesca Consagra, who with unfailing good spirits that buoyed my own, helped plan and oversee many aspects of the exhibition.

Others have contributed less directly but no less importantly by their loyalty and counsel, and by the sharing of their lives. I think particularly of photographers Myron Wood, Nick Nixon, Frank Gohlke, Lewis Baltz, John Gossage, Rick Dingus, Terry Toedtemeier, and Eric Paddock. And of friends Dale Moody, Stan Nikkel, Lorenz Schultz, Gerry Myers, Chuck Forsman, and Arthur Bullowa. And of Kerstin's family, and of my own. However individual still photography may look, it is collaborative. I have been more fortunate than I can say.

ROBERT ADAMS, Longmont, 1989

CONTENTS

FOREWORD

AT ONCE AWE-INSPIRING AND FORBIDDING, the western landscape symbolizes a contradiction at the root of American culture. Robert Adams's photographs clarify and intensify this contradiction, illuminating simultaneously the uplifting and sacred dimensions of open spaces and man's often ravaging imprint on the land.

Adams offers a vision of unfolding beauty and grace. These are not romantic images echoing an all but vanished era of vast wilderness, open vistas, and endless possibilities. Frequently portraying the evidence of man as something threatening, the photographs nonetheless hold out a possibility that man's presence could be welcome if he were to change. Adams subtly informs his work with the passionate belief that humankind must coexist with the land rather than continue the tradition of hostility that began with some of the first settlers.

More and more frequently the artifacts we encounter around us are the unnecessary detritus of daily life—beer cans, foam packaging, plastic bags. Most insidious is the legacy of poison resulting from the manufacture of nuclear and thermonuclear weapons at places such as Rocky Flats, or the waste products produced by nuclear reactors. These time bombs are ready to explode or leak radioactivity after a productive life of thirty or forty years.

Less dramatic is the commercial strip development in most urban areas, the tract houses blanketing the landscape, and the pollution from factories and vehicles. They contribute to an overwhelming sense that the fabric of our humanity may be destroyed.

Robert Adams has devoted his life and art to a greater awareness of our fundamental connection to the land. His work calls for a concentrated effort, not simply to preserve, but to conceive strategies which will make the best use of our wealth and resources.

In this retrospective volume and its accompanying exhibition, Robert Adams's photographs can be seen as metaphors of his experience and aspirations, and as lasting evidence of the life in all things. Even in the saddest and most desolate of his images there is dignity and simplicity, grace and vividness—a meditation.

MICHAEL E. HOFFMAN

THE OBBLIGATO

THIS HILL IS FAR
ENOUGH.
IT'S TRUE. EITHER
YOU ARE HERE

OR YOU'RE NOT. AND
IF YOU
ARE, THIS IS THE
PLACE TO STAND

AND TAKE THE EARTH
TO TASK,
TO GIVE IT ALL
YOU'VE GOT AND

NOT ASK BACK BUT
OF IT,
AS GRACE, ITS FOOD,
ITS FLOWER,

TO BE LIKE THOSE
WHO BROUGHT
YOU HERE, WHO PER-
SISTED, WHO

BORE YOU, NURSED YOU,
TAUGHT YOU,
WHO SAW THROUGH NIGHTS
SANG TO YOU,

BECAUSE THEY FELT
THEY MUST,
BECAUSE THEY LOVED
EVEN THIS.

CID CORMAN

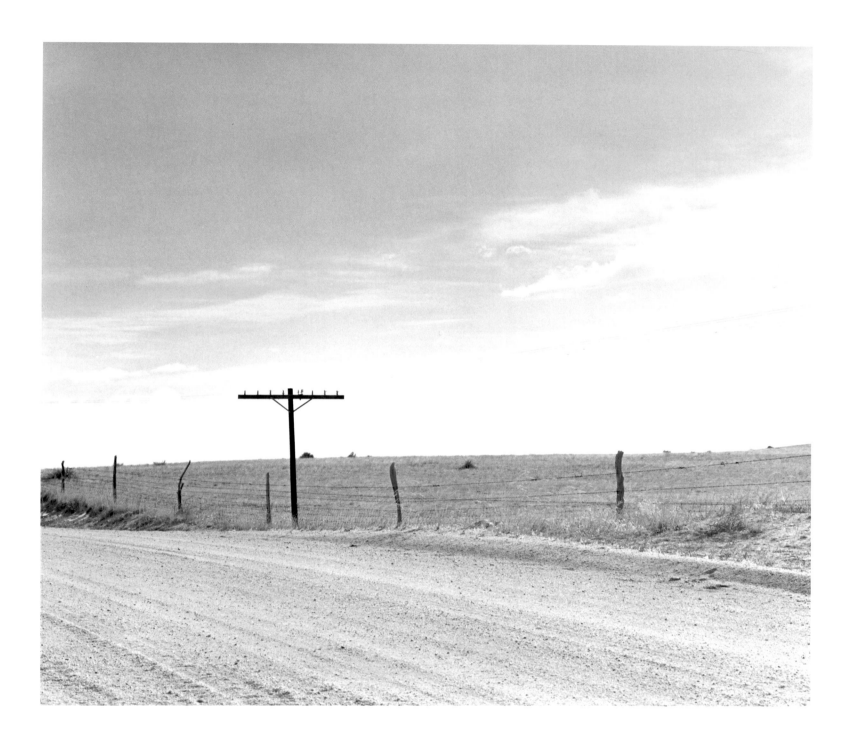

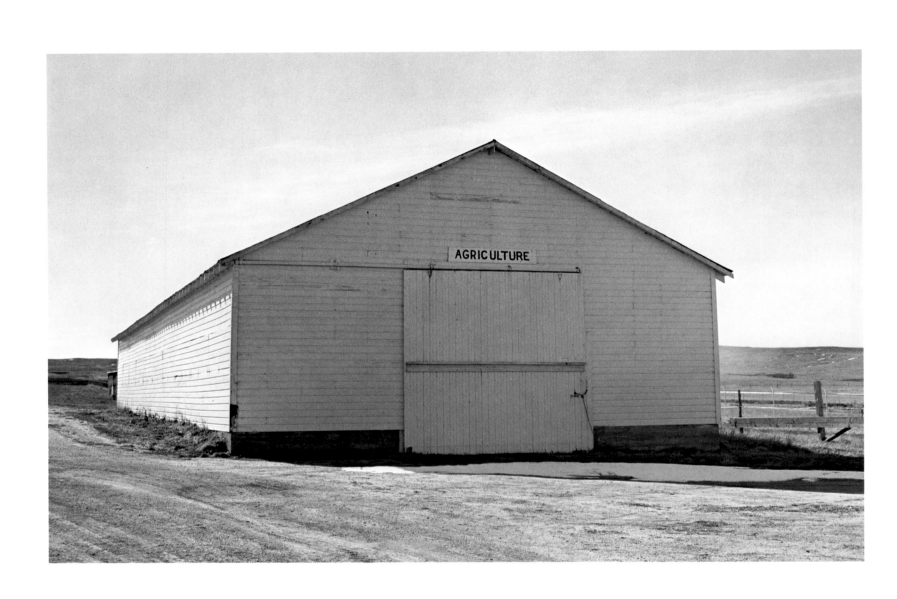

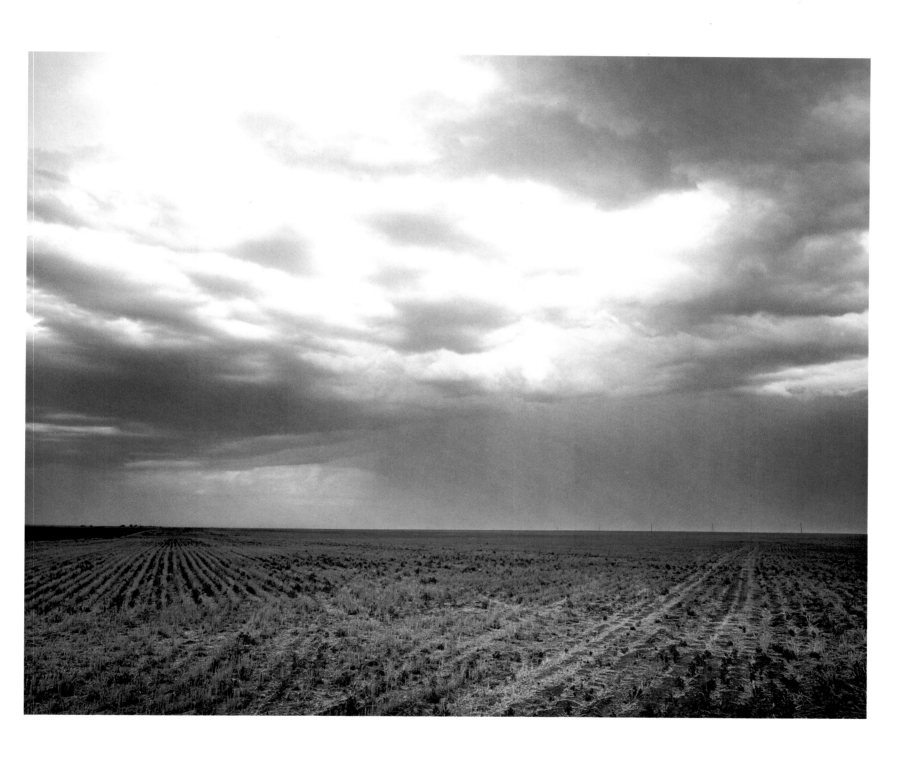

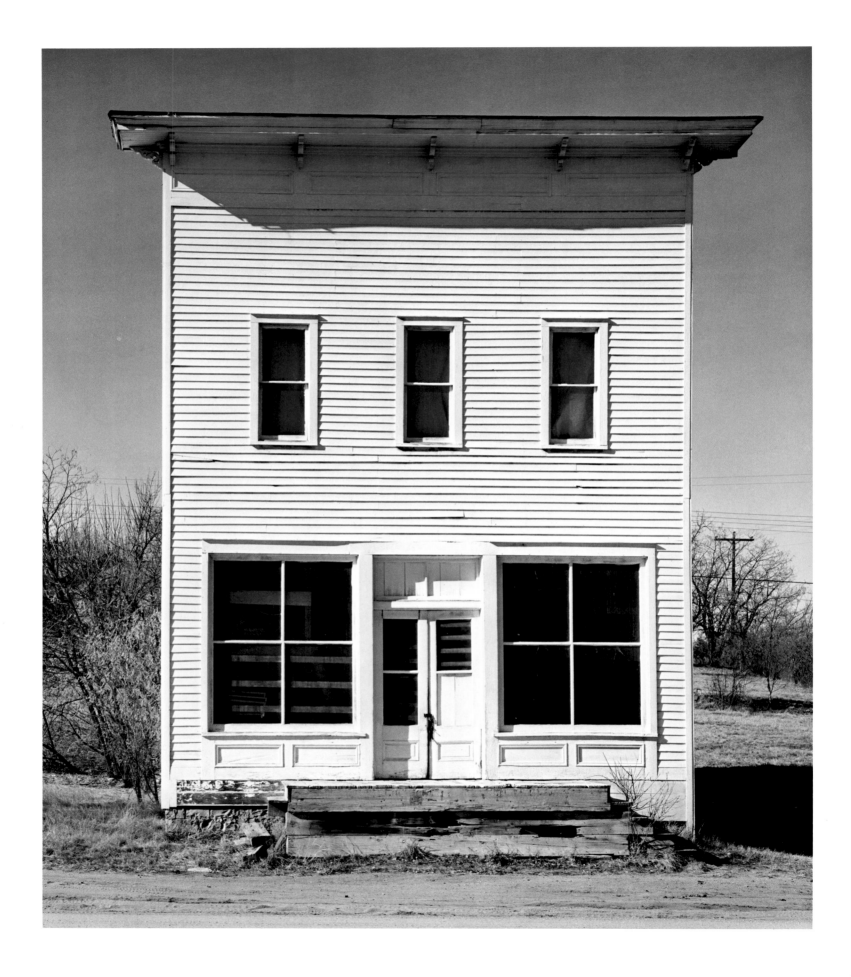

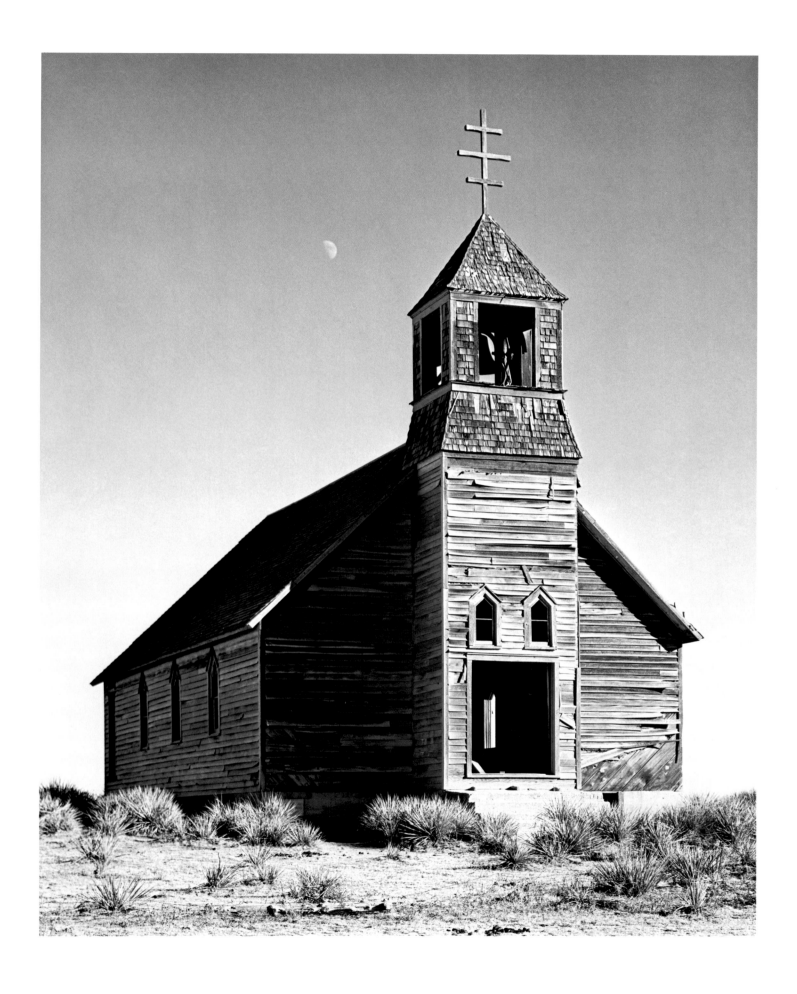

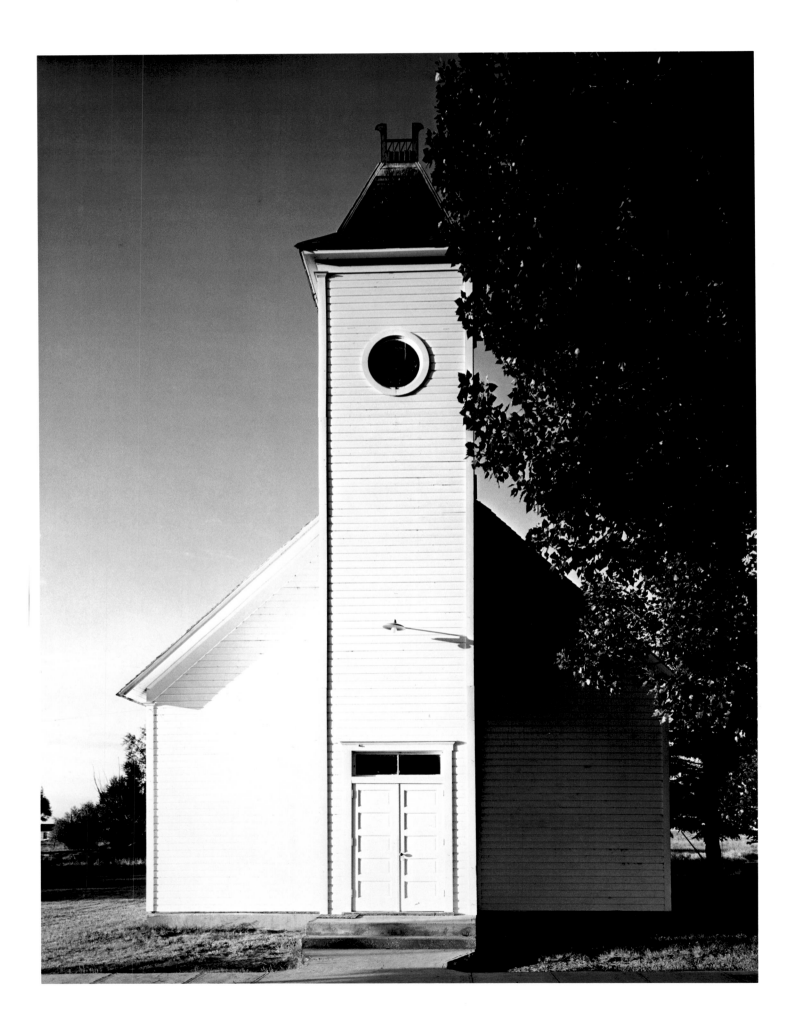

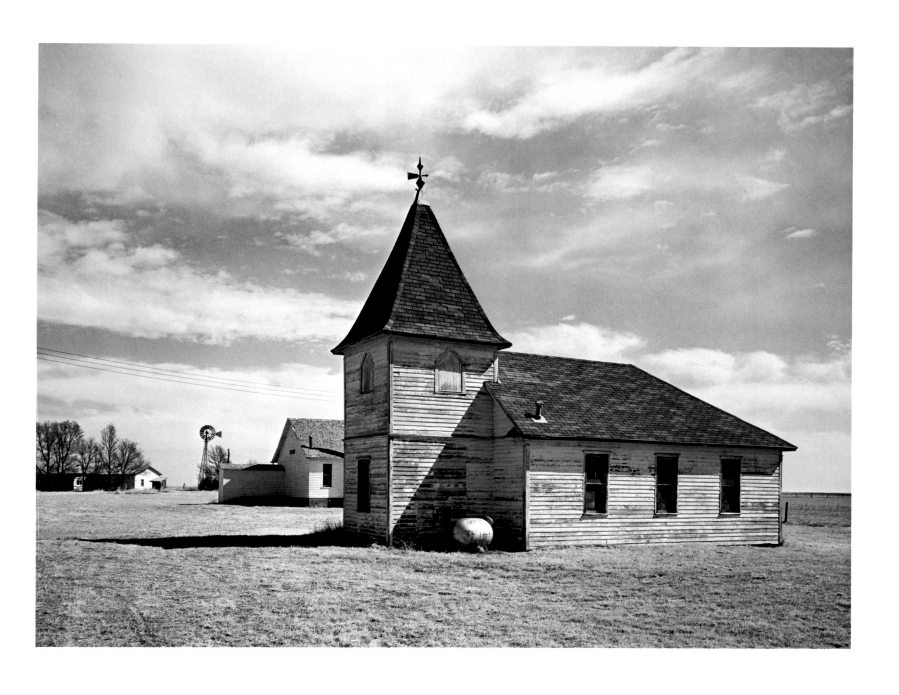

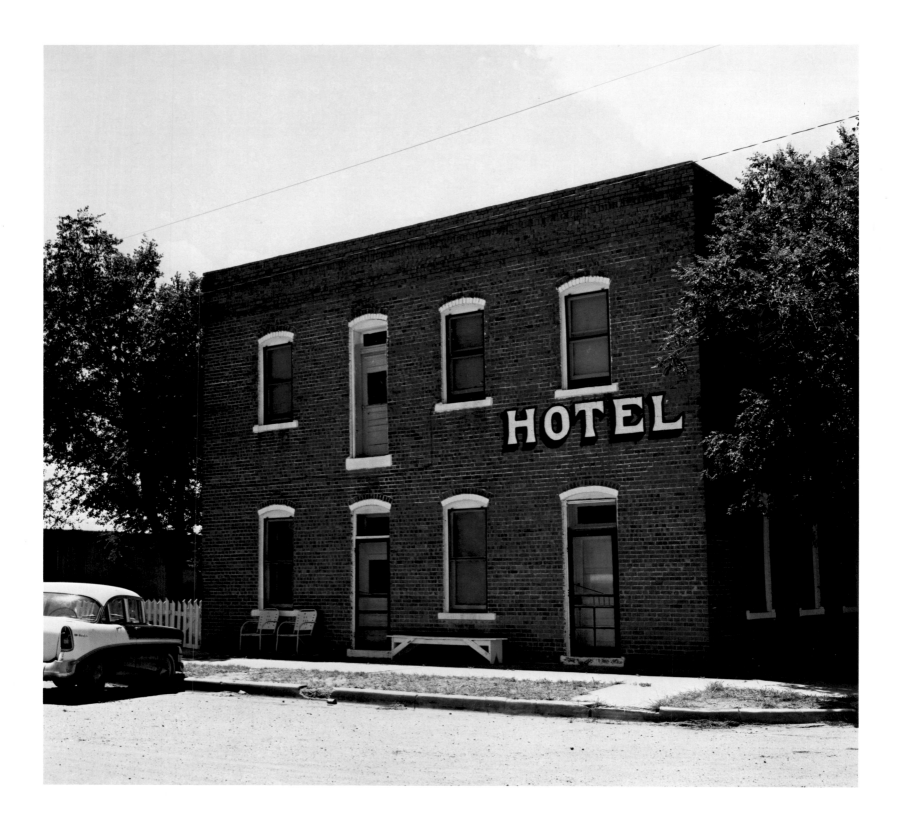

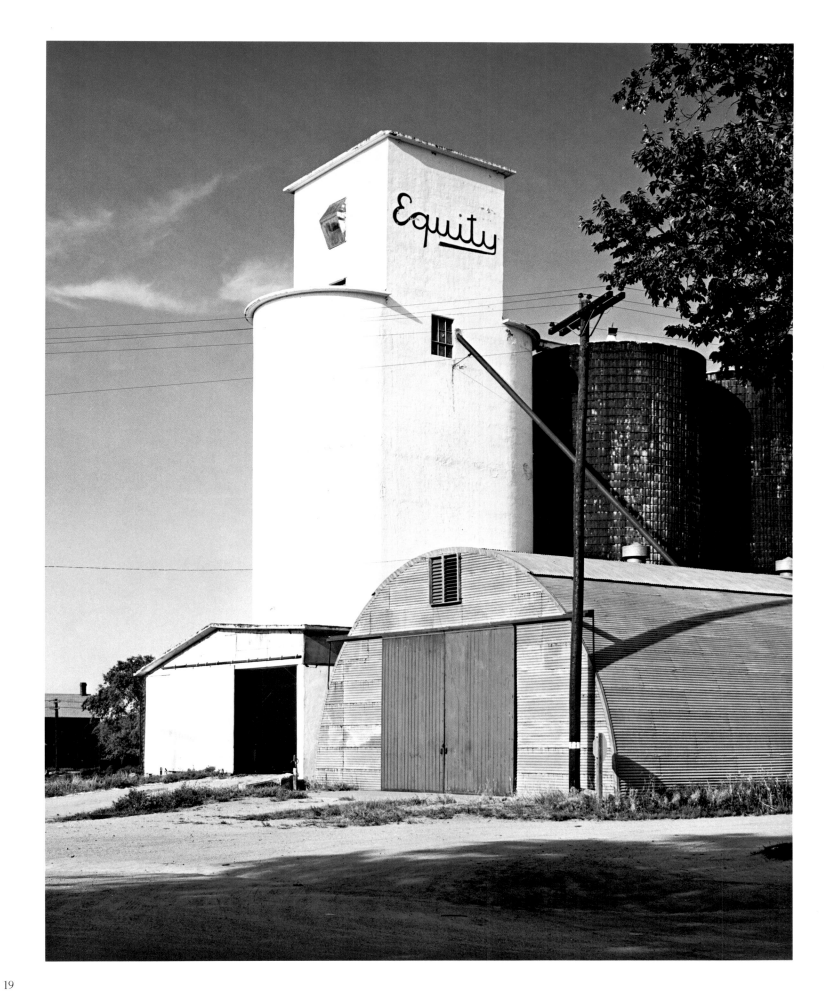

Prairie buildings—spare, white, and isolated—
are emblems of our hope and its vulnerability.
Even architecture in town finds its reference
point at the ends of streets, at the horizon.

Mystery in this landscape is a certainty,
an eloquent one. There is everywhere silence—
a silence in thunder, in wind, in the call of
doves, even a silence in the closing of a
pickup door. If you are crossing the plains,
leave the interstate and find a back road
on which to walk; listen.

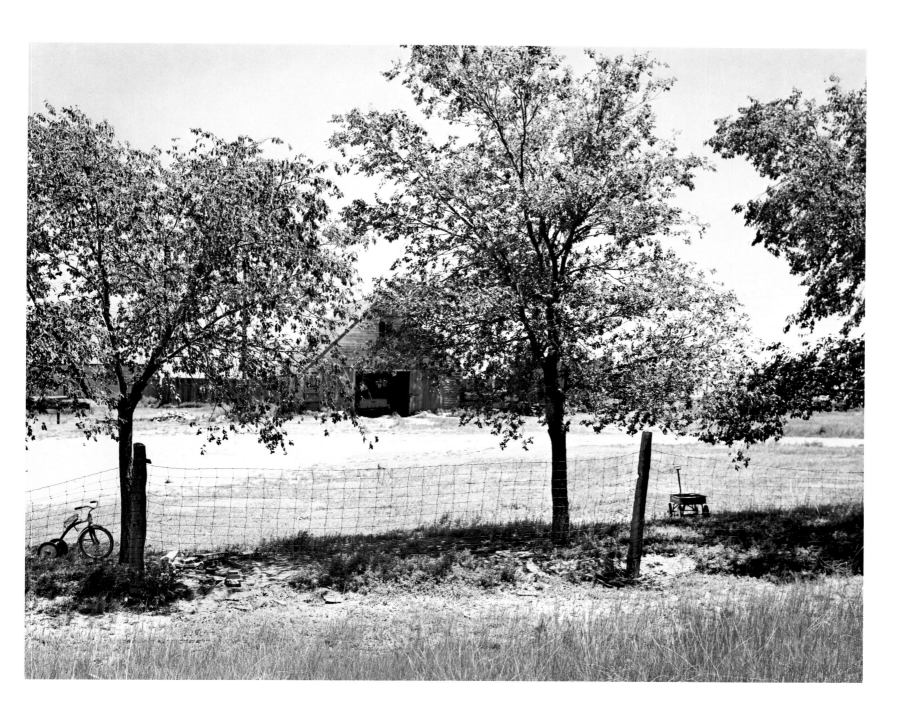

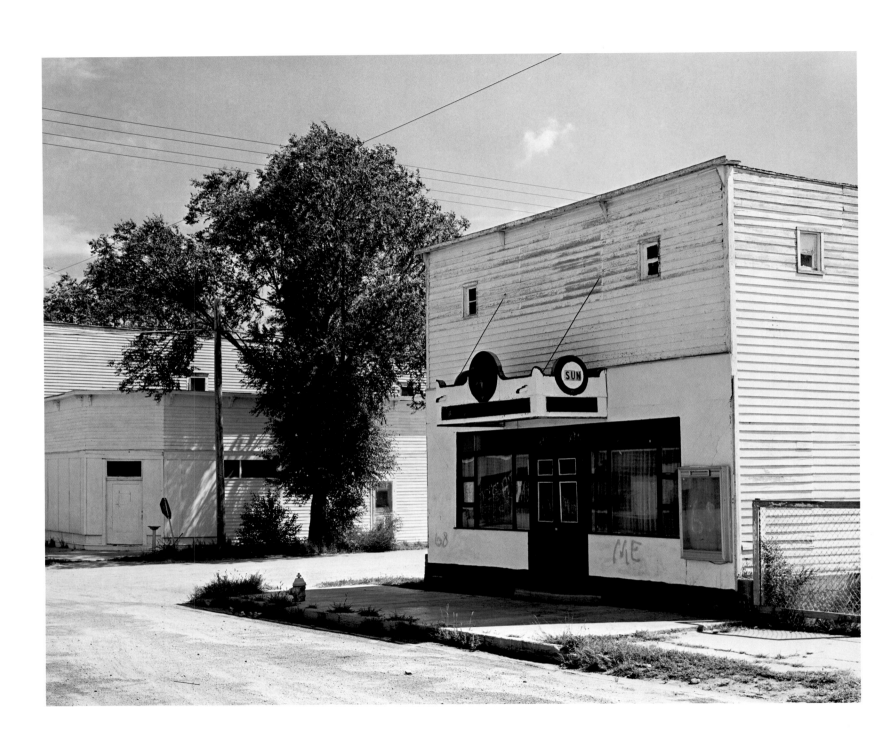

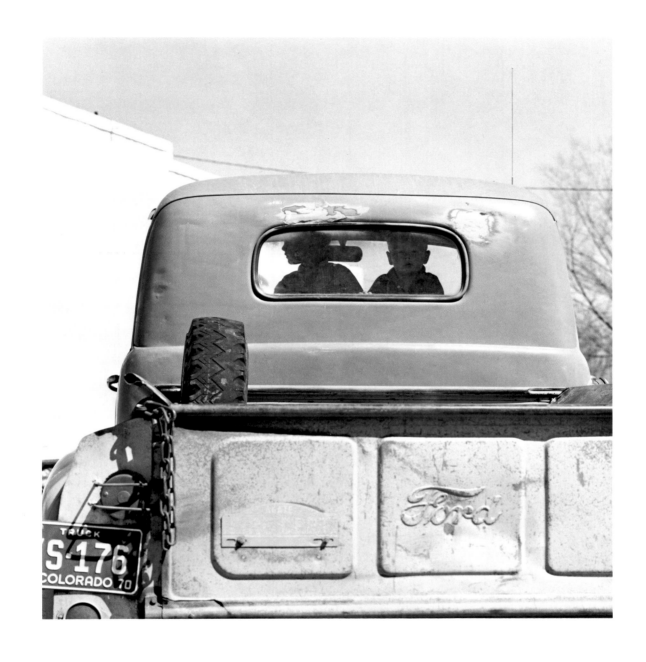

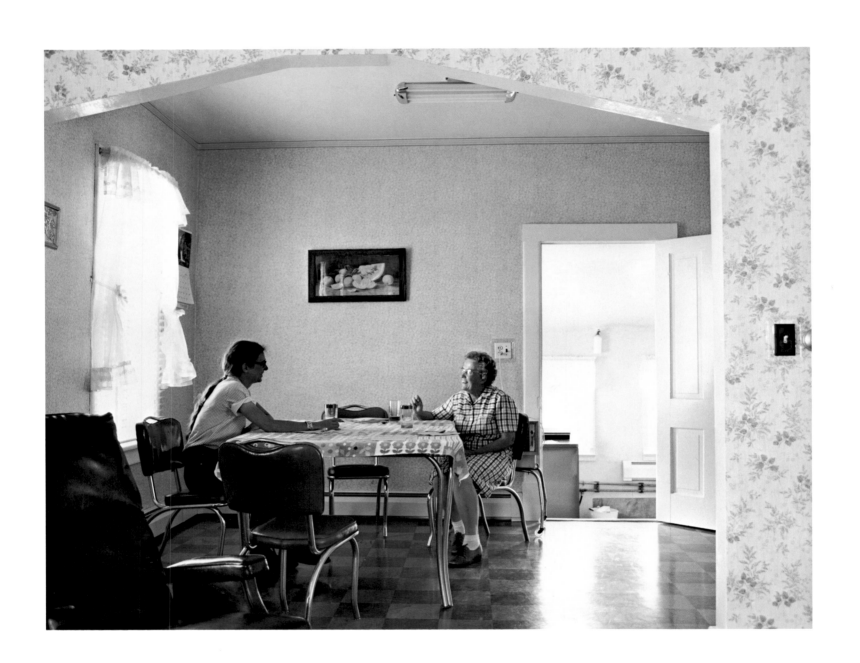

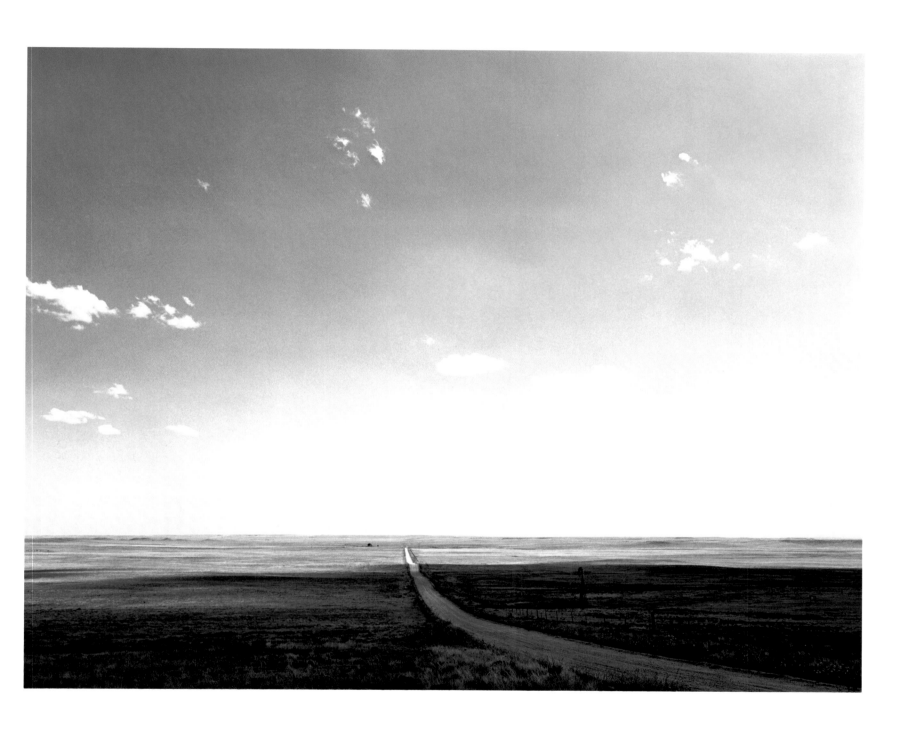

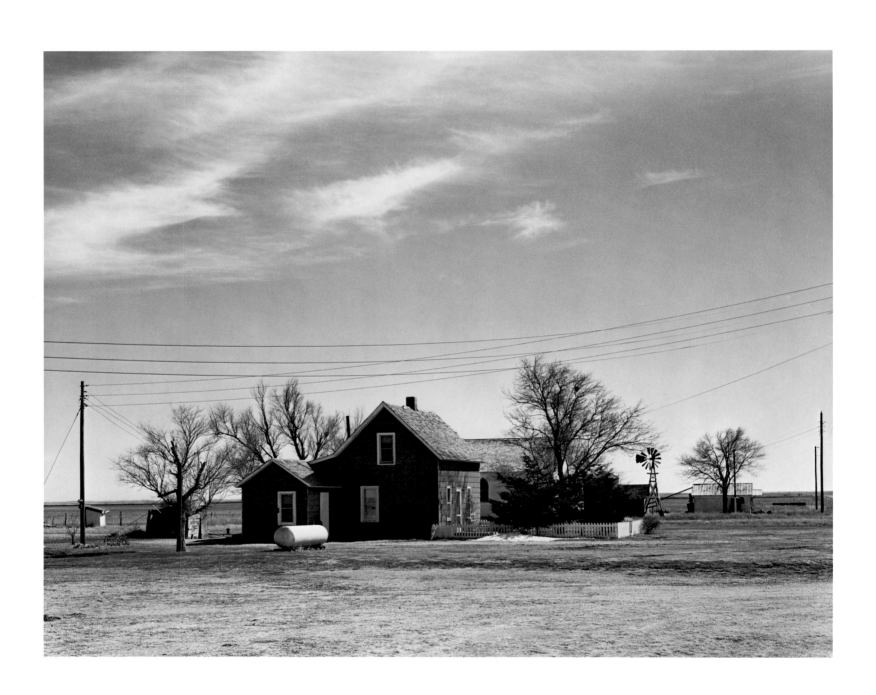

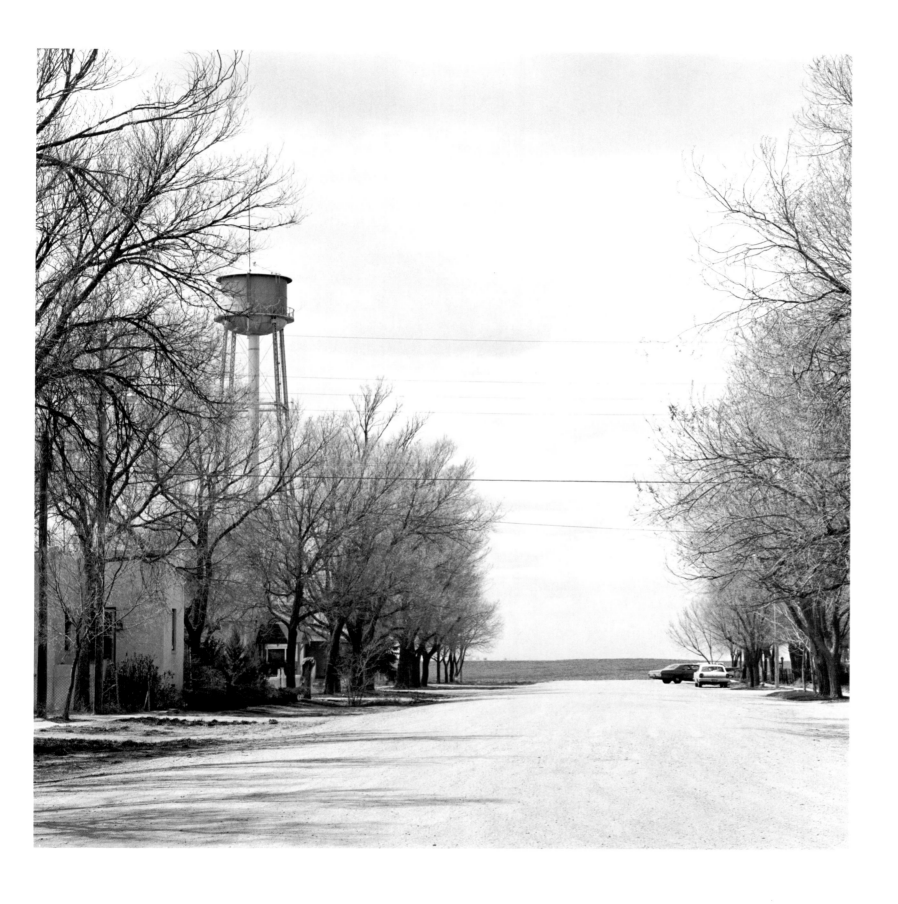

The first uplift of the Rocky Mountains,
the Front Range, revealed to nineteenth-century
pioneers the grandeur of the American West,
and established the problem of how to respond
to it. Nearly everyone thought the
geography amazing; Pike described it in 1806 as
"sublime," and Kathryn Lee Bates eventually
wrote "America the Beautiful" from the
top of the peak he discovered. Nonetheless,
as a practical matter most people hoped
to alter and exploit the region.

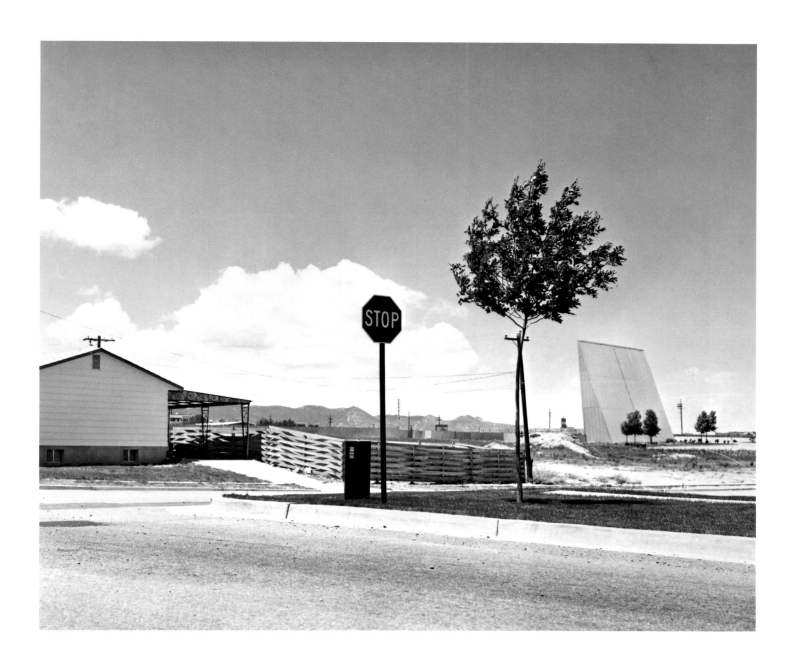

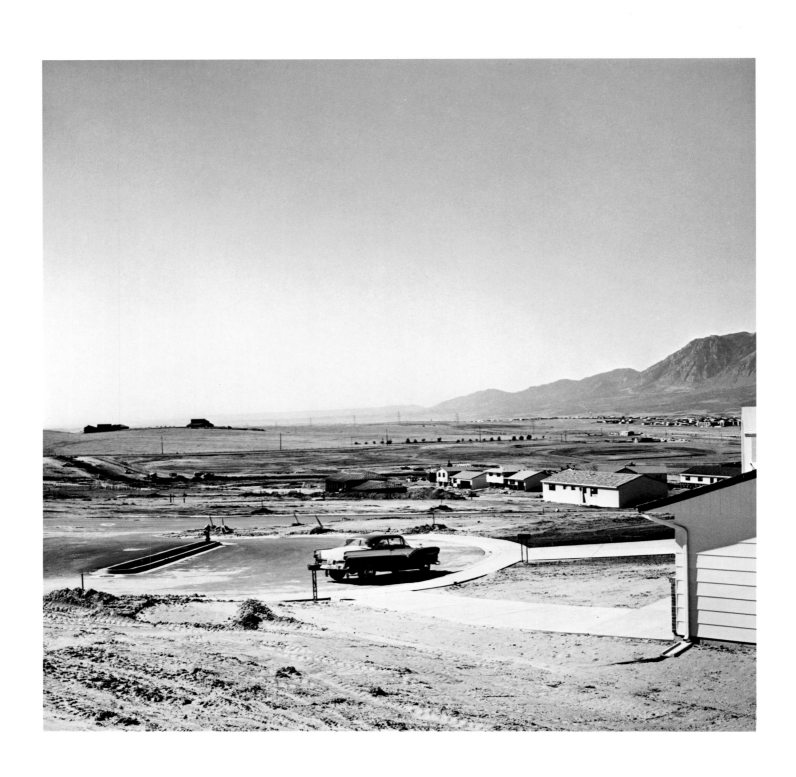

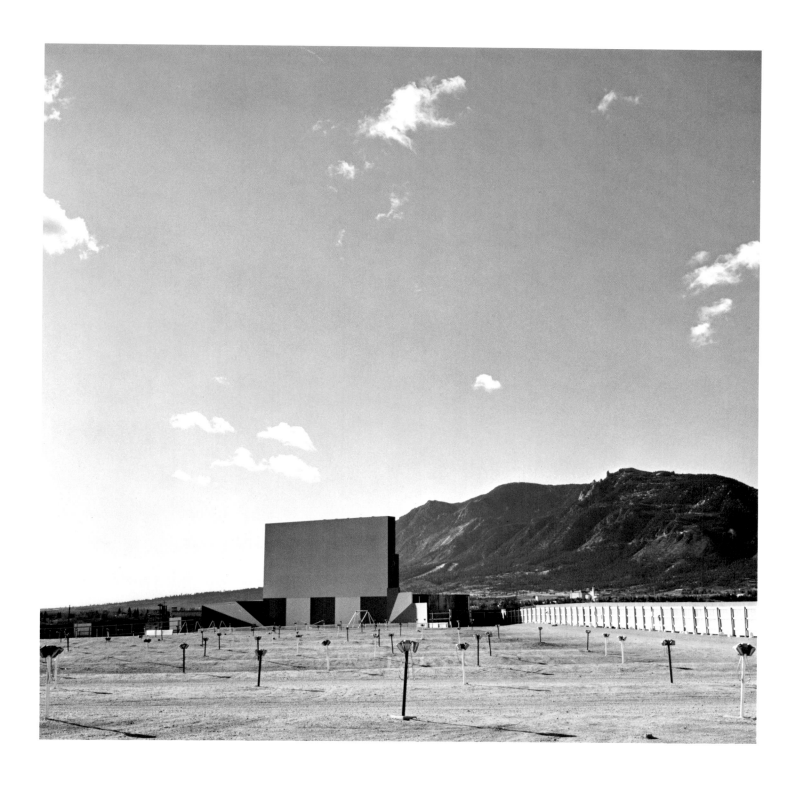

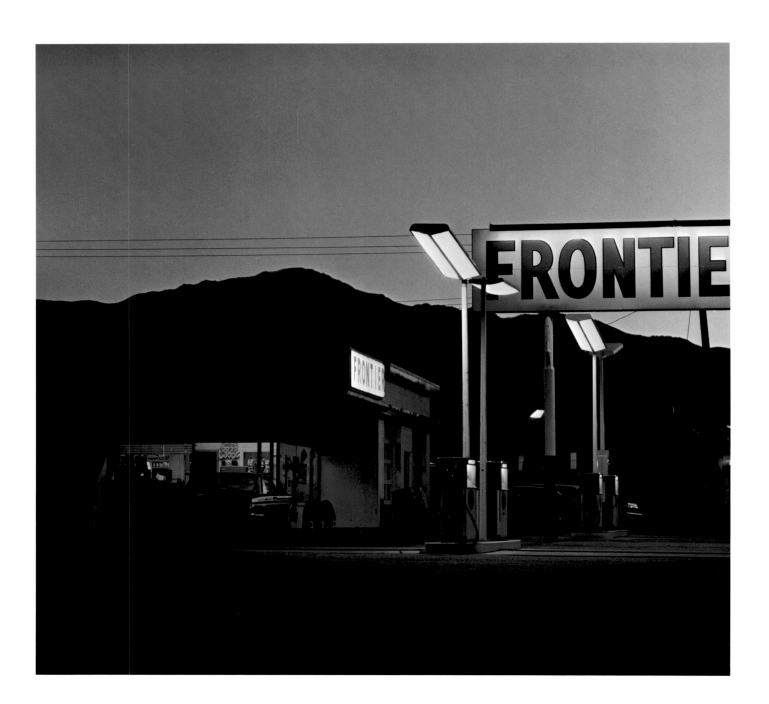

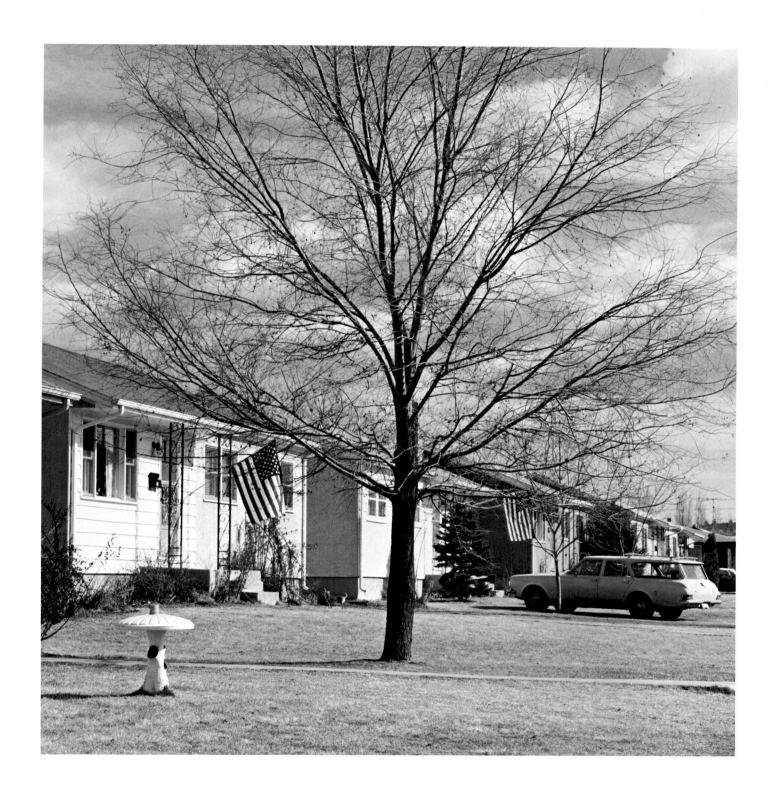

33

The house was identical with others in the
development. I felt the sadness of the figure,
but I also loved the light.

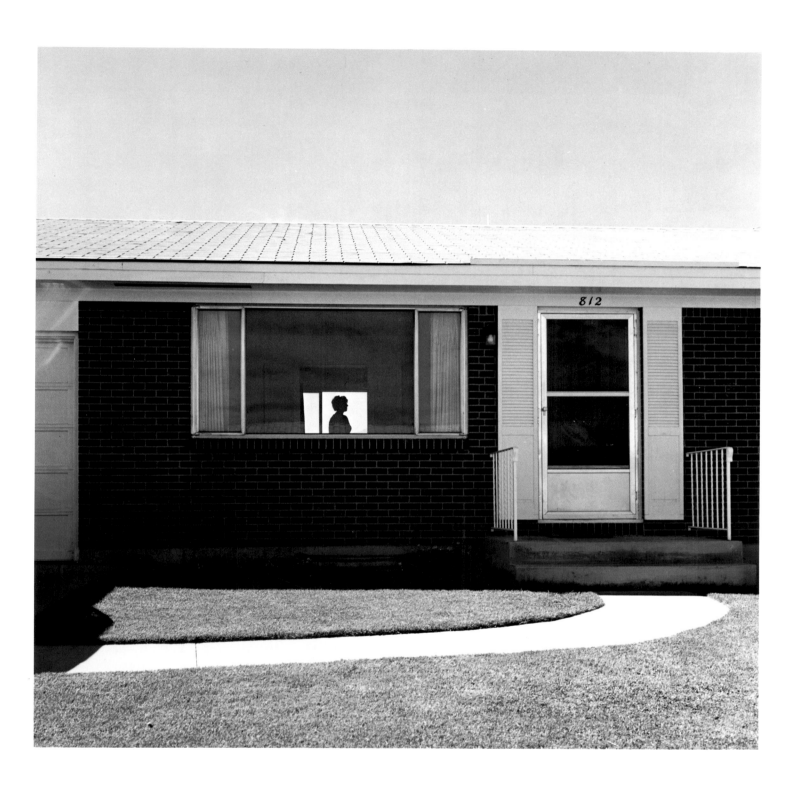

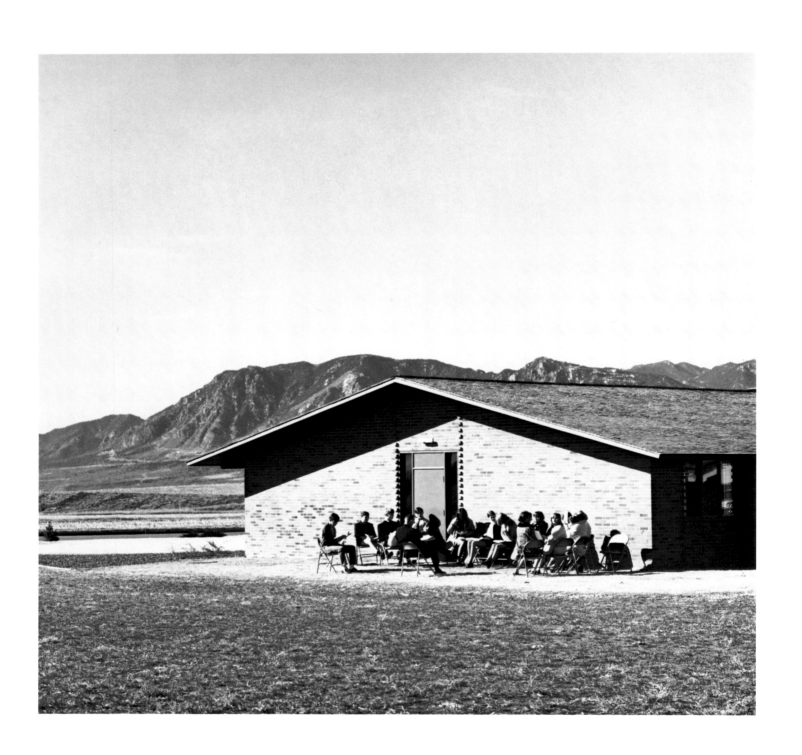

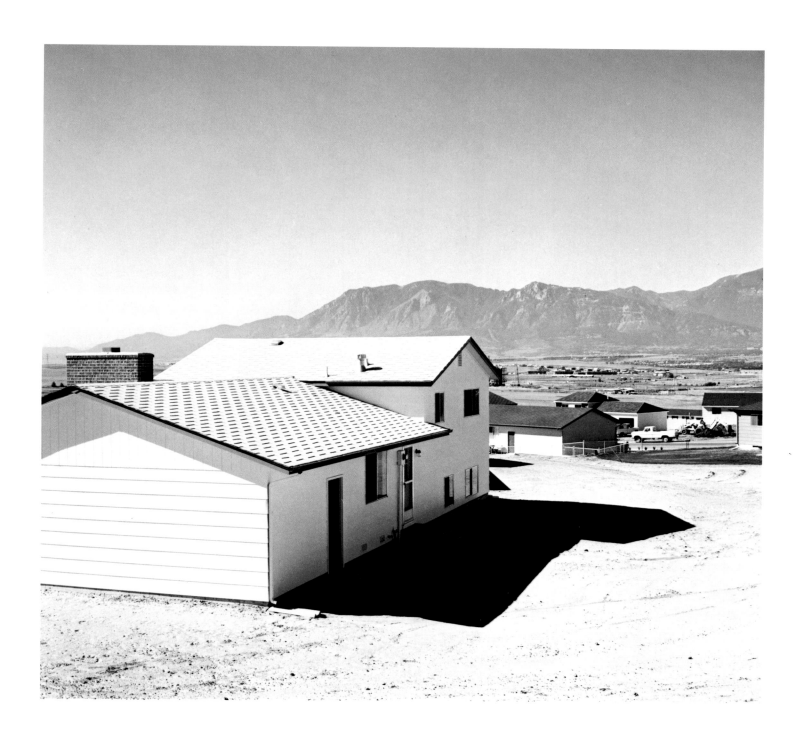

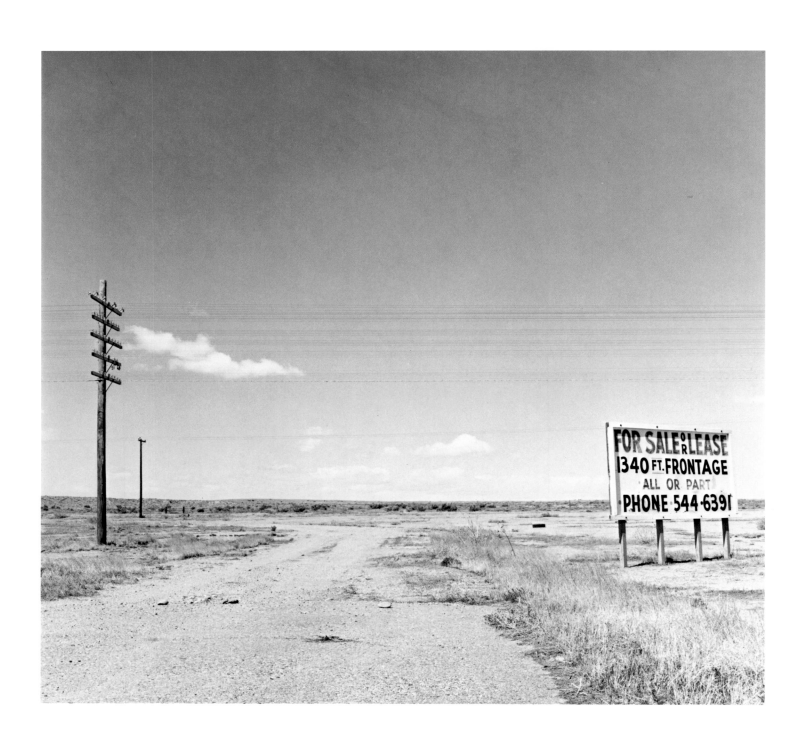

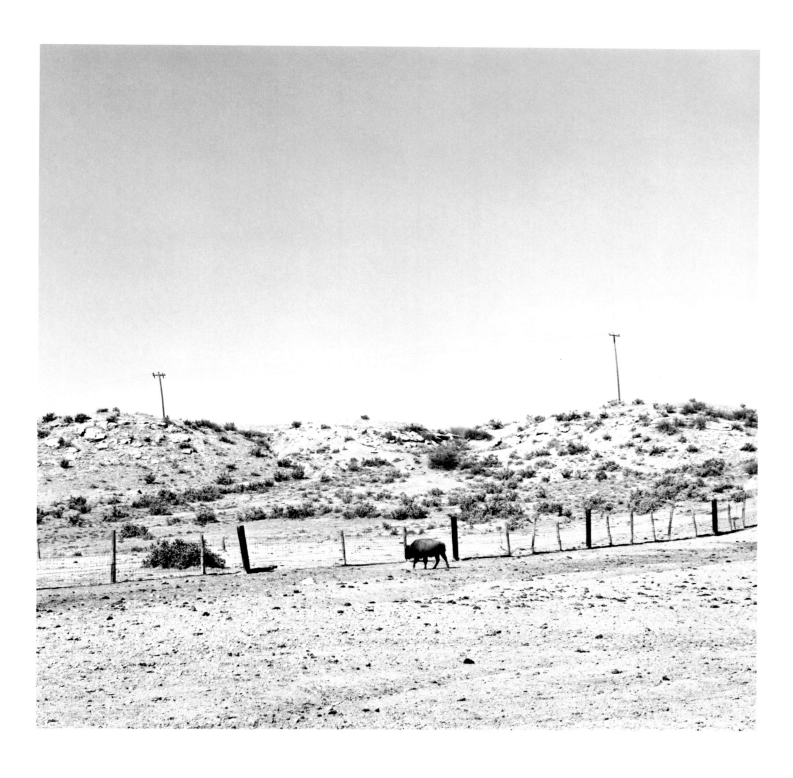

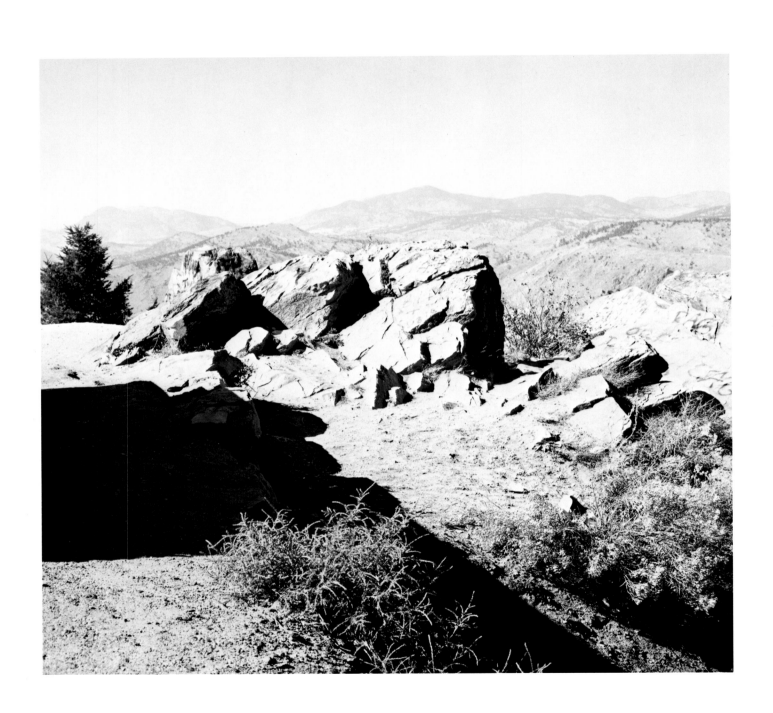

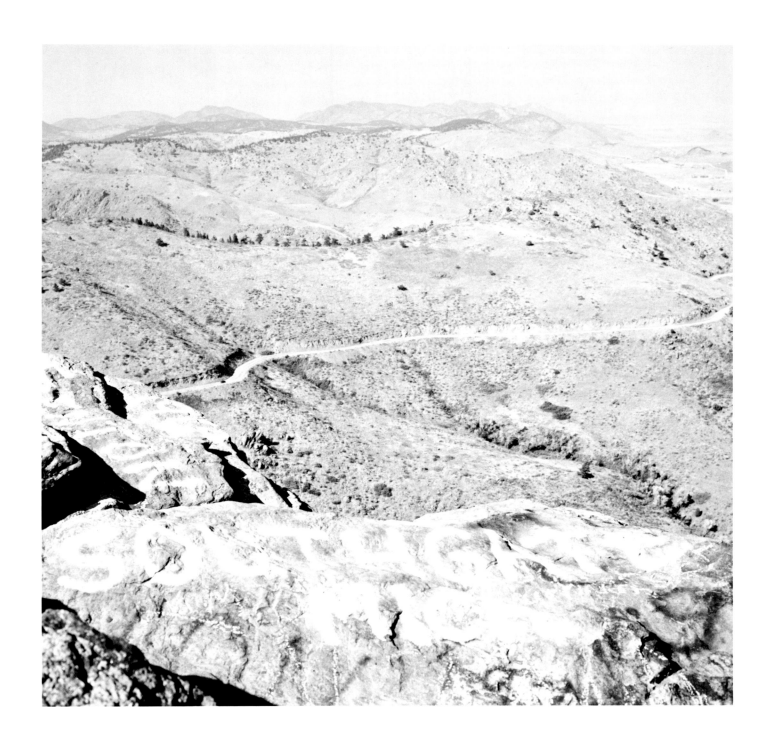

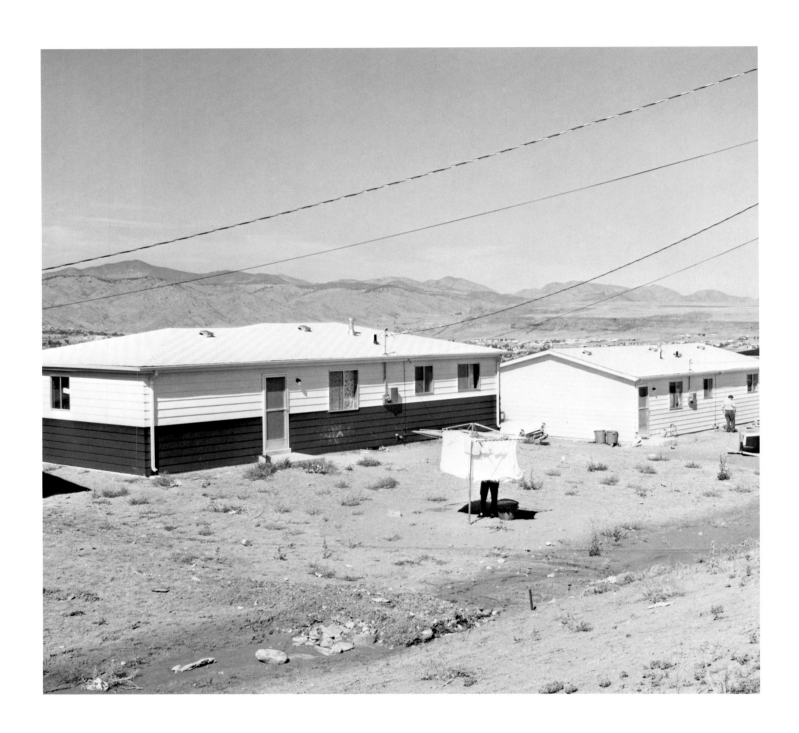

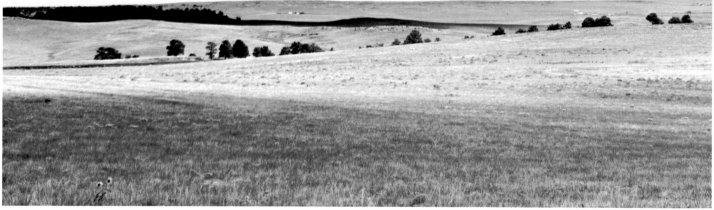

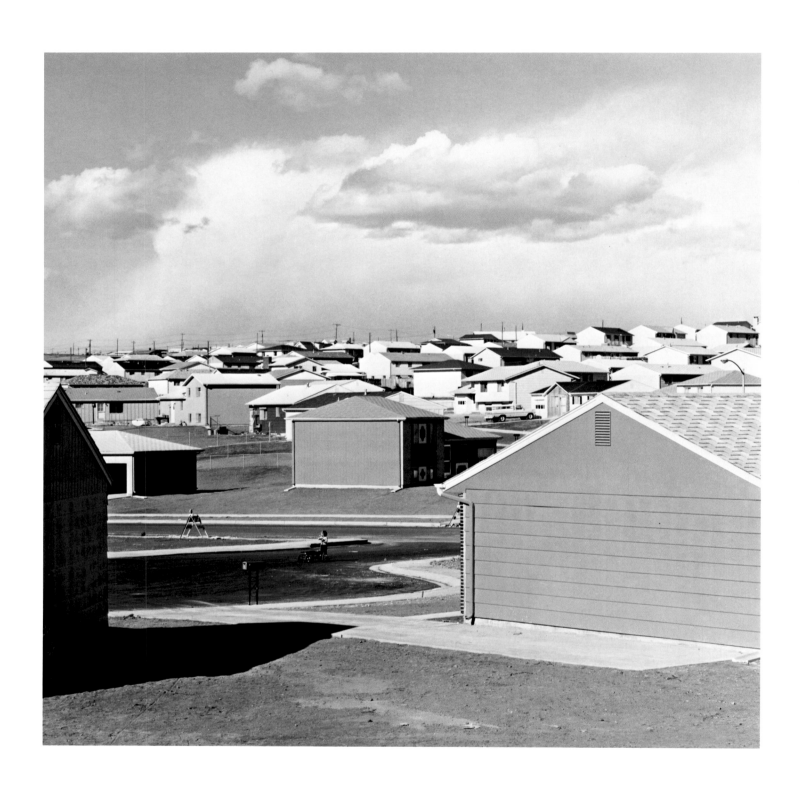

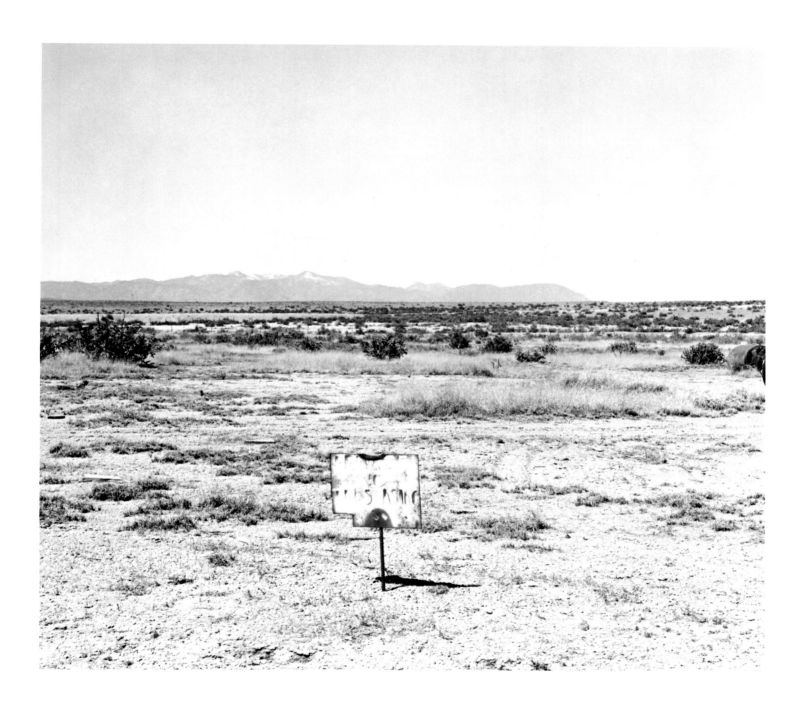

In Denver's vacant lots one can still find, no matter
how numerous the food wrappers and pieces of styrofoam,
an old, tough green—Spanish bayonet, cactus, and sage.
Perhaps most reassuring of all, there remain
cottonwoods, those commercially useless trees that
are habitat for birds and children. Whether I was
photographing these accidental sanctuaries, however,
or bare, new tracts, I tried to keep in mind
a phrase from a novel by Kawabata: "My life,
a fragment of a landscape." The same applied,
I thought, to each of us. . . .

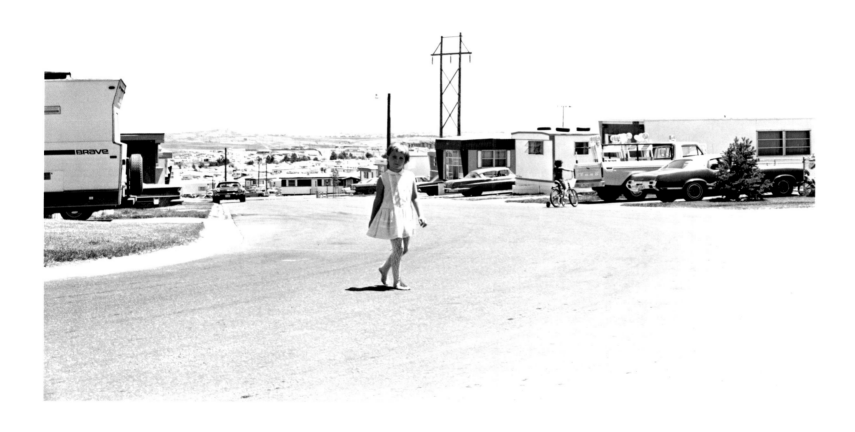

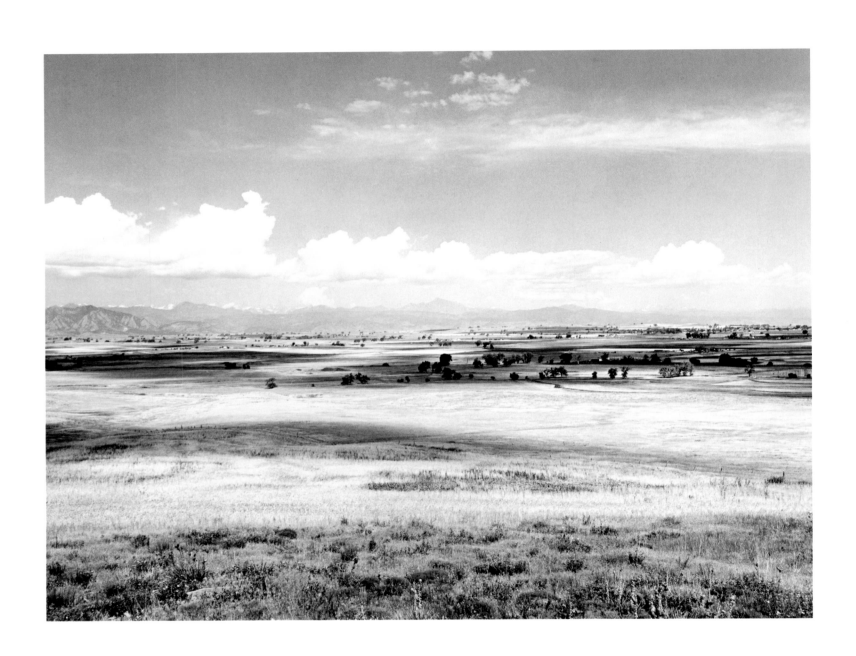

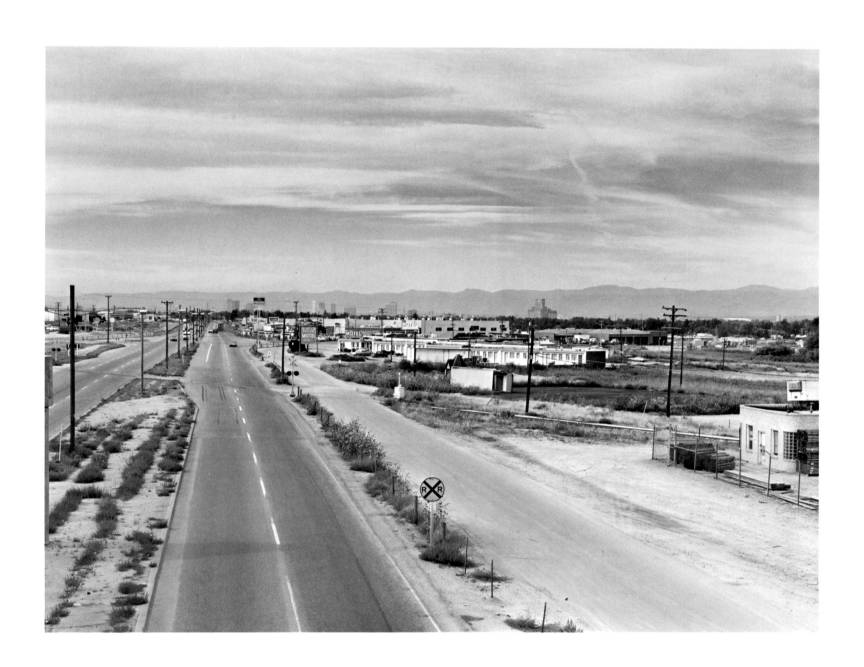

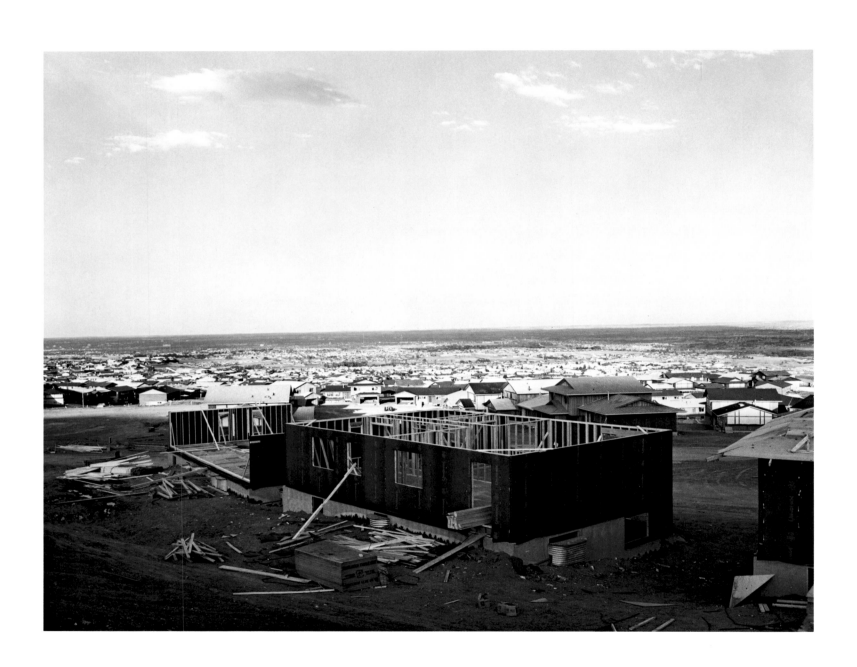

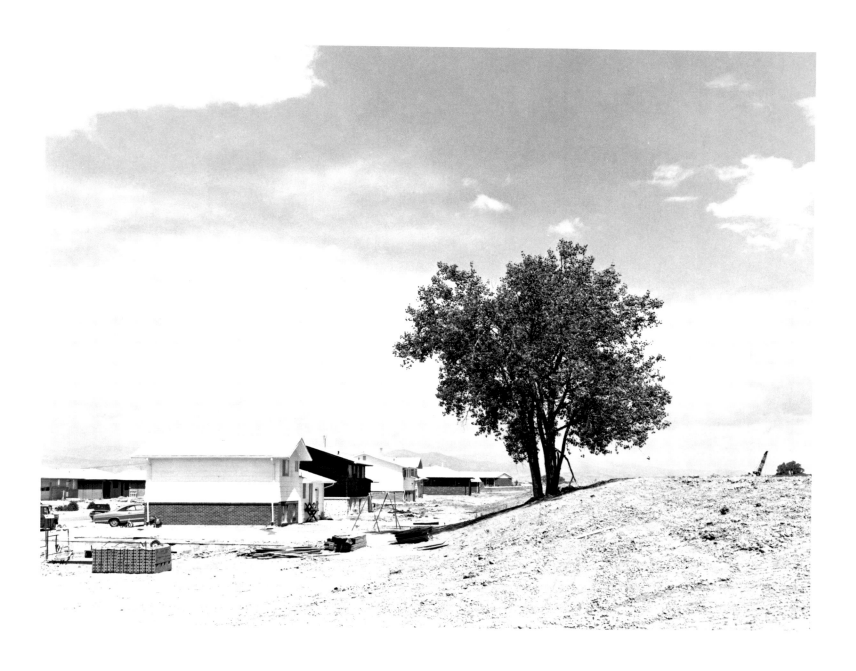

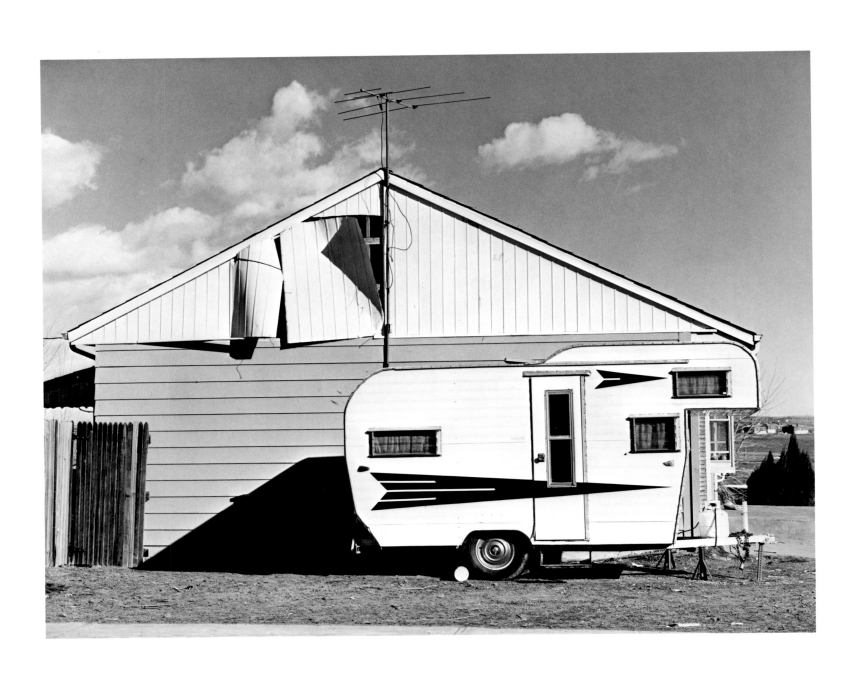

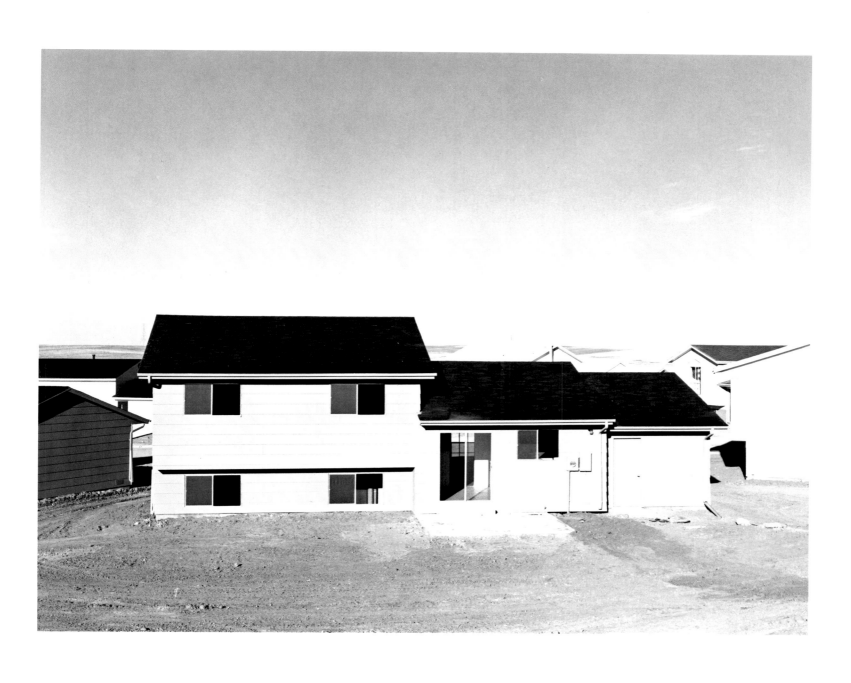

Whatever else this [picture] may be it is also a
photograph about shopping and about the experience
of being a consumer in a late-industrial society, a
condition with no fixed location. In the early 1970s
West German radicals coined the double-edged term
konsumterror to describe, in its less militant usage,
the numbing alienation that follows the sublimation
of political choice into a myriad of atomized,
meaningless consumer "decisions."

LEWIS BALTZ, "Konsumterror," *Camera Austria*, 1985

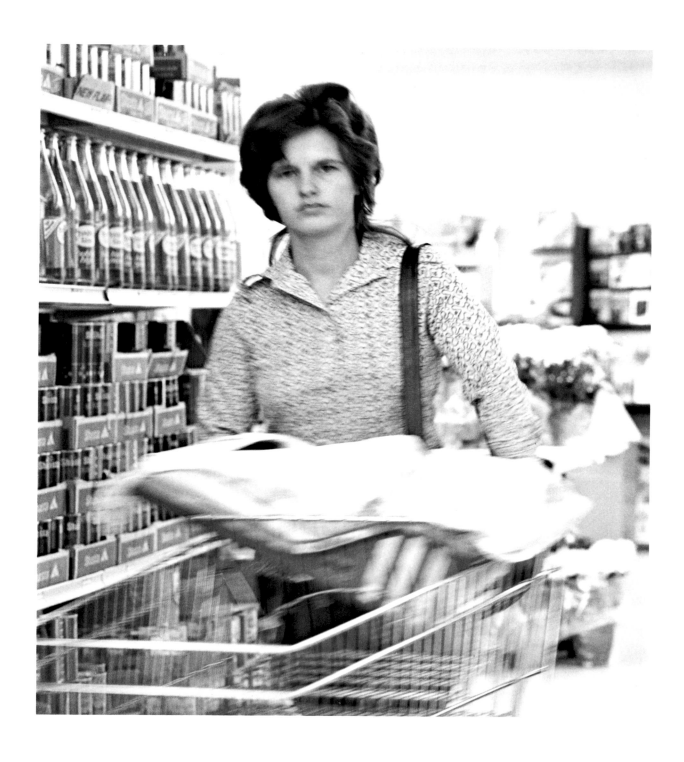

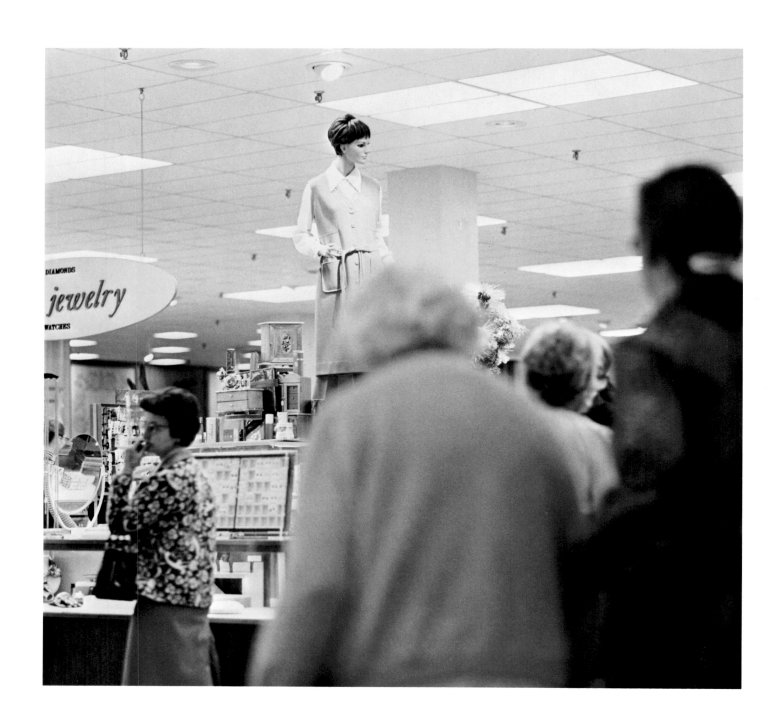

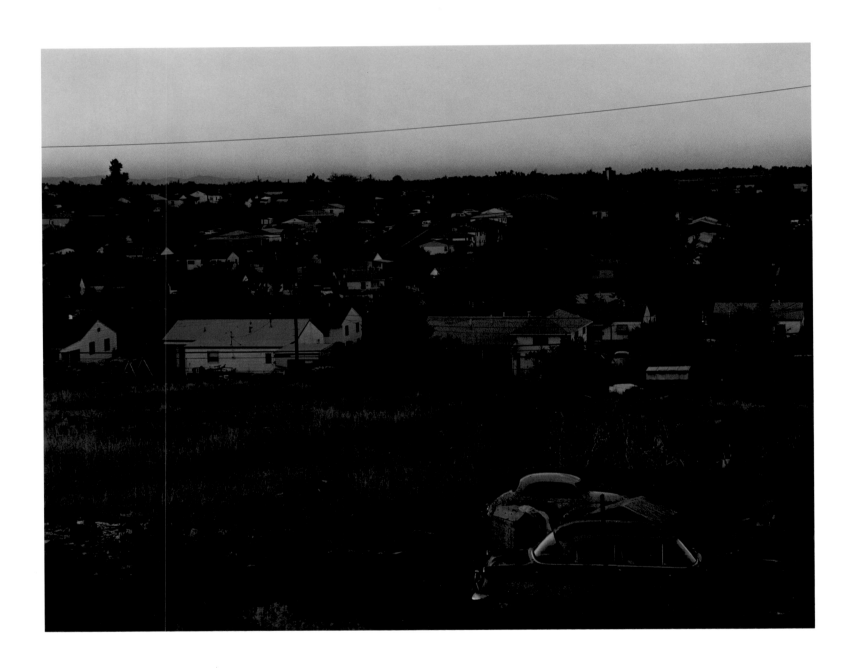

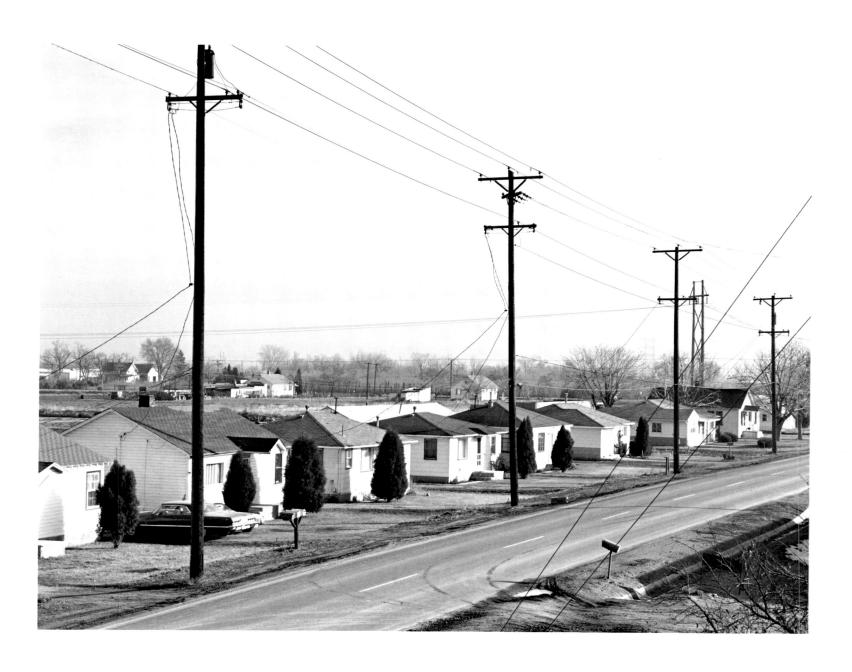

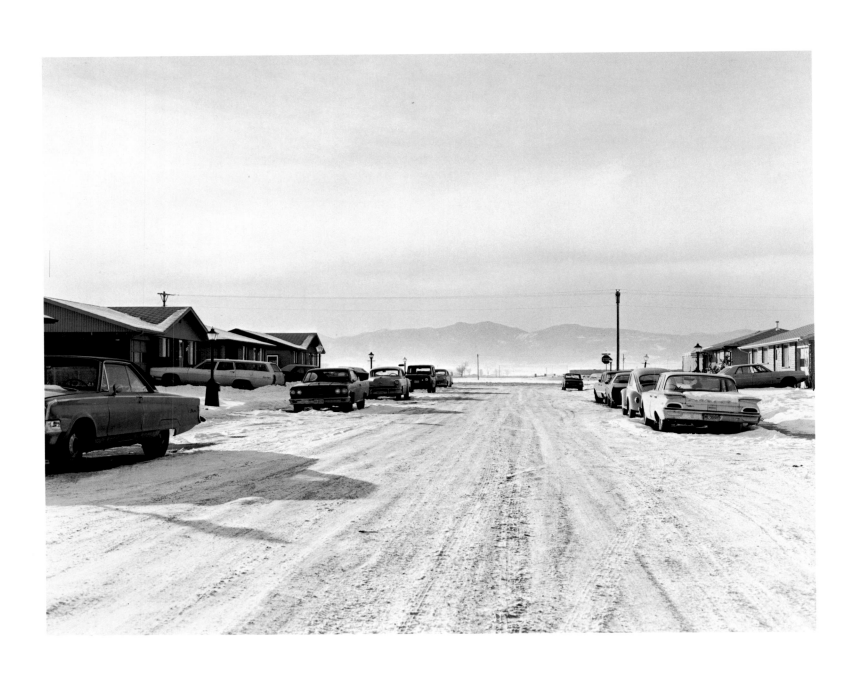

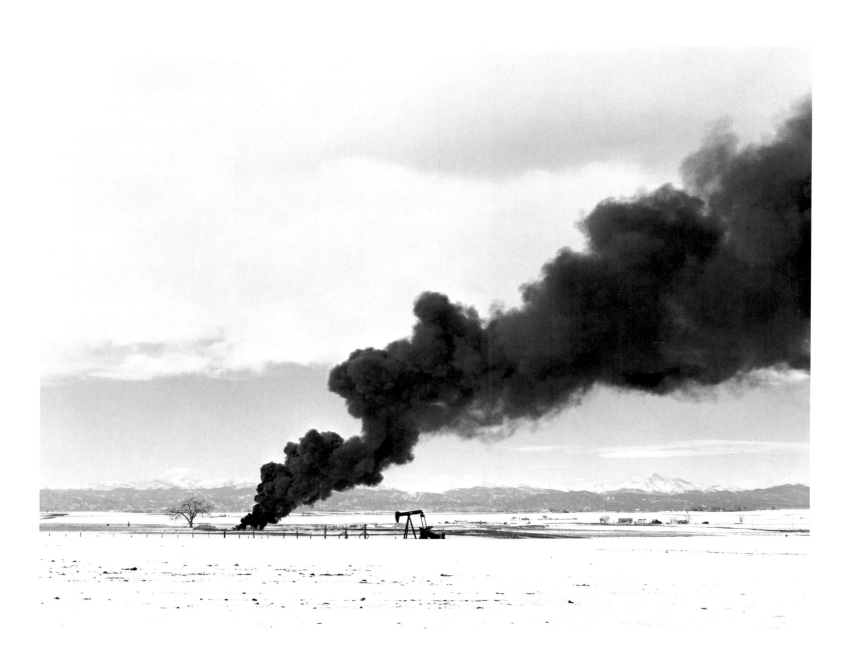

On the prairie there is sometimes
a quiet so absolute that it allows one to
begin again, to love the future.

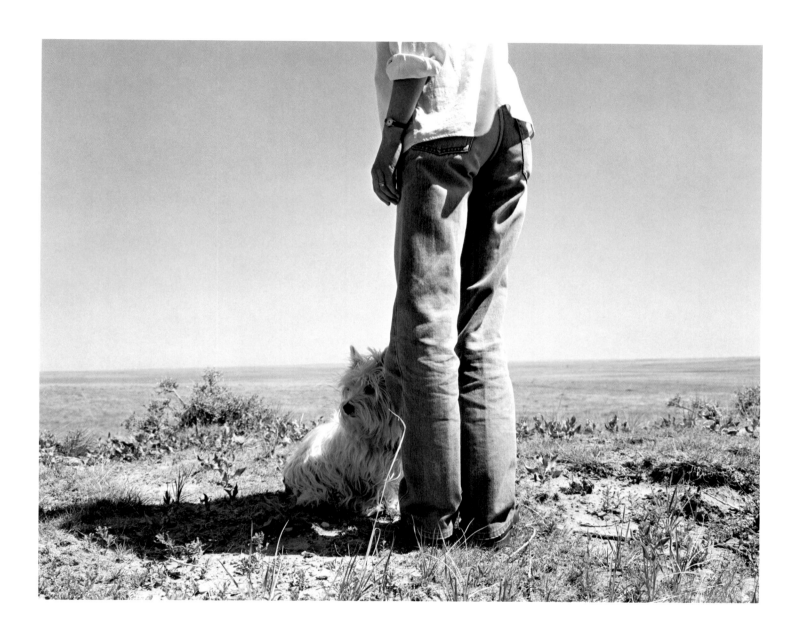

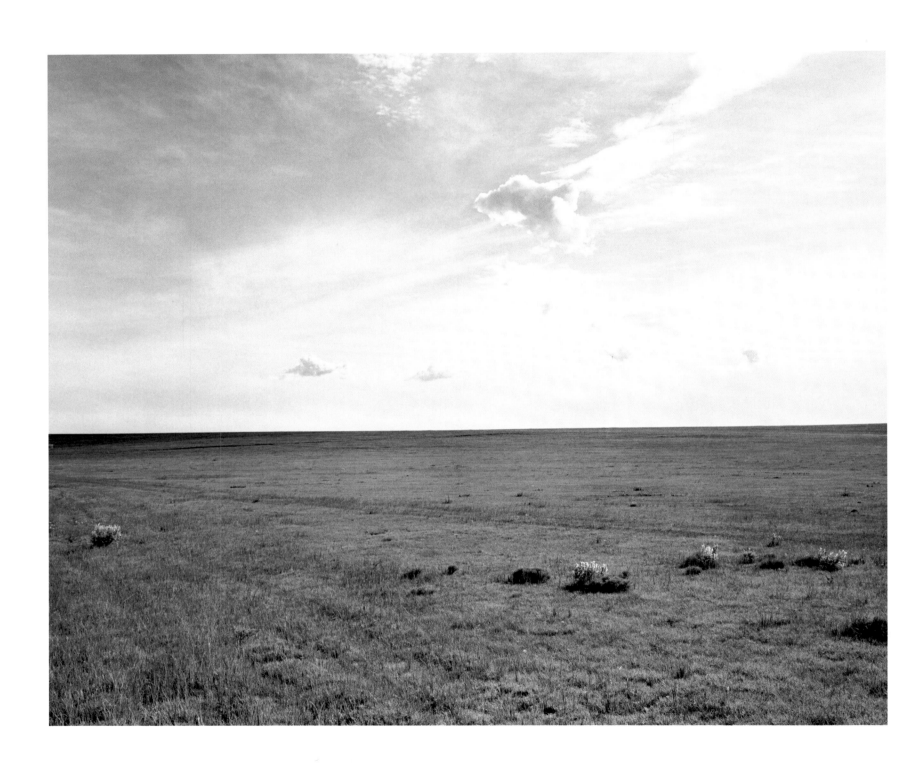

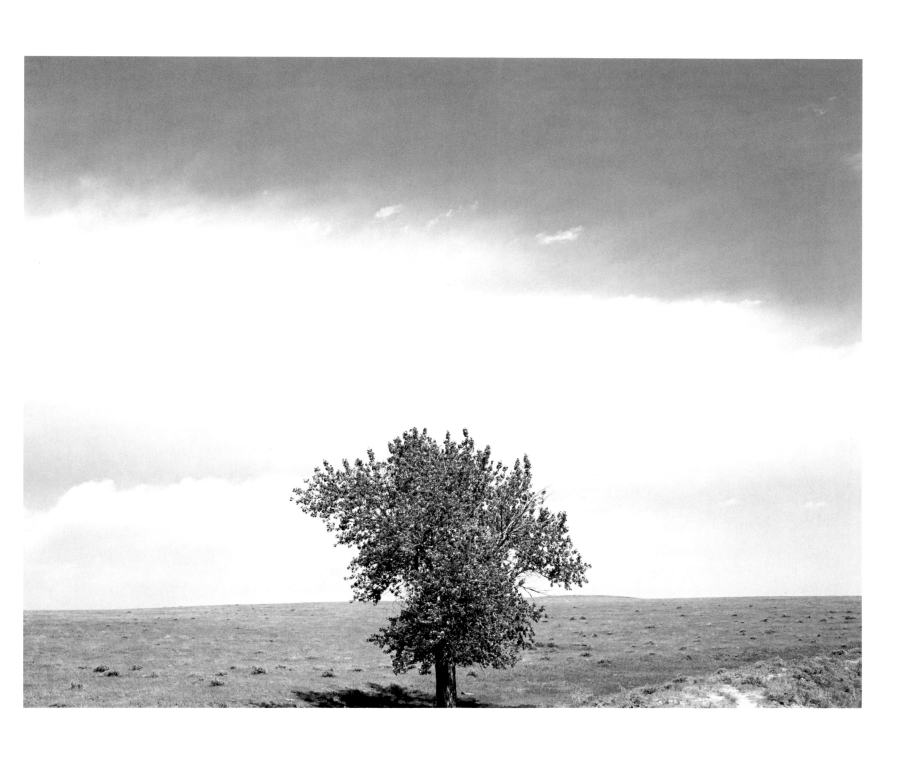

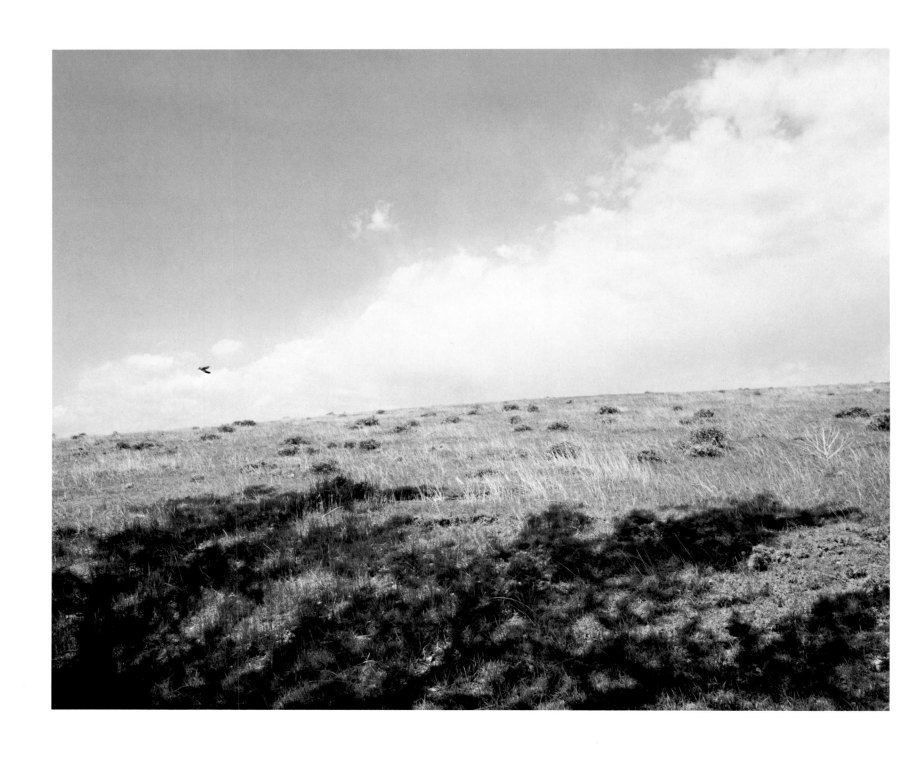

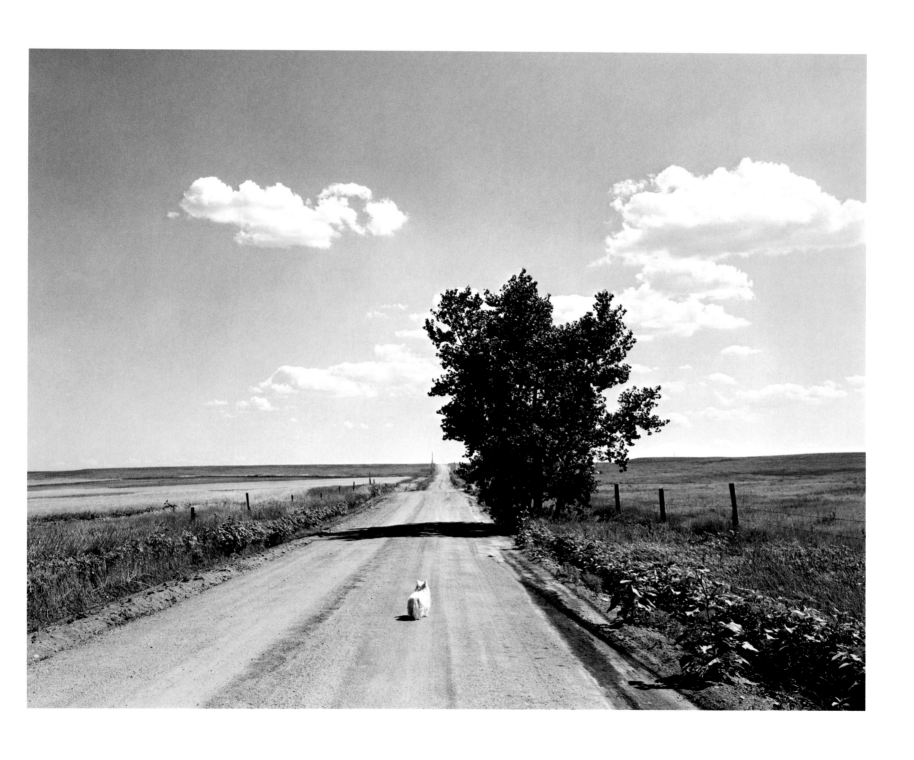

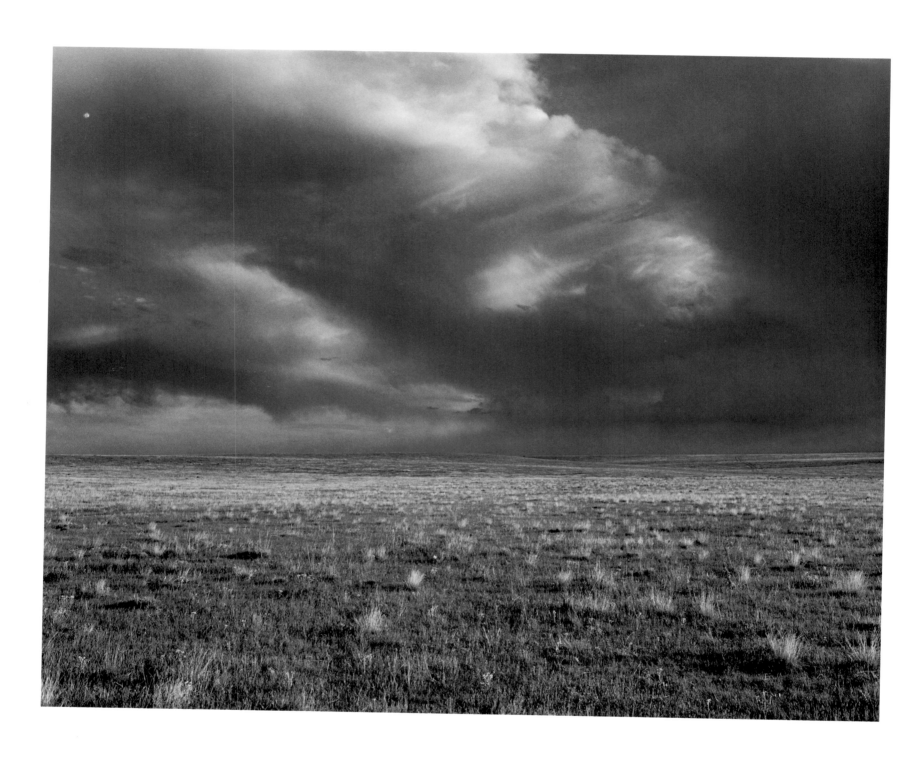

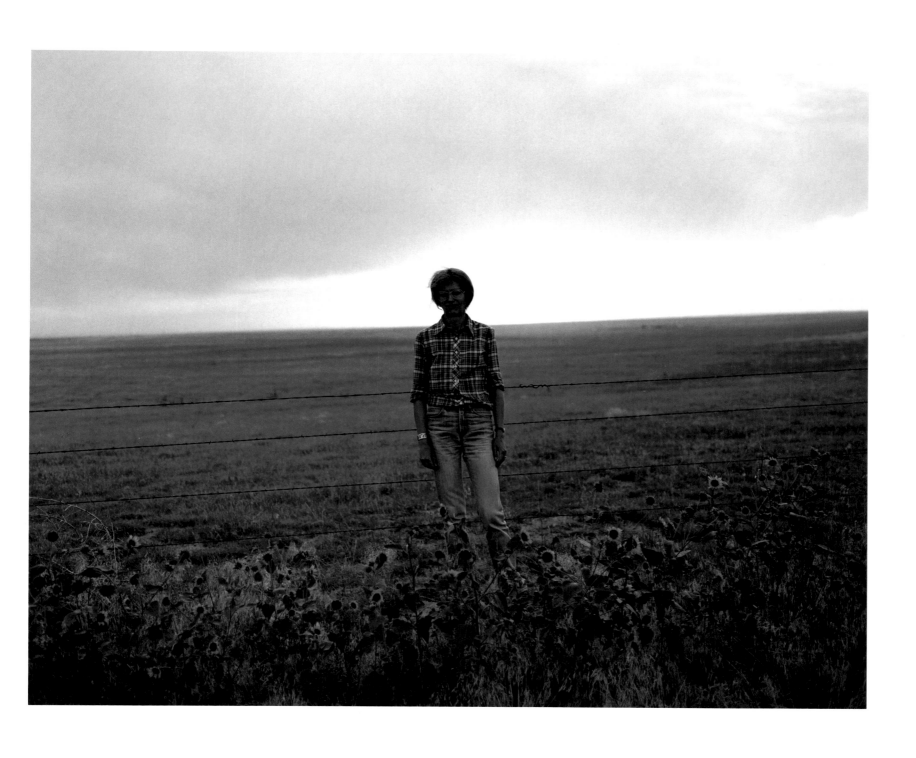

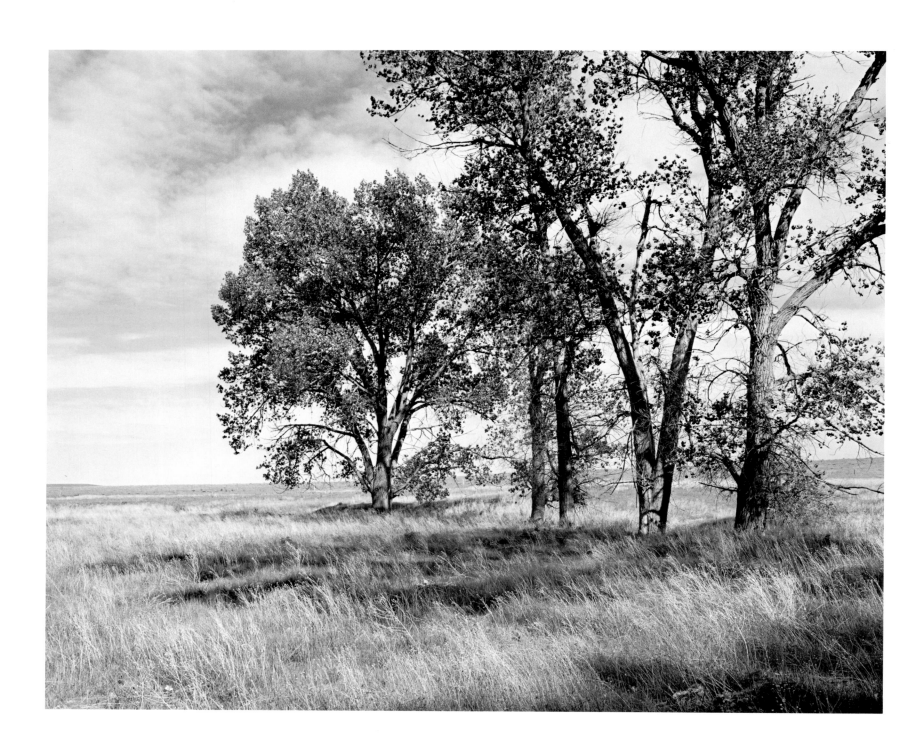

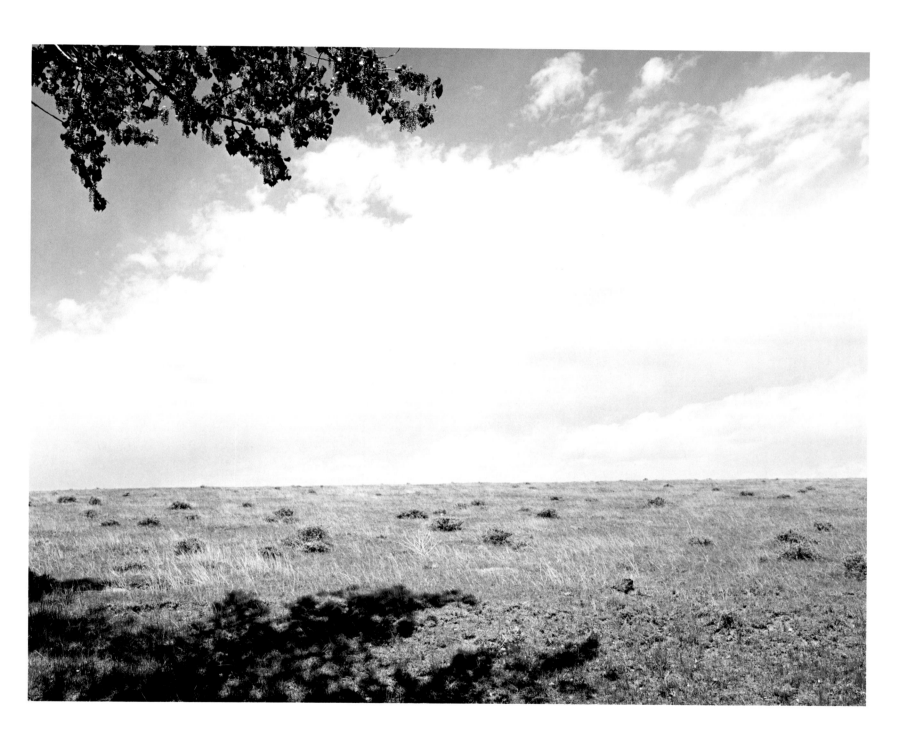

Exploration of the West began in the nineteenth century
at the Missouri River. On its banks pioneers understood
themselves to be at the edge of a sublime landscape,
one that they believed would be redemptive.
My own ancestors, as it happens, settled along
the river, and my grandfather made enthusiastic trips
onto the Dakota prairies to make panoramic photographs.
For these reasons, and because I had lost my way
in the suburbs, I decided to try to rediscover
some of the land forms that had impressed our forebears.
Was there remaining in the geography a strength that
might help sustain us as it had them?

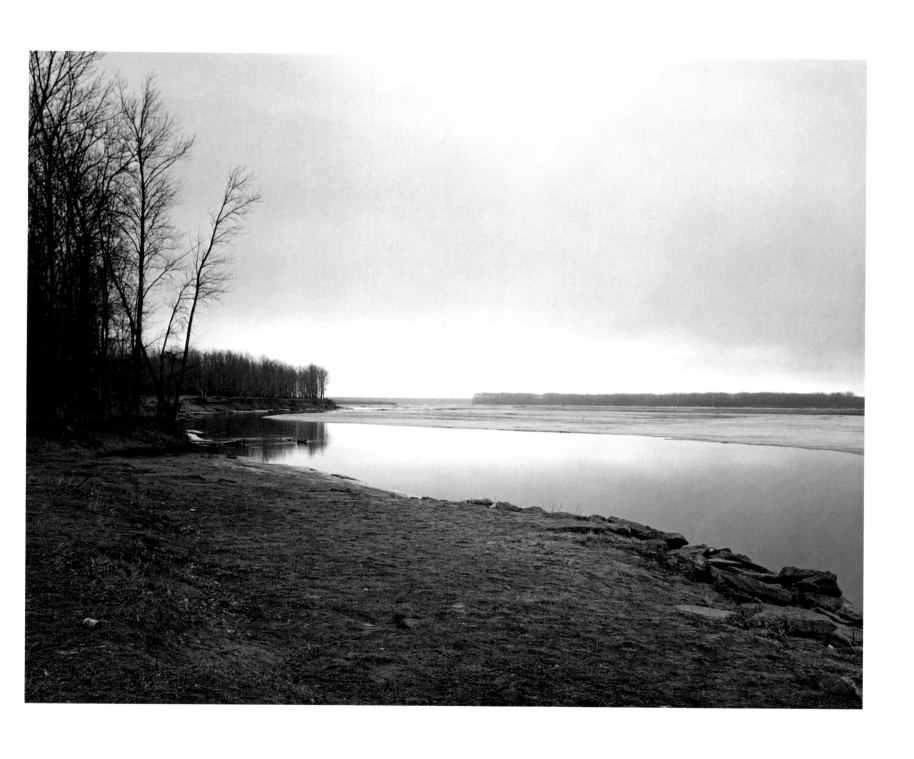

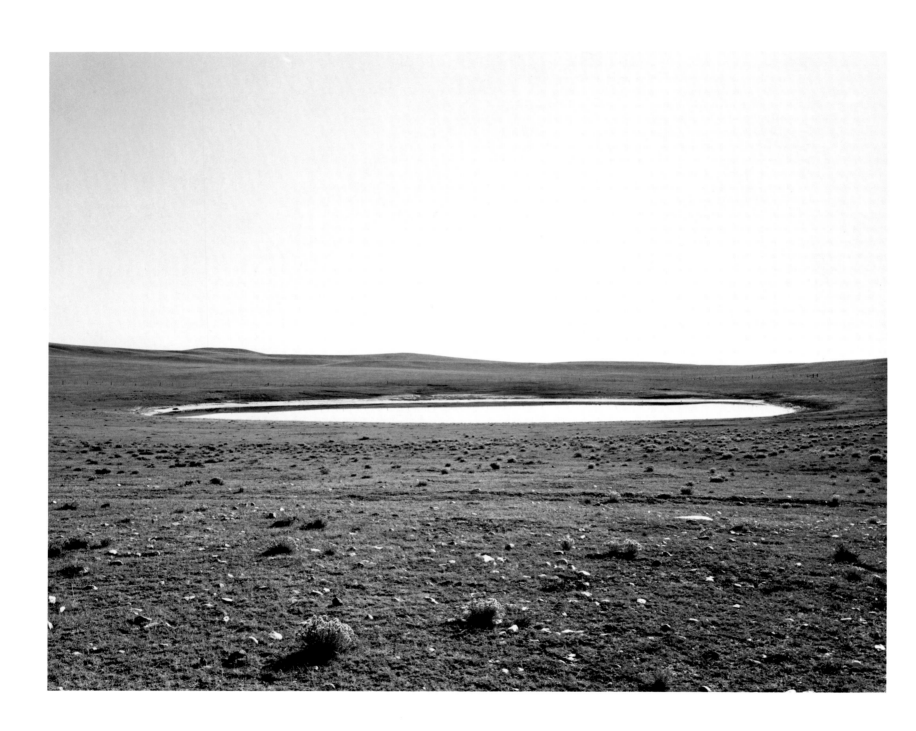

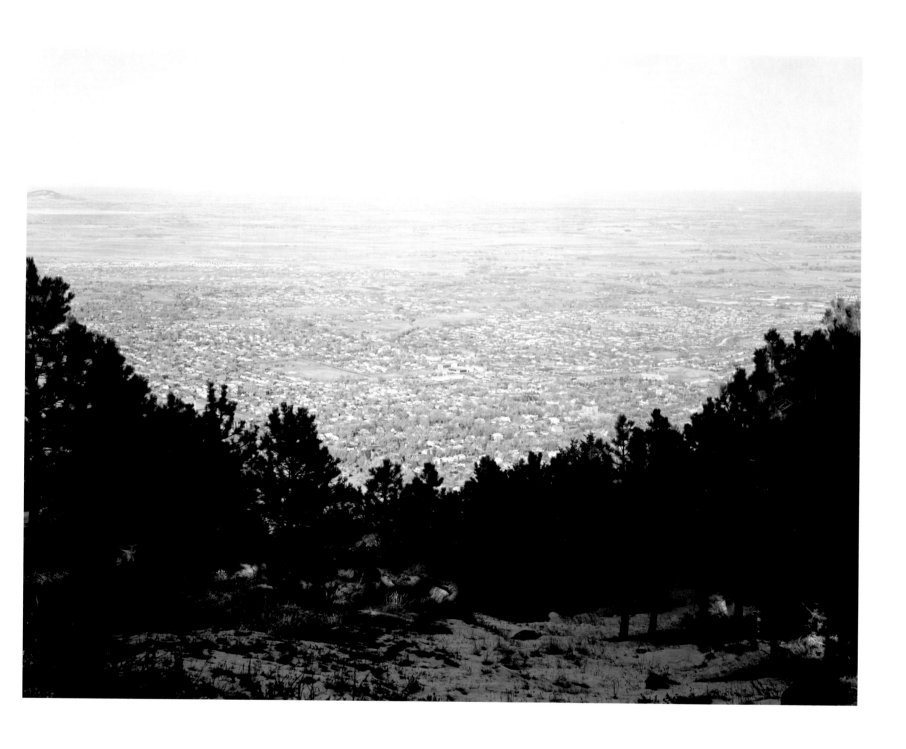

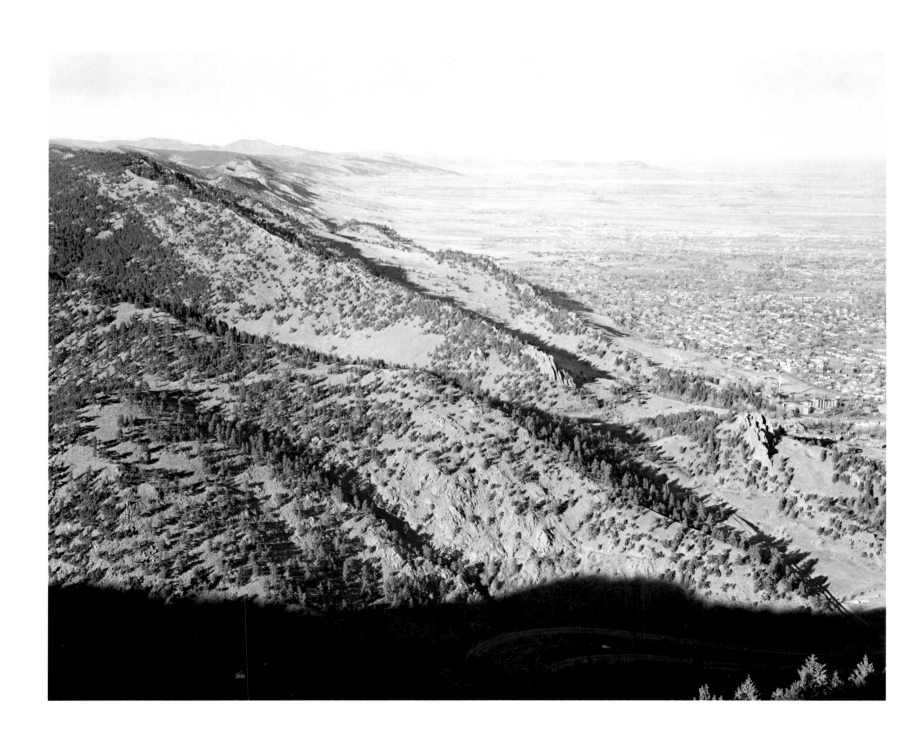

To the extent that life seems a process
in which everything is taken away,
minimal landscapes are places where we
live out with greater than usual
awareness our search for an exception,
for what is not taken away.

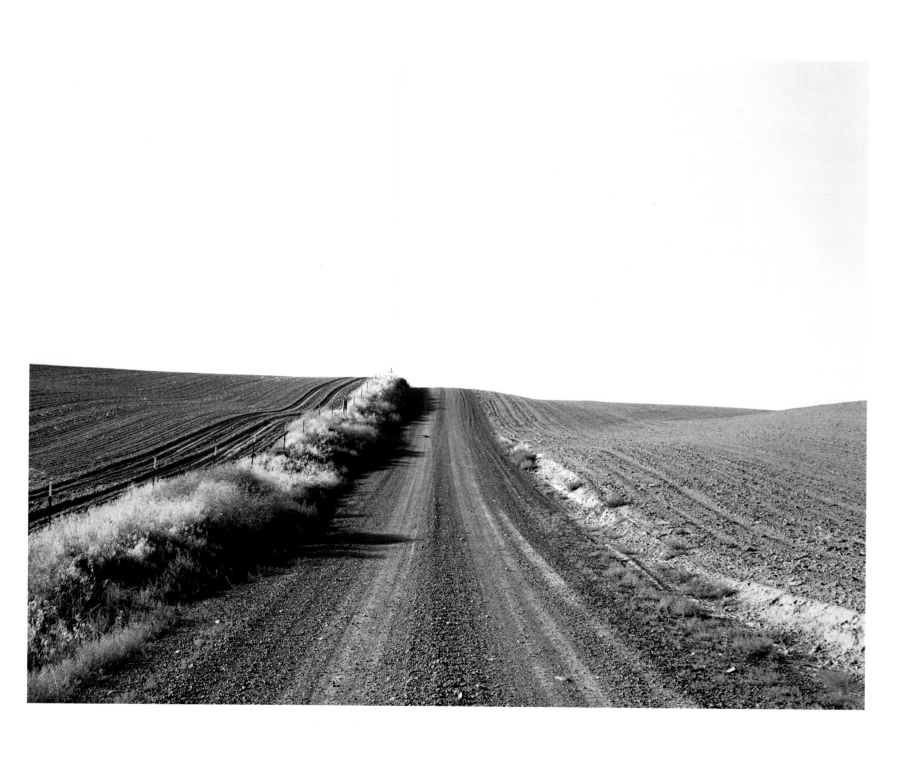

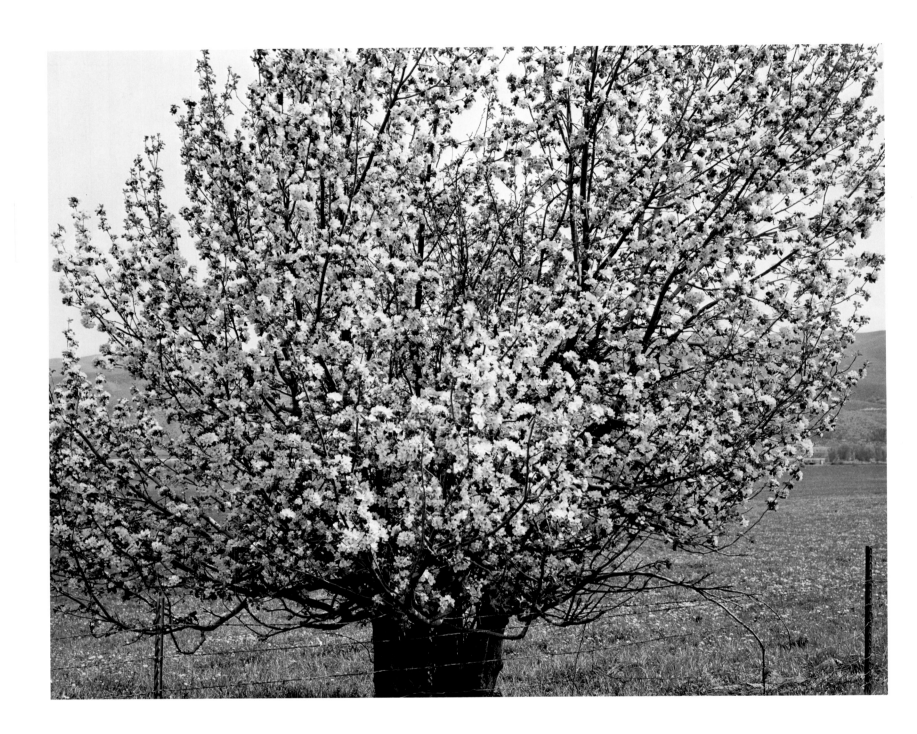

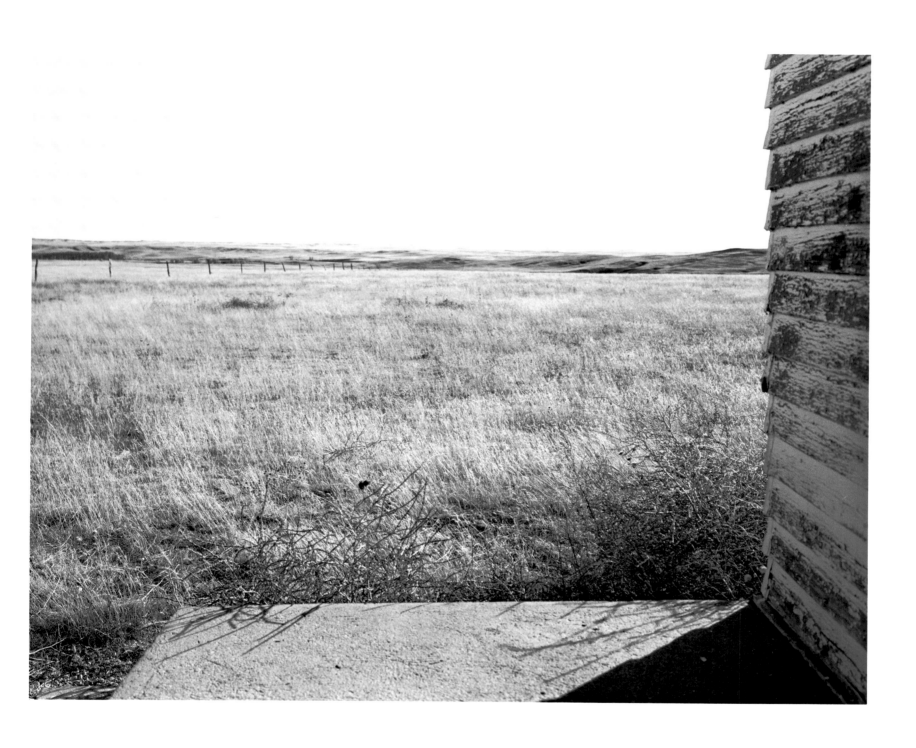

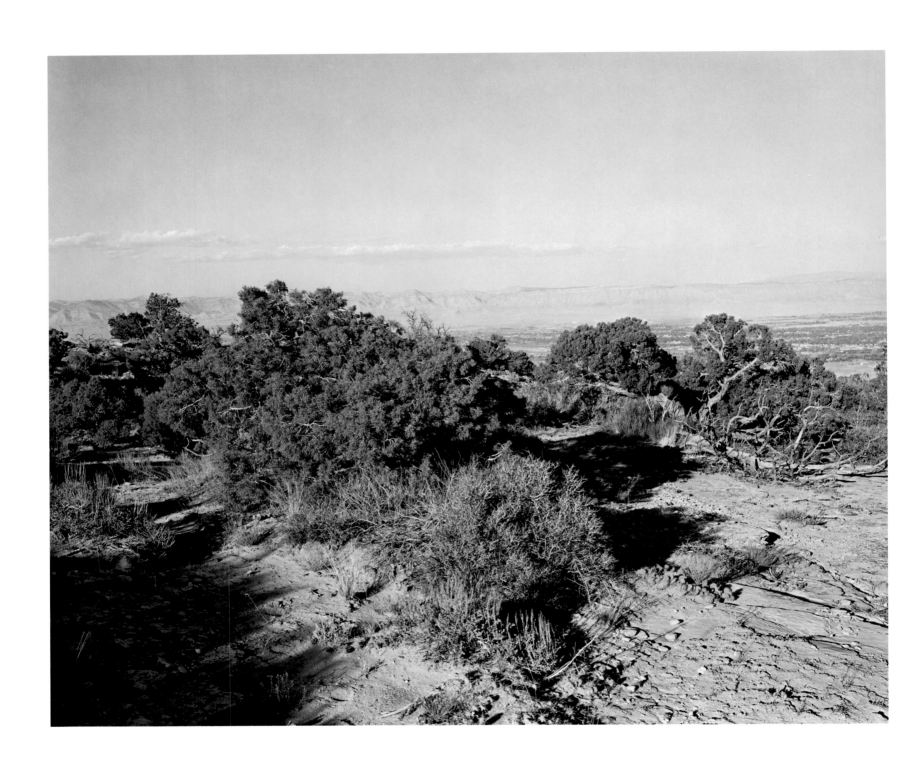

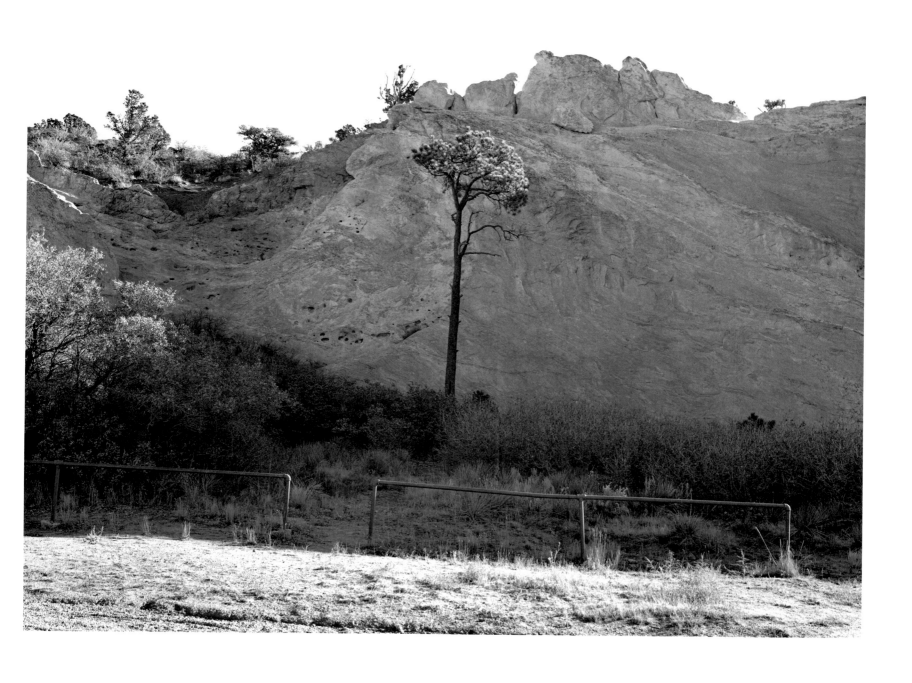

91

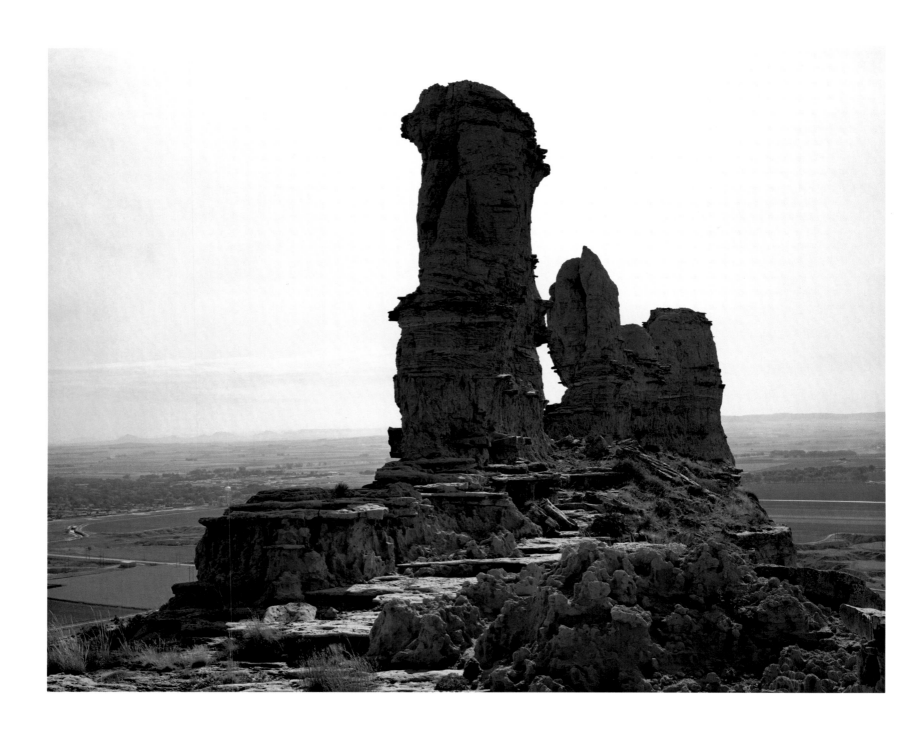

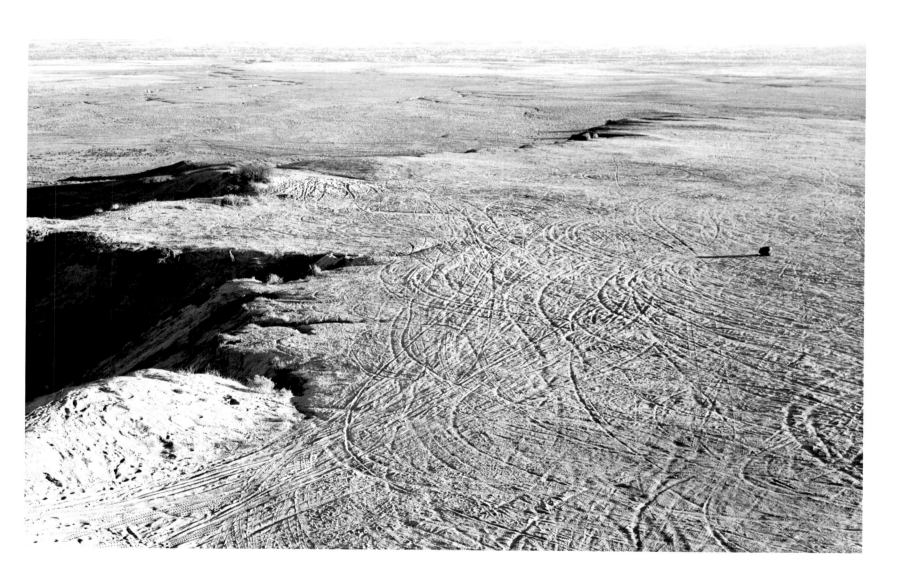

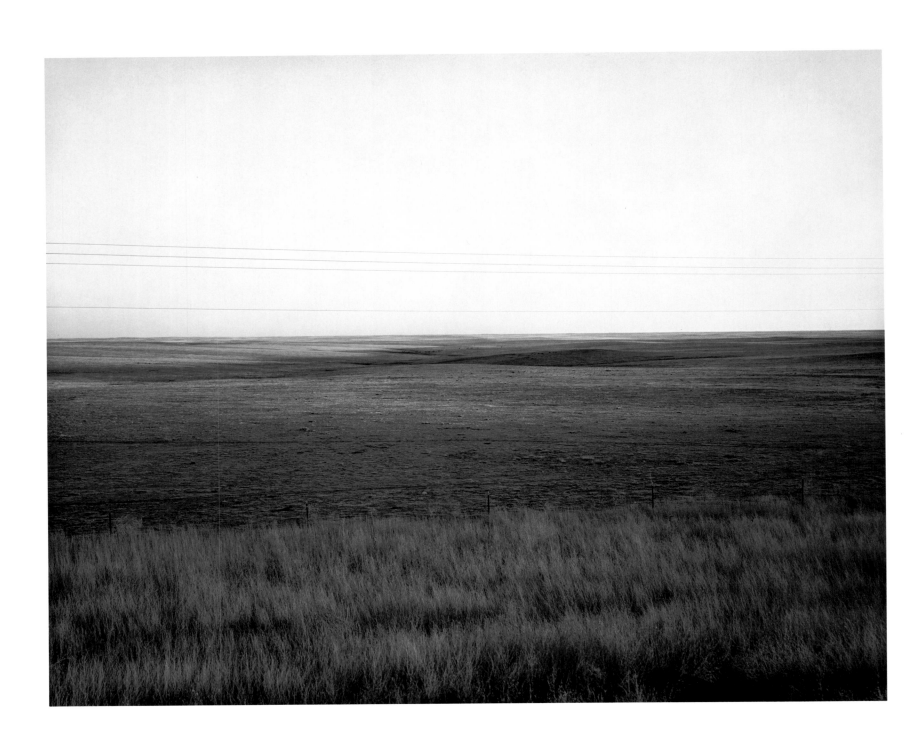

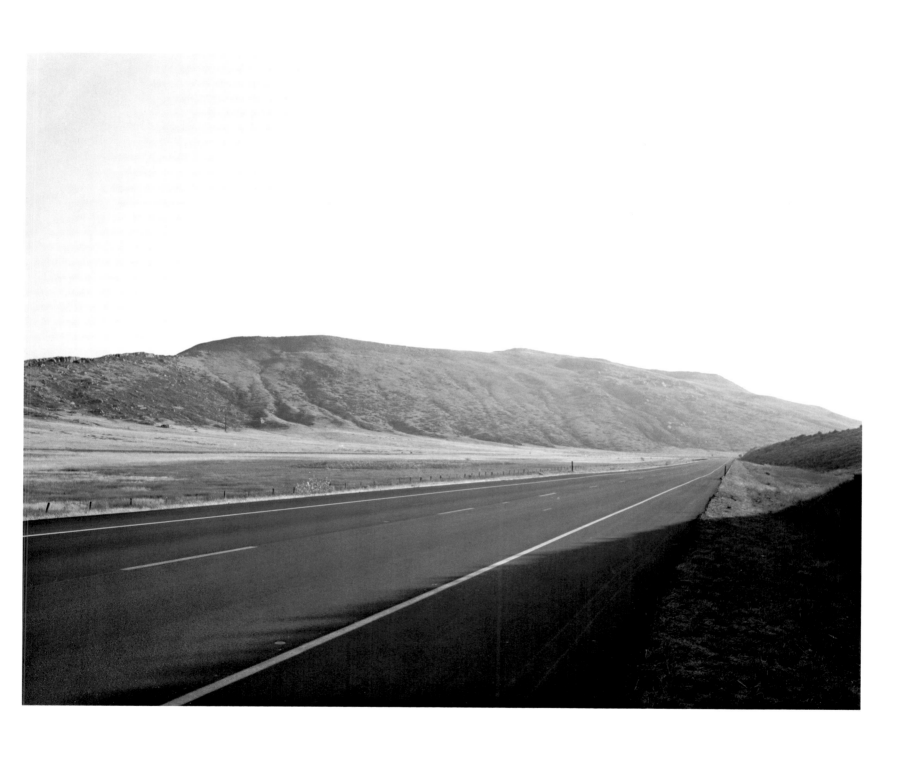

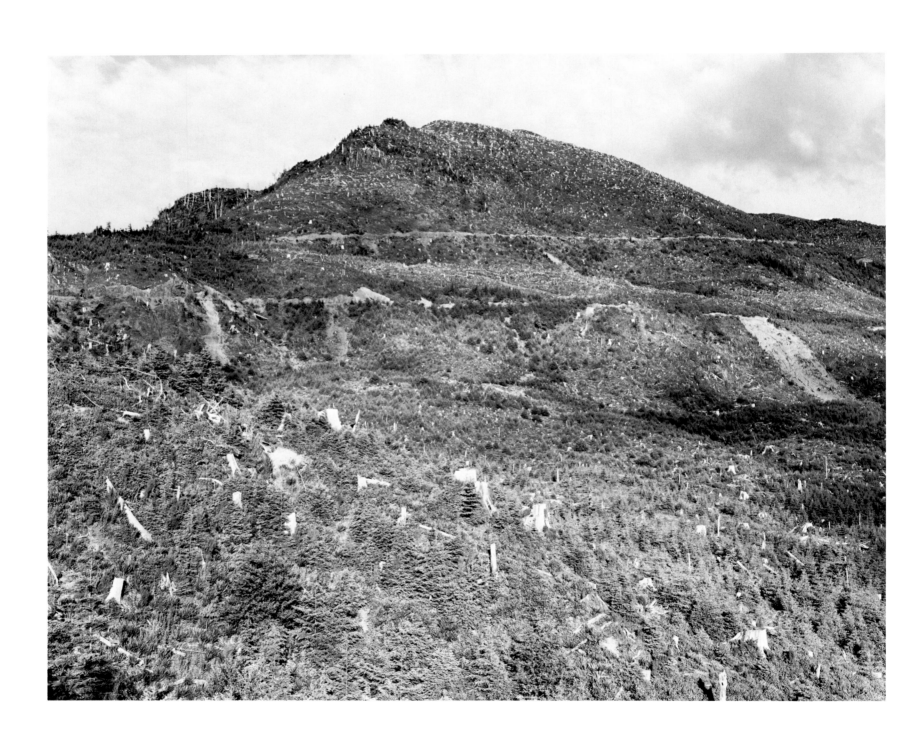

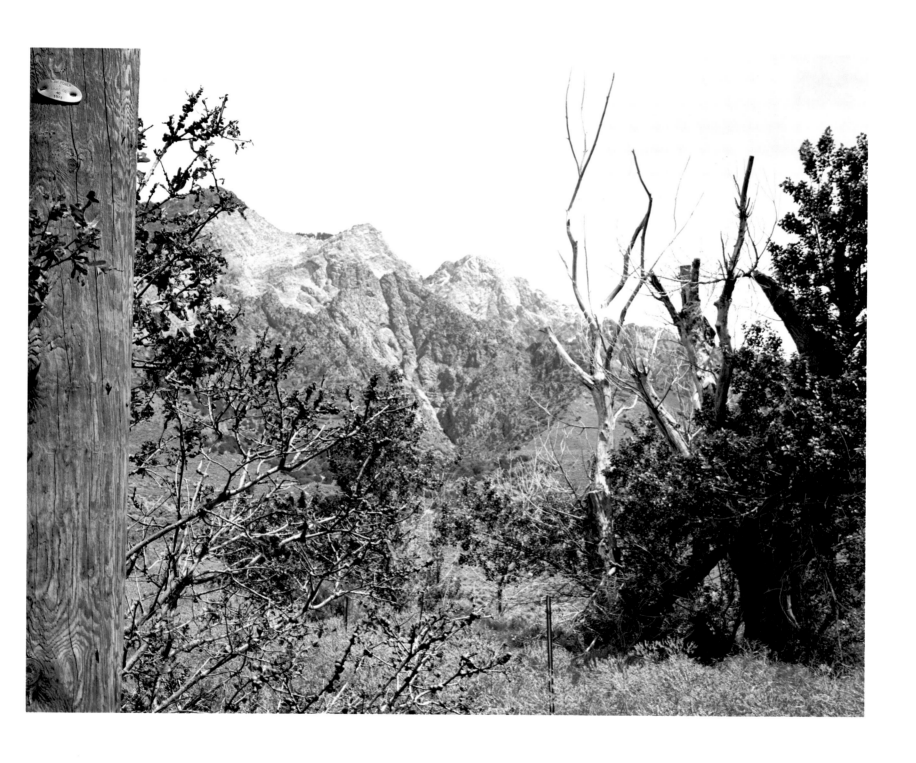

American nuclear and thermonuclear bombs are equipped
with plutonium detonators manufactured at the Rocky Flats
Nuclear Weapons Plant. The factory is located ten miles
upwind from Denver, Colorado. . . .

Armaments built at risk to Denver become part of a
worldwide system so open to error and malfunction that
it is reasonable to believe many of us will, at a scarcely
imaginable but exact time, die from them.

If we confront this conclusion we want almost at once
to give up, to be free of what seems impossible hope.
When we can find in ourselves the will to keep asking
questions of politicians, it is, I think, after we have
noticed the individuals with whom we live. How mysteriously
absolute each is. How many achieve, in moments of
reflection or joy or concern, a kind of heroism.
Each refutes the idea of acceptable losses.

*The following eleven photographs were made in the vicinity of
the Rocky Flats Nuclear Weapons Plant.*

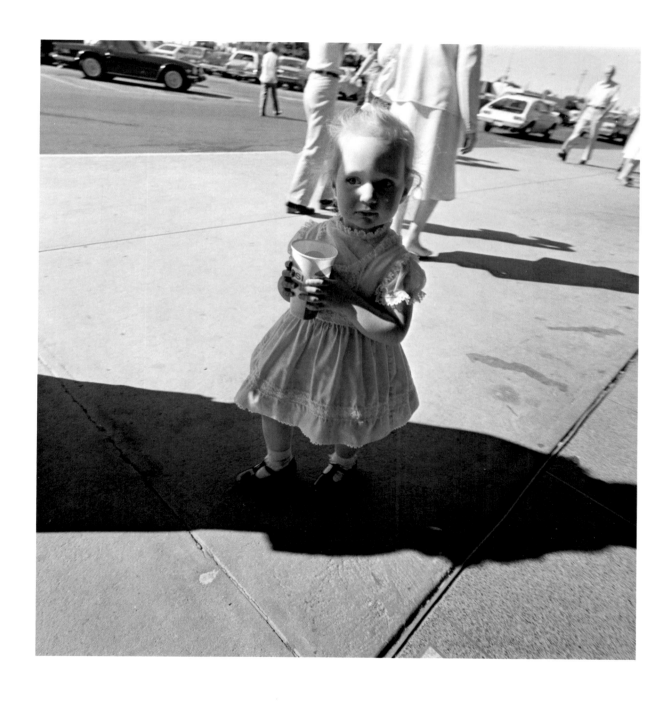

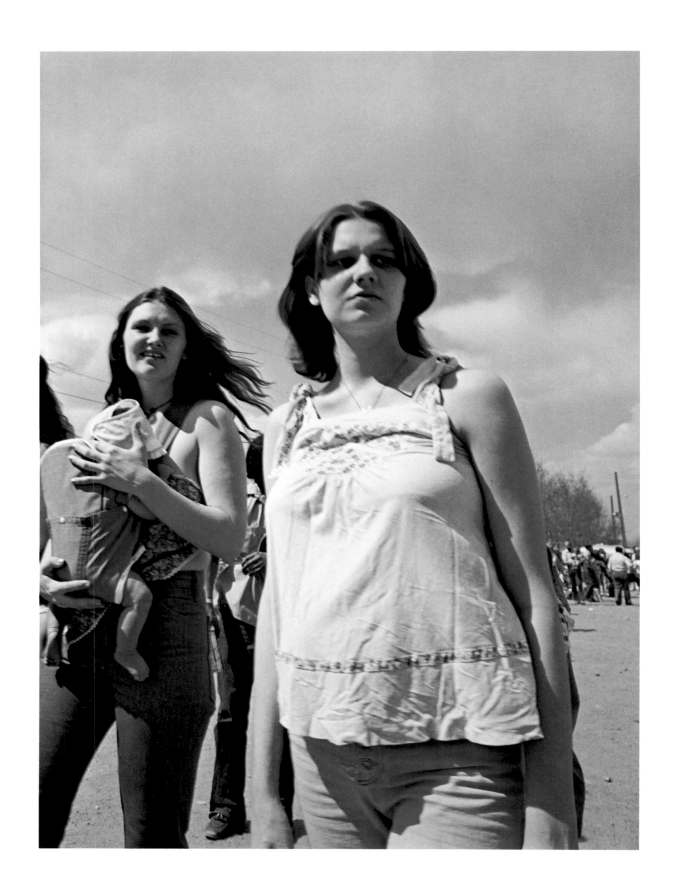

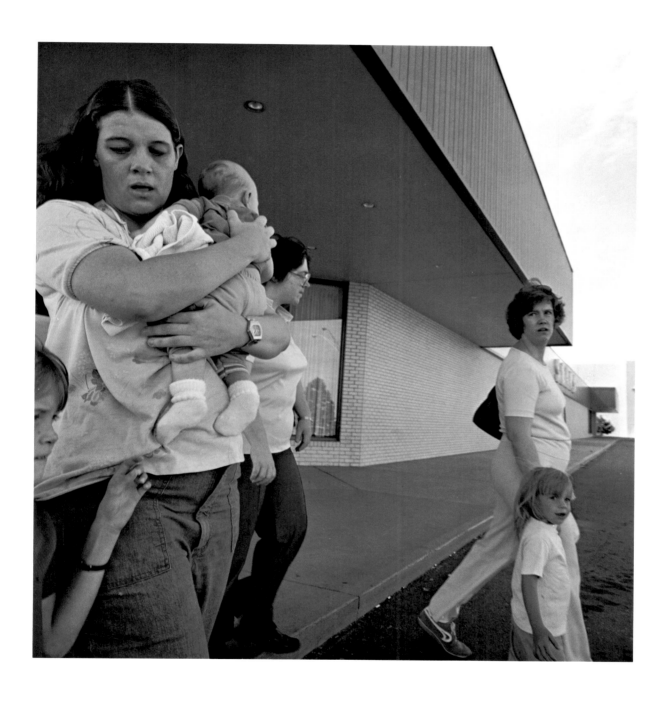

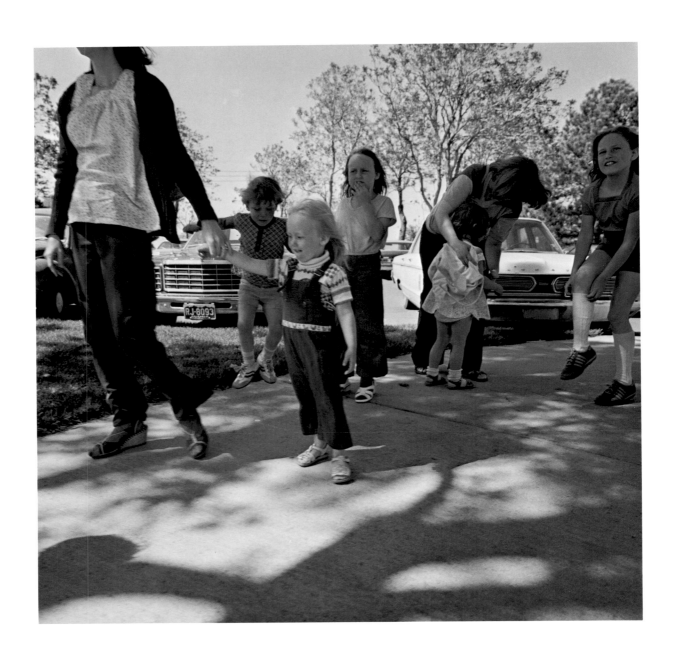

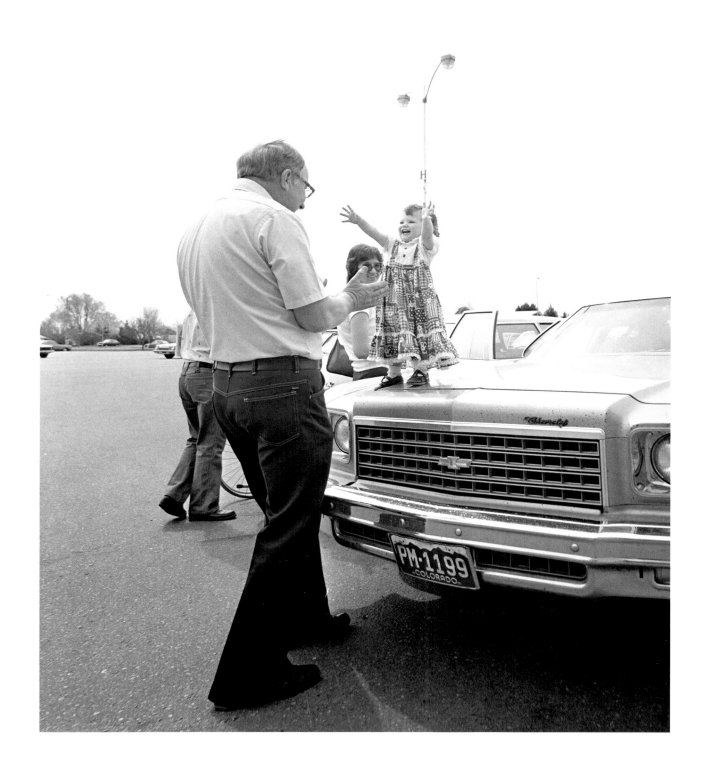

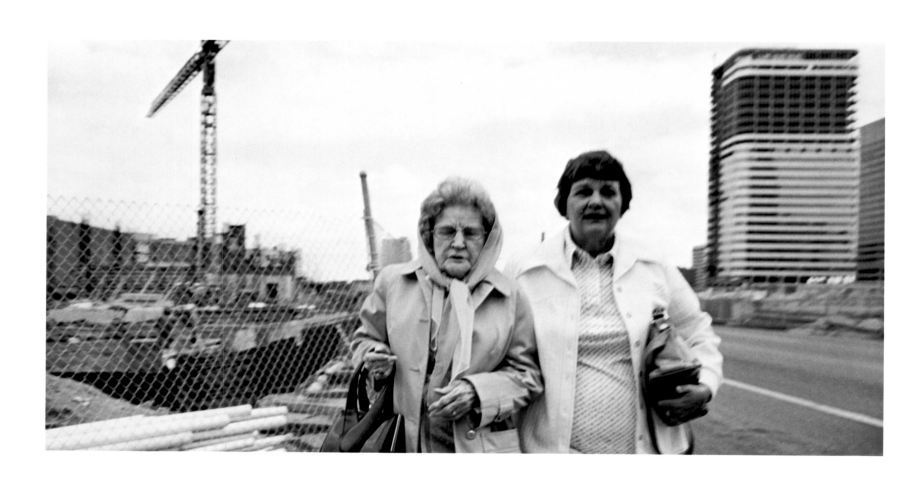

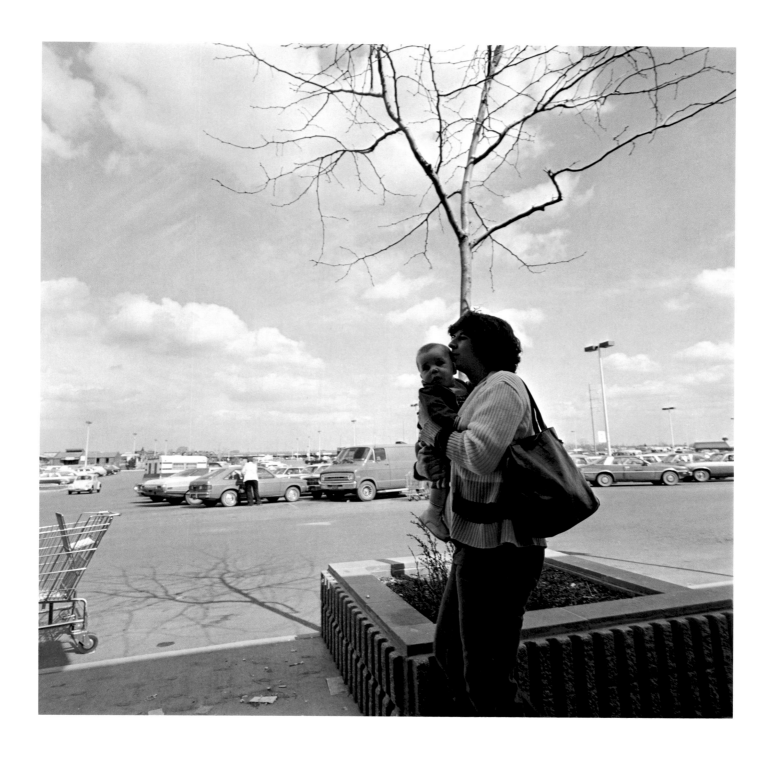

Everything is spectacular in its way. It's all
valuable. It's all of a piece.

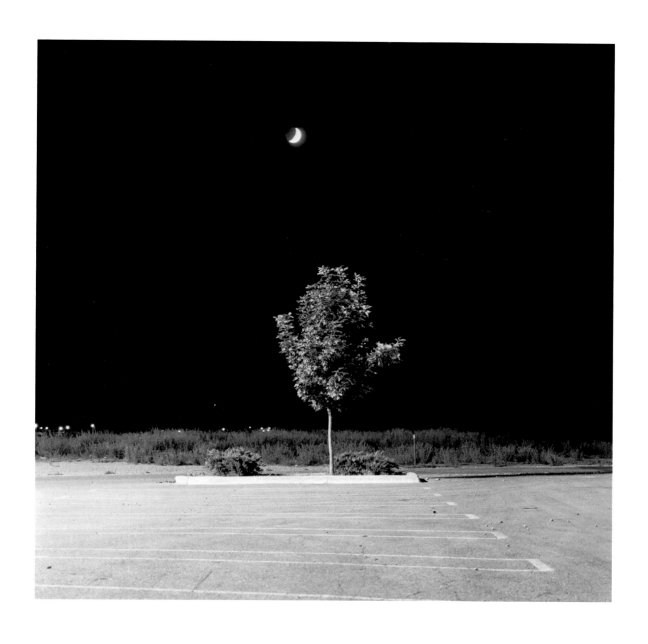

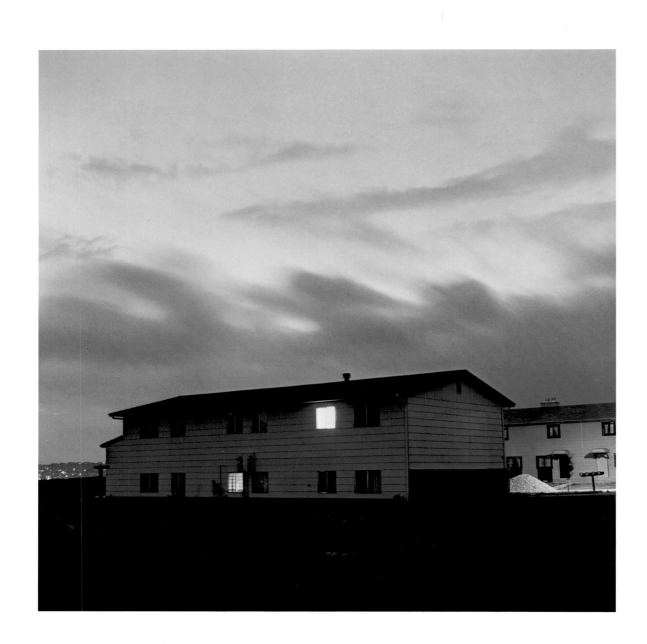

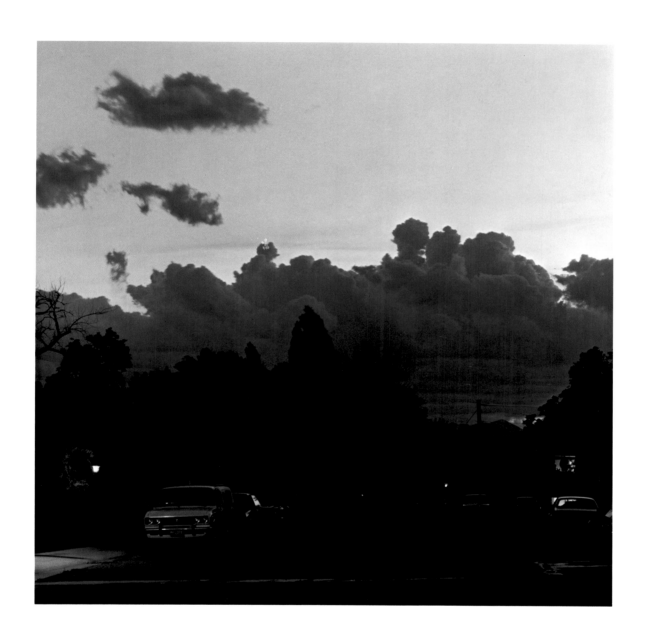

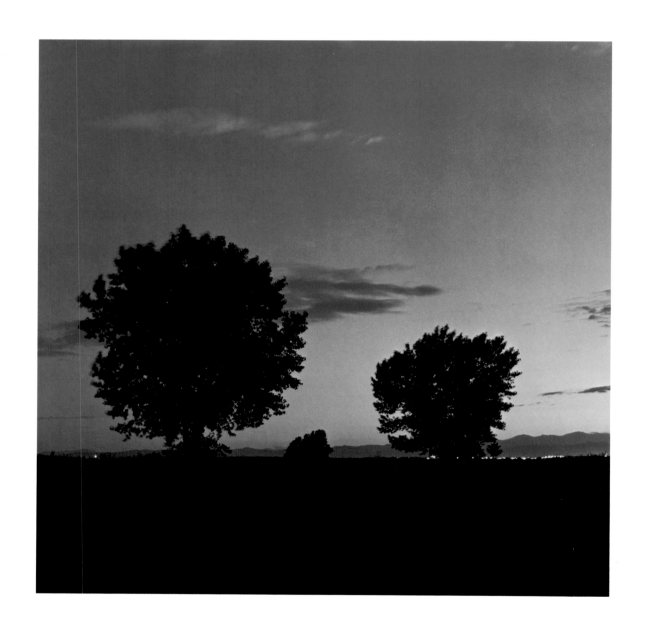

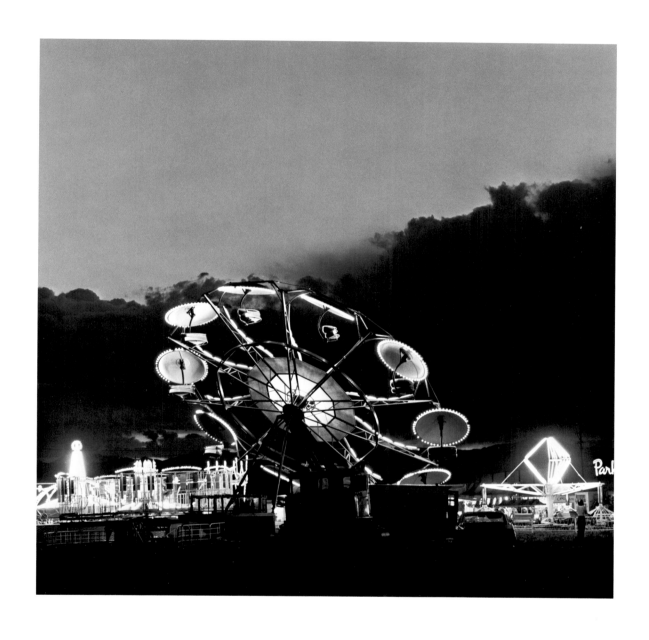

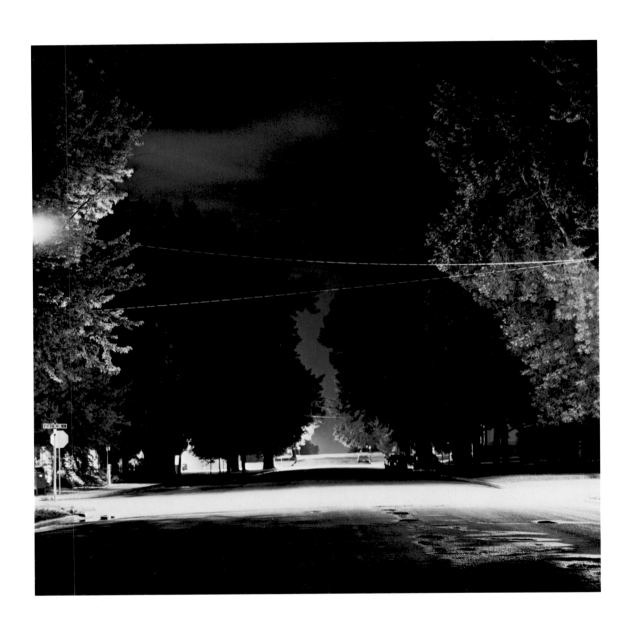

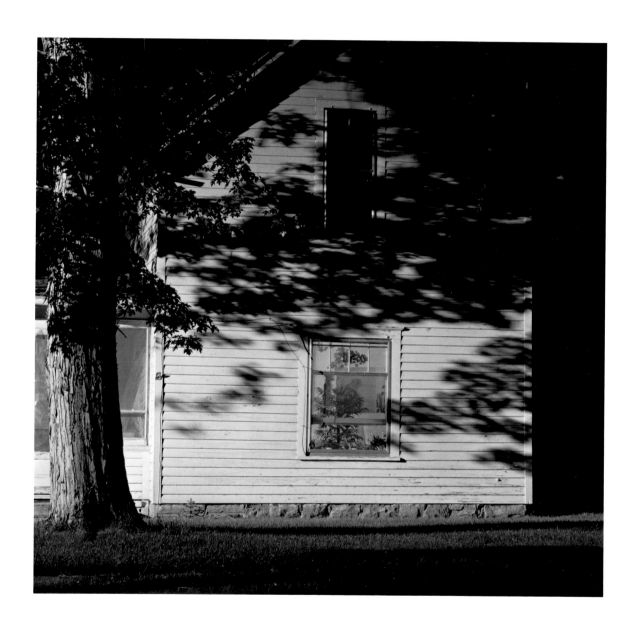

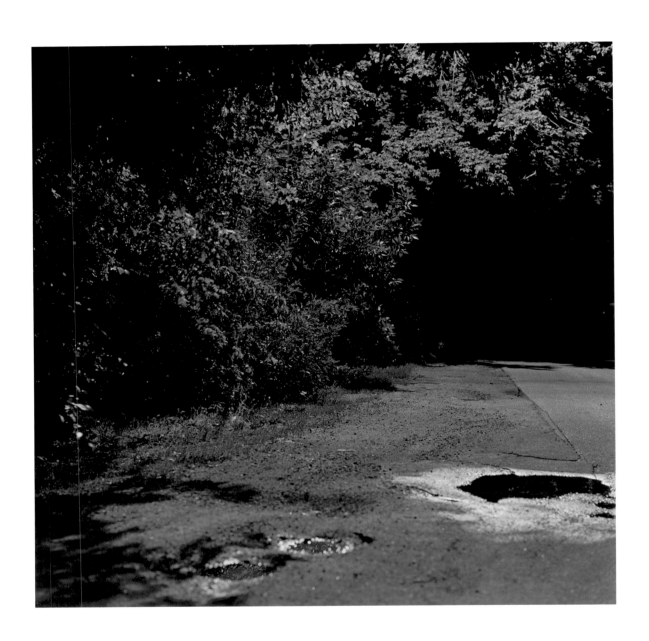

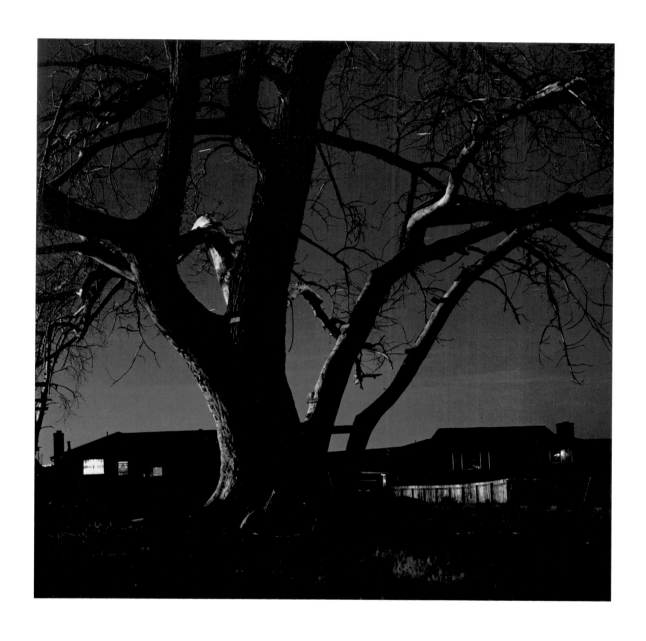

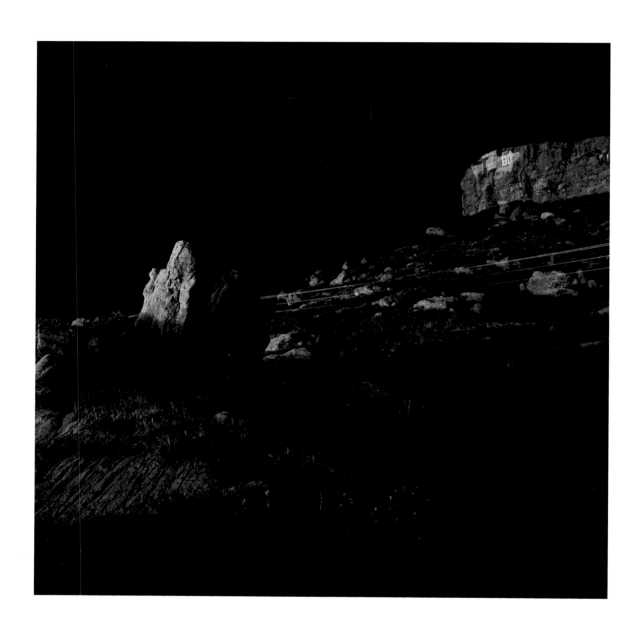

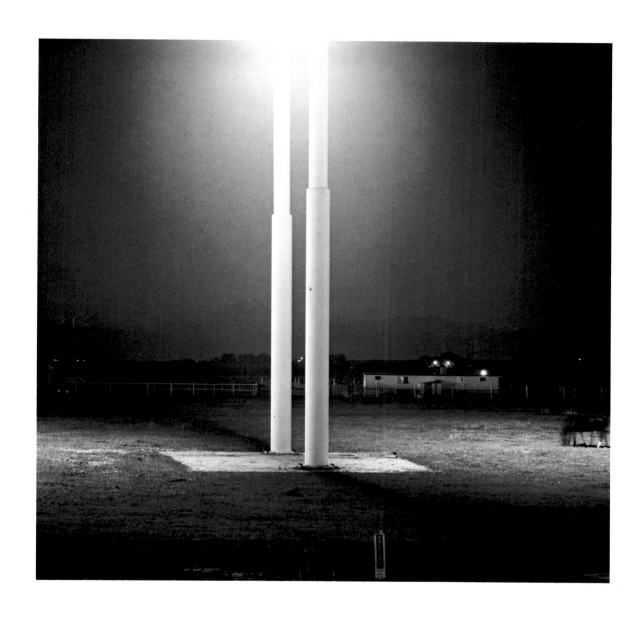

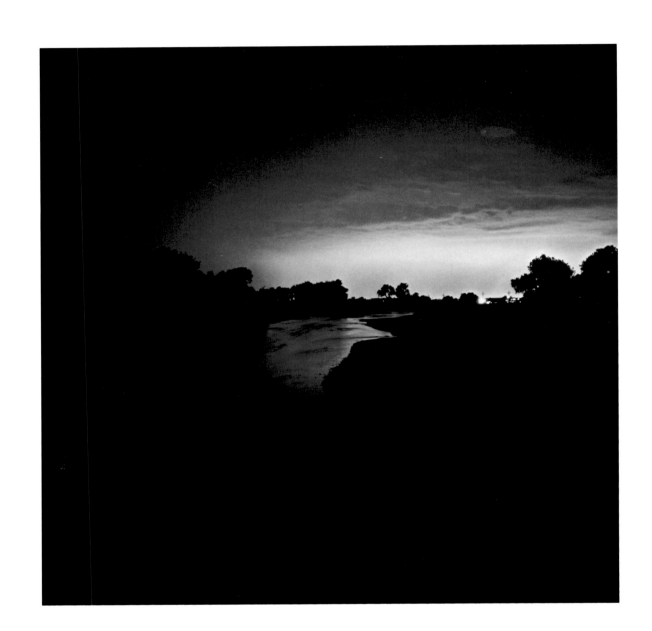

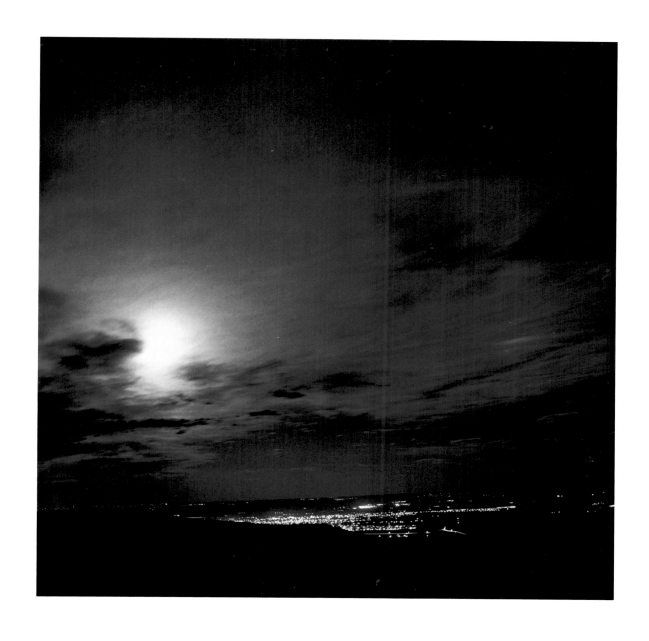

Southern California was, by the reports of those who lived there
at the turn of the century, beautiful; there were live oaks on
the hills, orchards across the valleys, and ornamental cypress,
palms, and eucalyptus lining the roads. Even now we can almost
extrapolate an Eden from what has lasted—from the architecture
of old eucalyptus trunks, for example, and from the astringent
perfume of the trees' flowers as it blends with the sweetness
of orange blossoms.

What citrus remain today, however, are mostly abandoned,
scheduled for removal, and large eucalyptus have often been
vandalized, like the hundreds west of Fontana that have been
struck head high with shotgun fire.

Whether those trees that stand are reassuring is a question
for a lifetime. All that is clear is the perfection of what we
were given, the unworthiness of our response, and the certainty,
in view of our current deprivation, that we are judged.

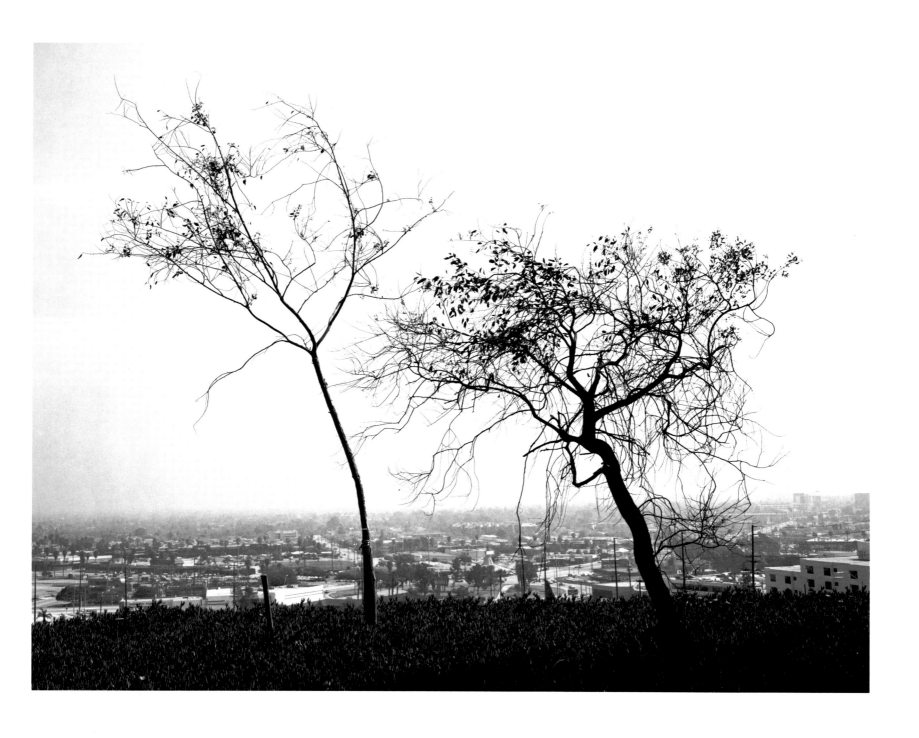

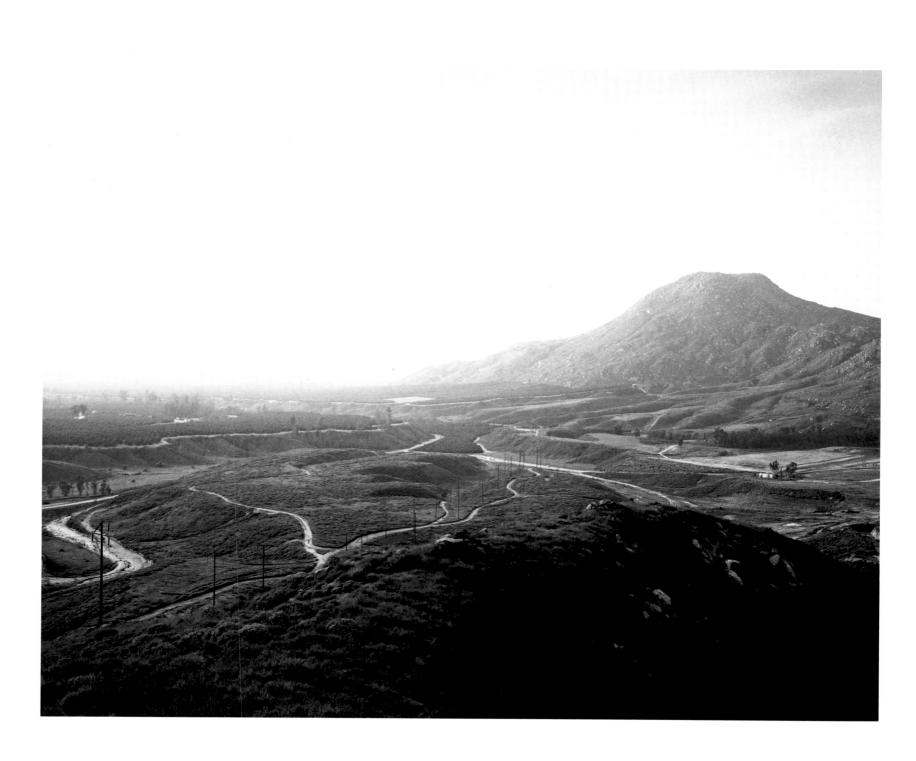

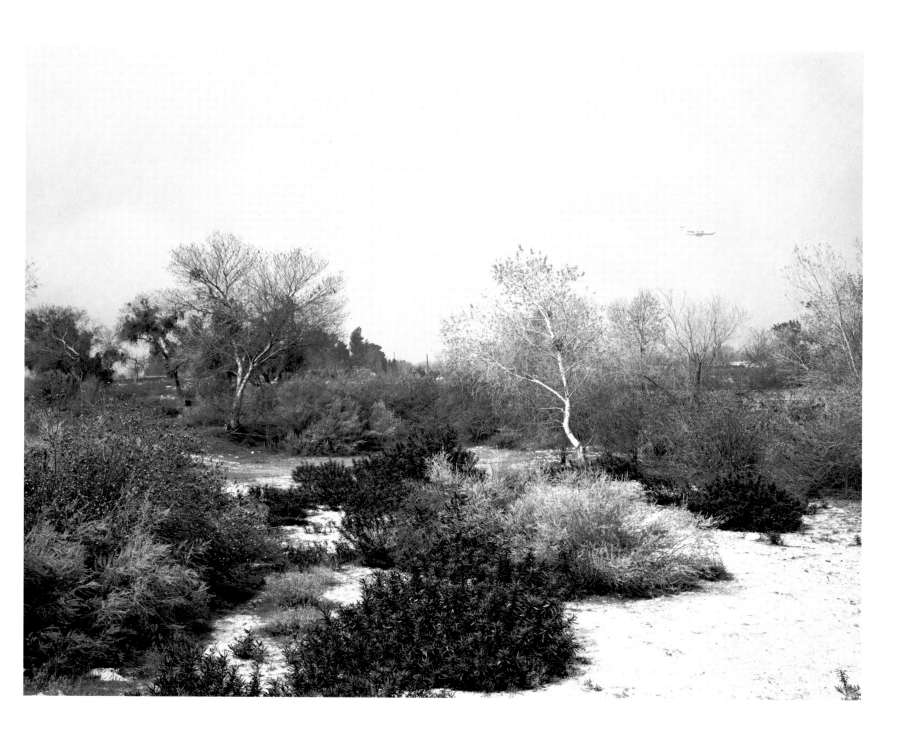

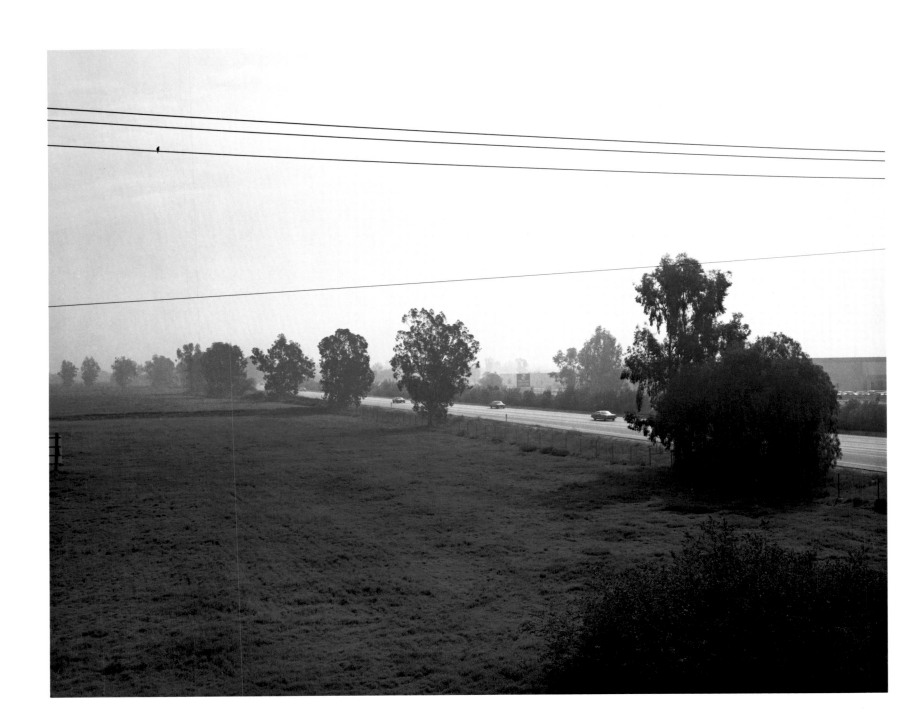

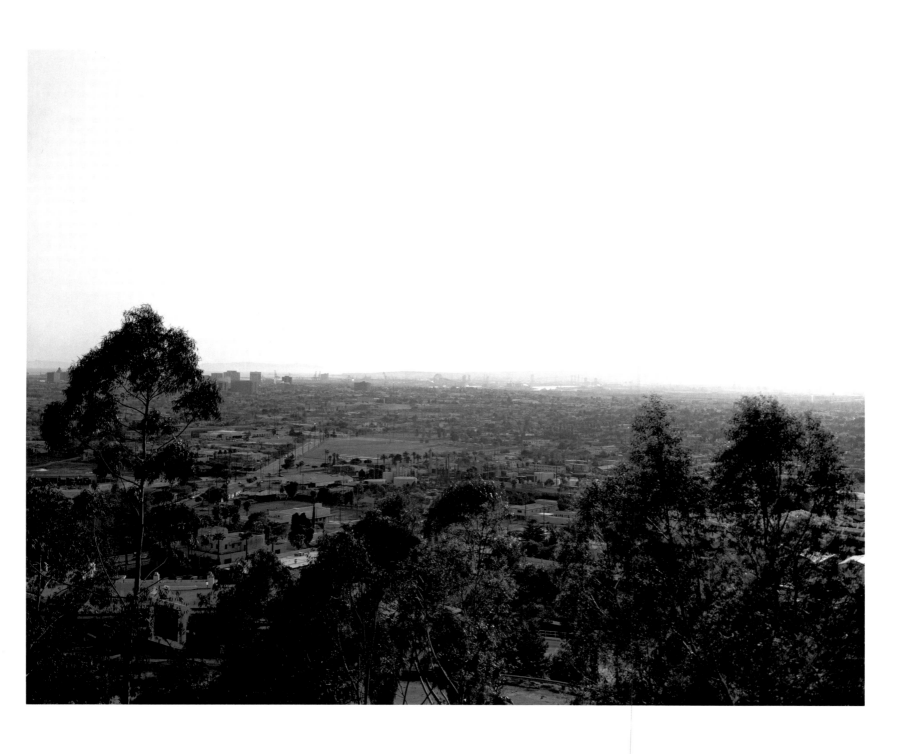

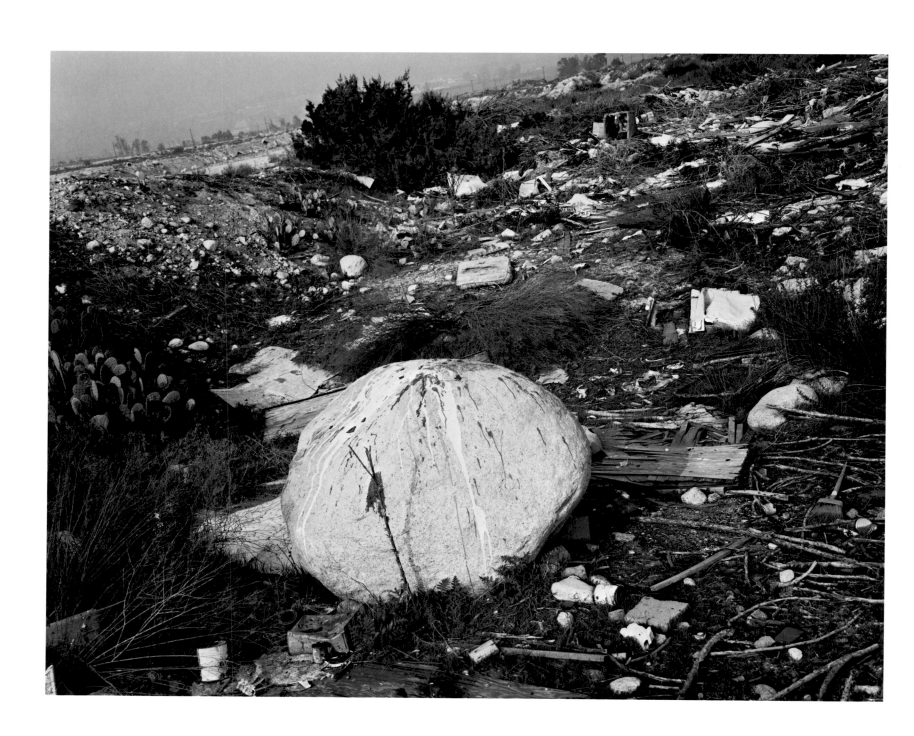

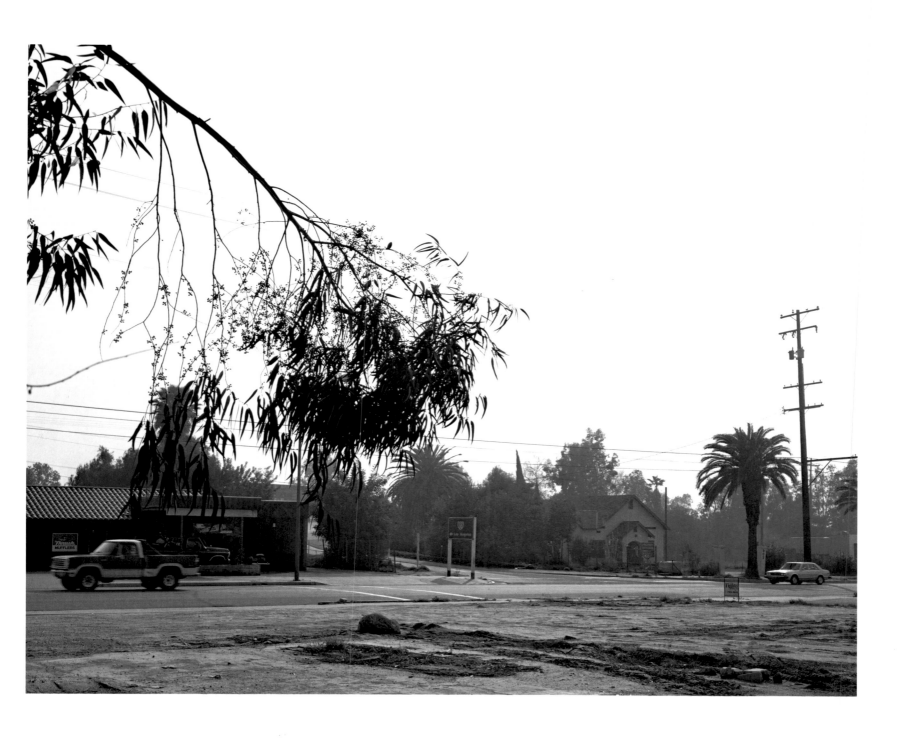

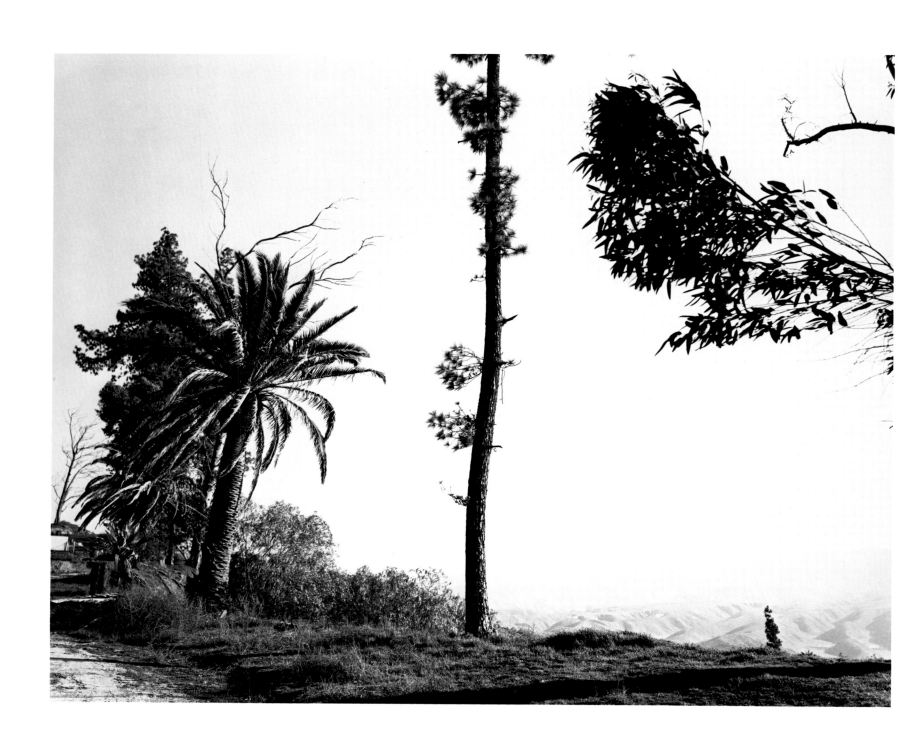

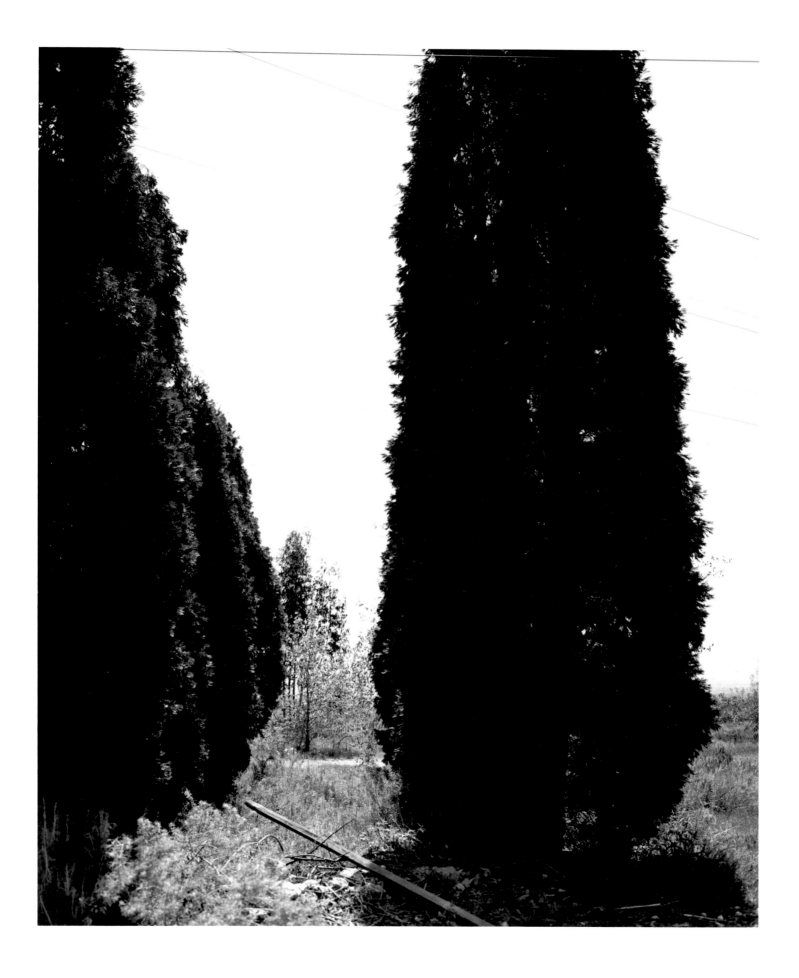

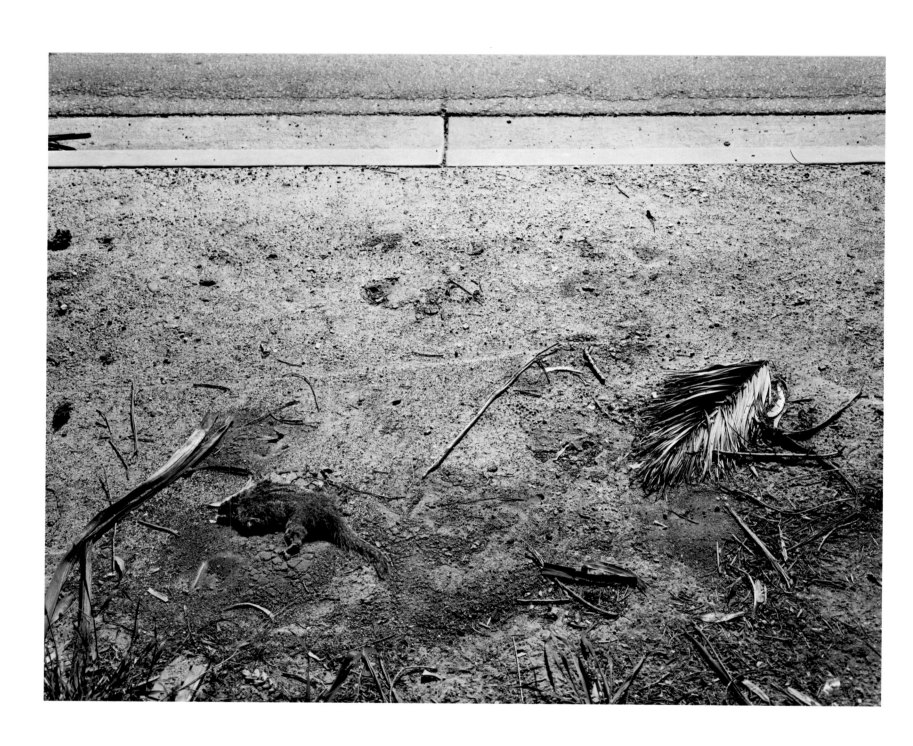

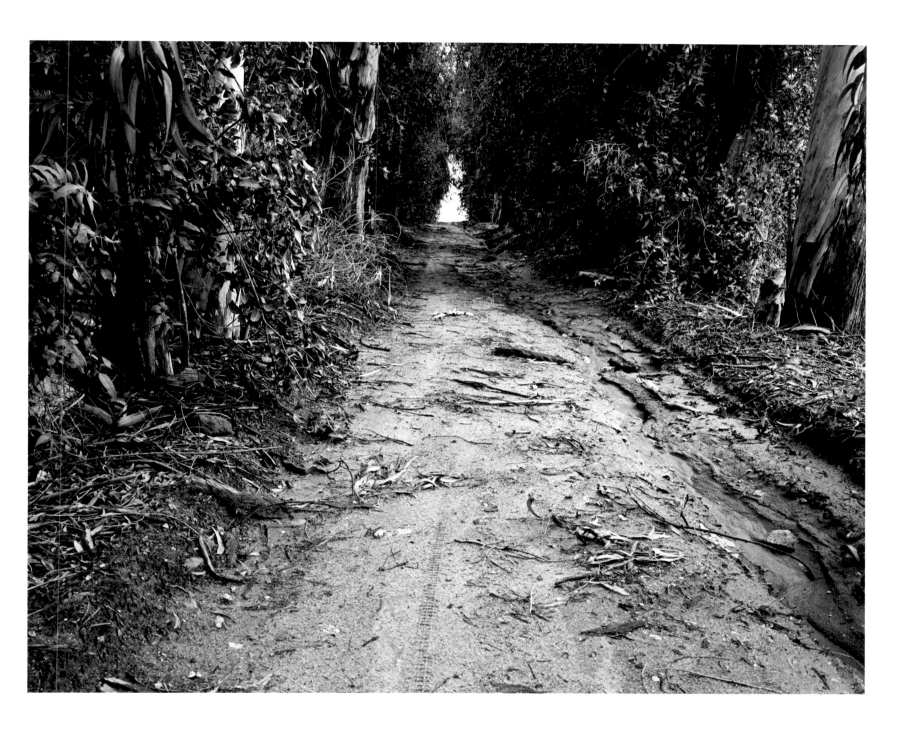

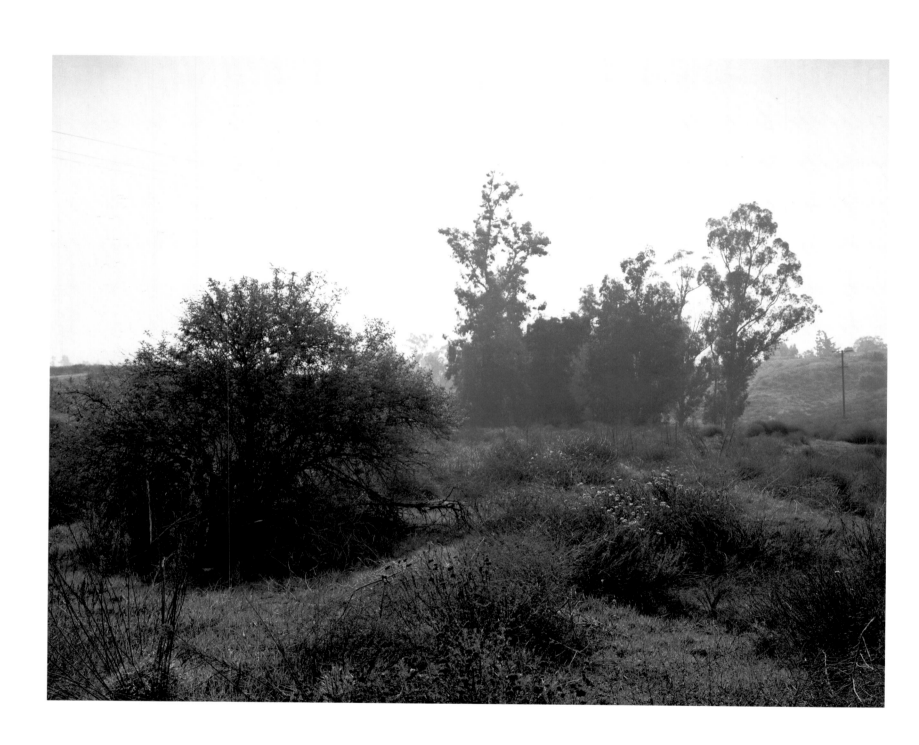

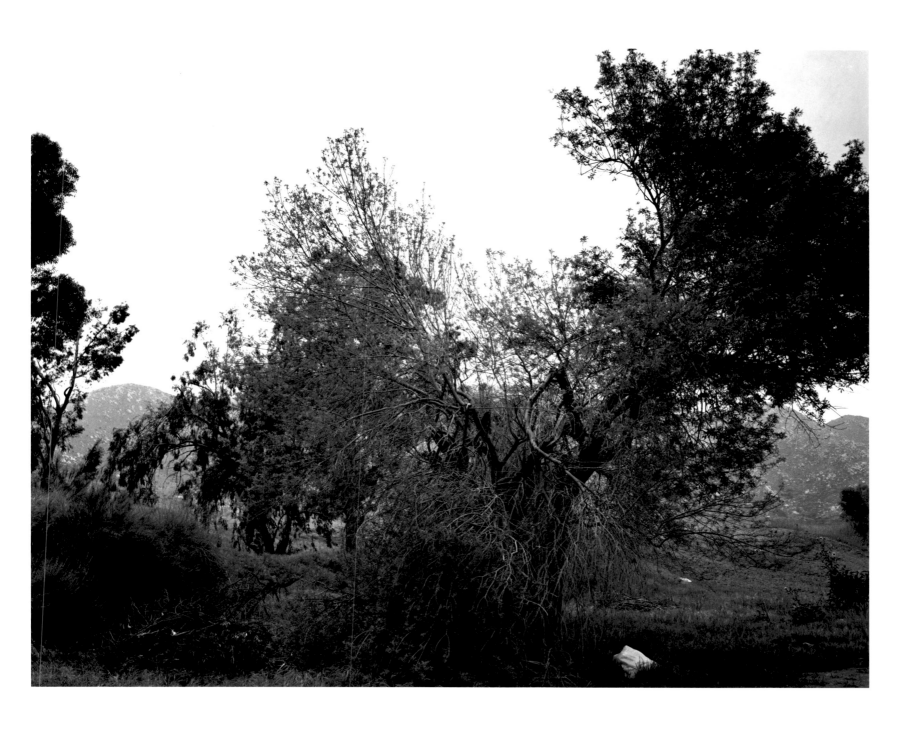

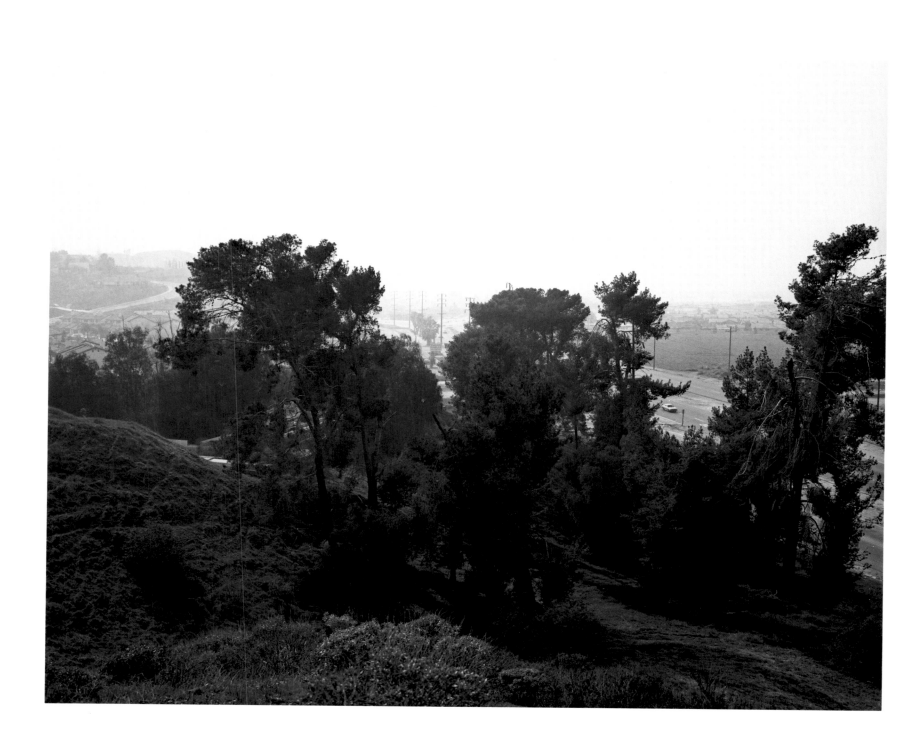

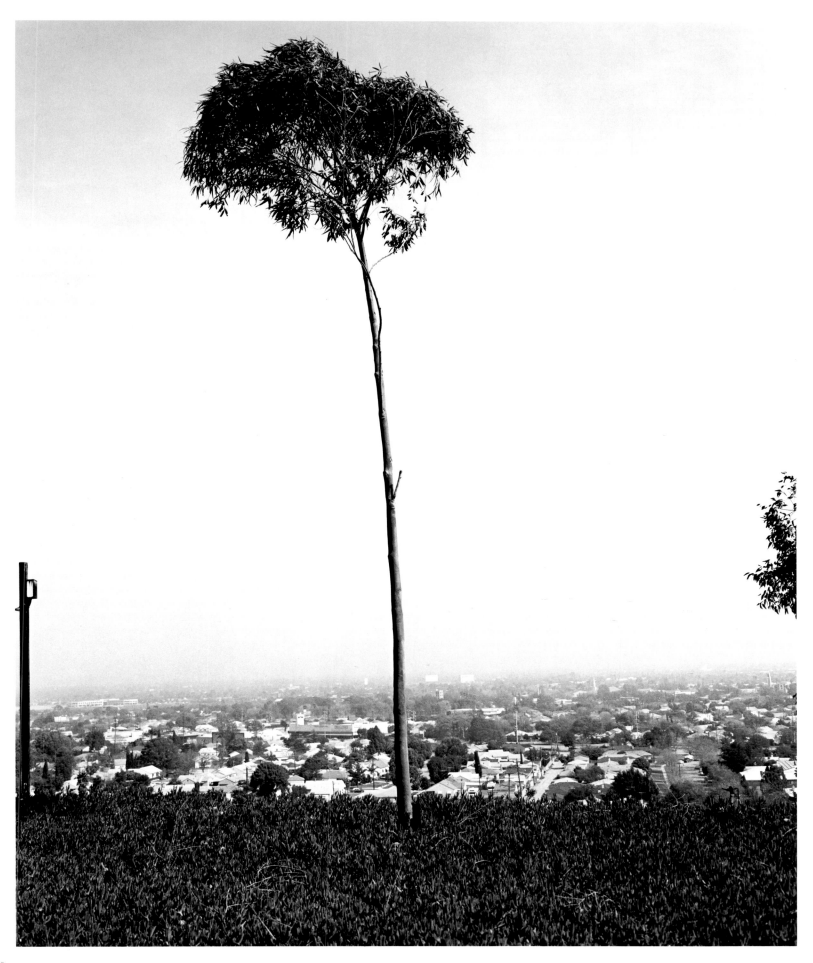

Might we somehow learn the hope of the
plains Indians who . . . danced the Ghost Dance,
their final celebration of their dream of the
land's restoration? The ceremonies were often held,
judging by the images we have, in scrappy pastures
right at the edge of their enemies' contempt.

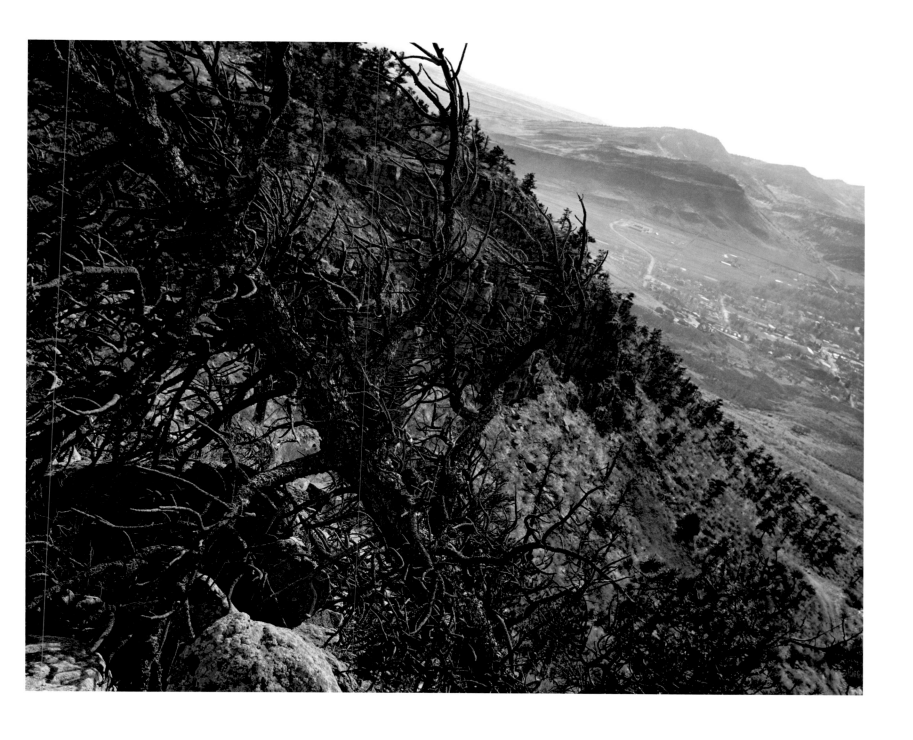

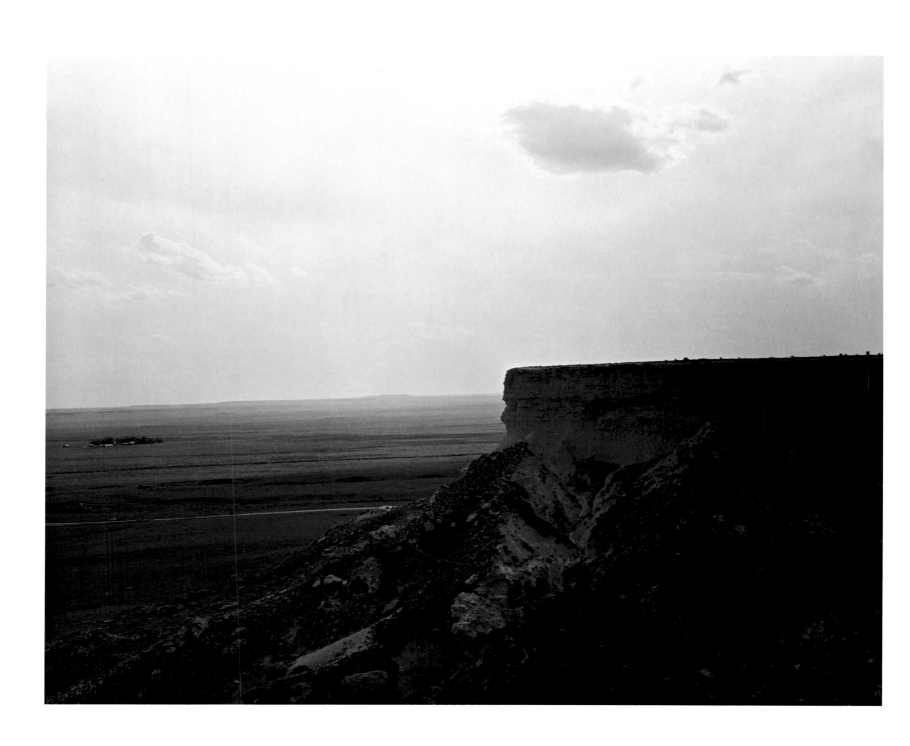

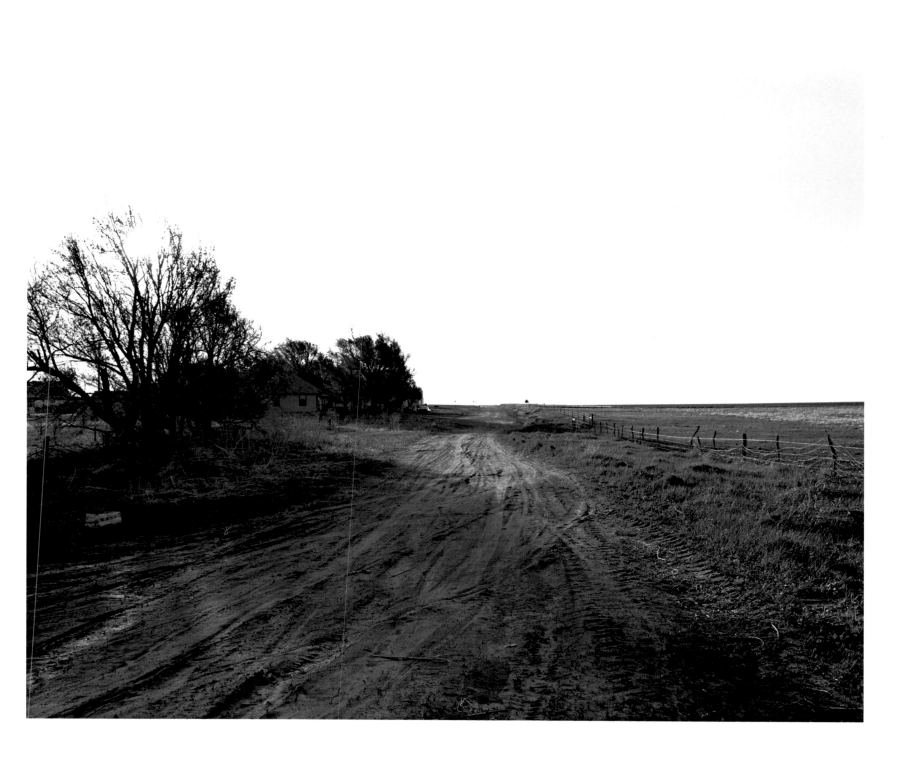

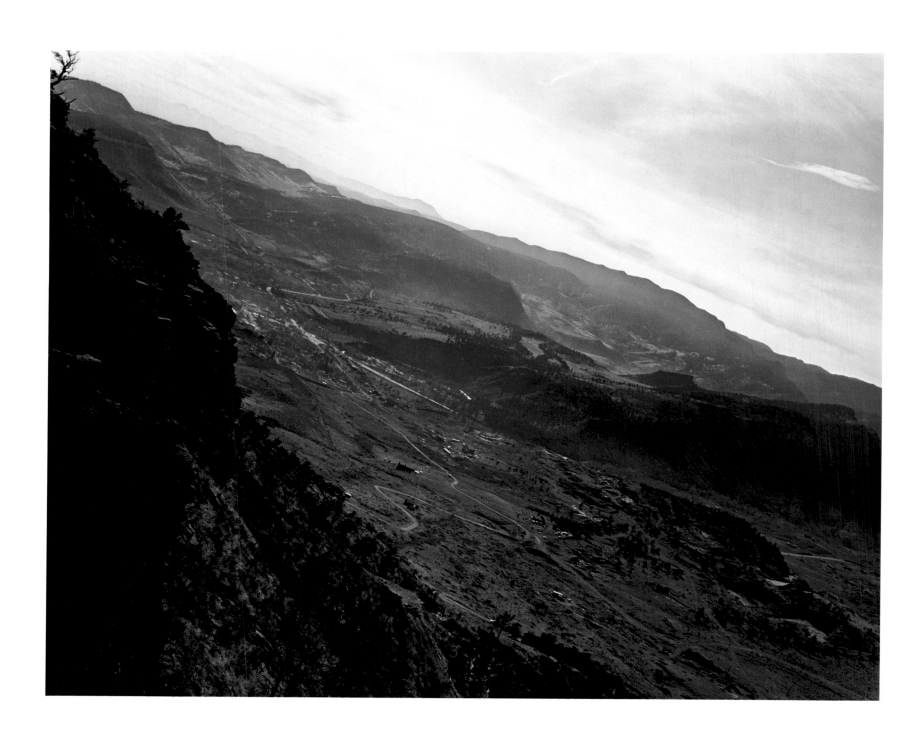

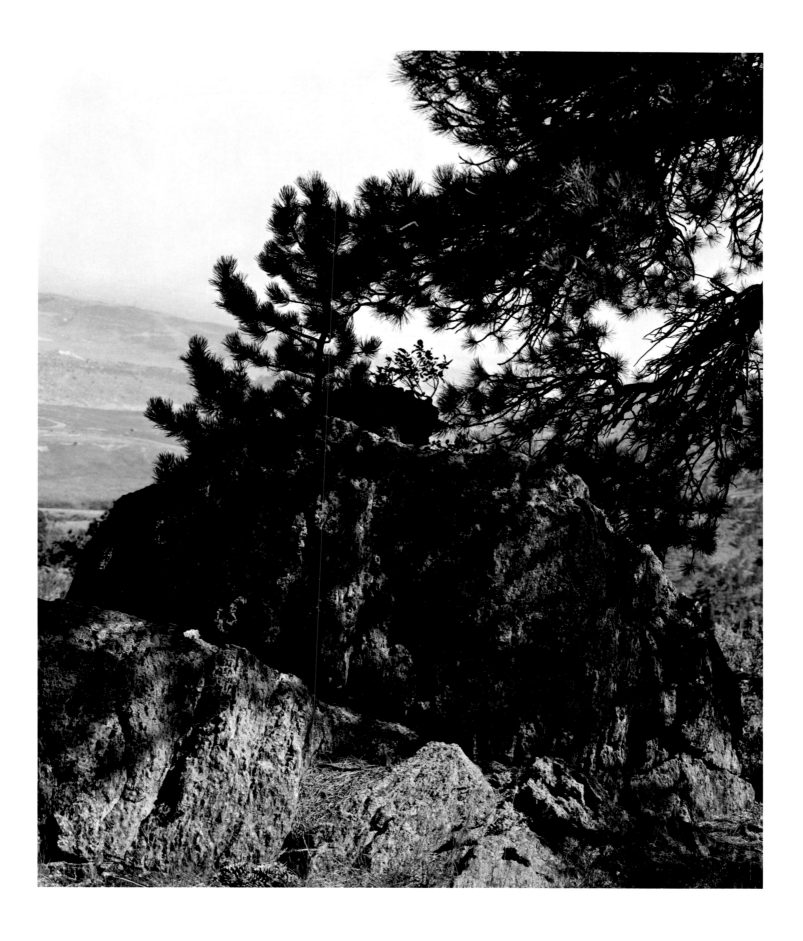

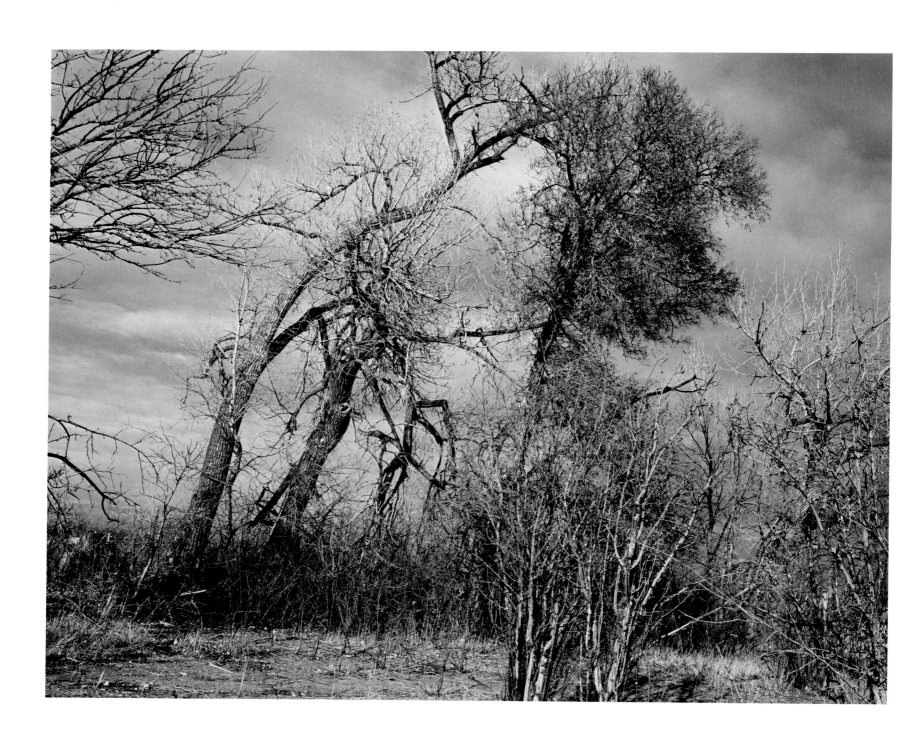

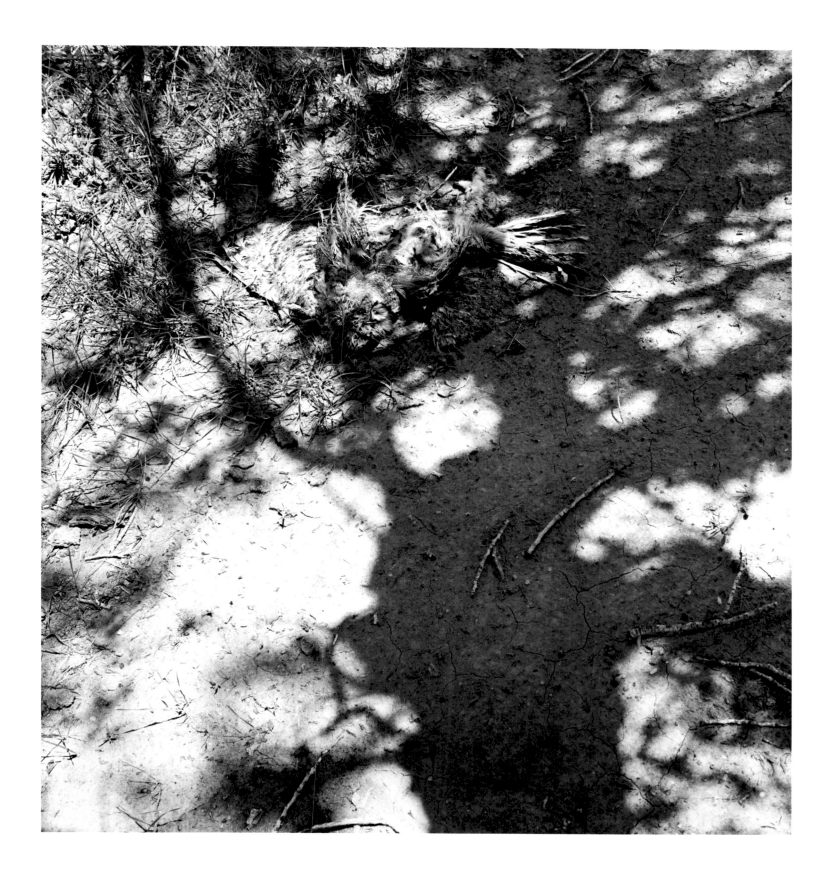

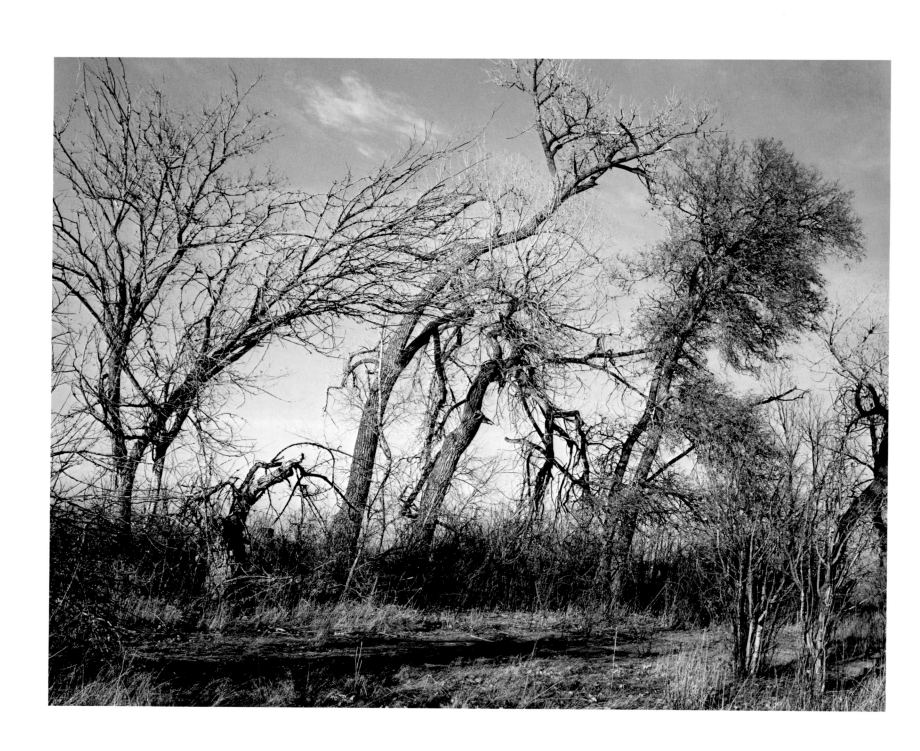

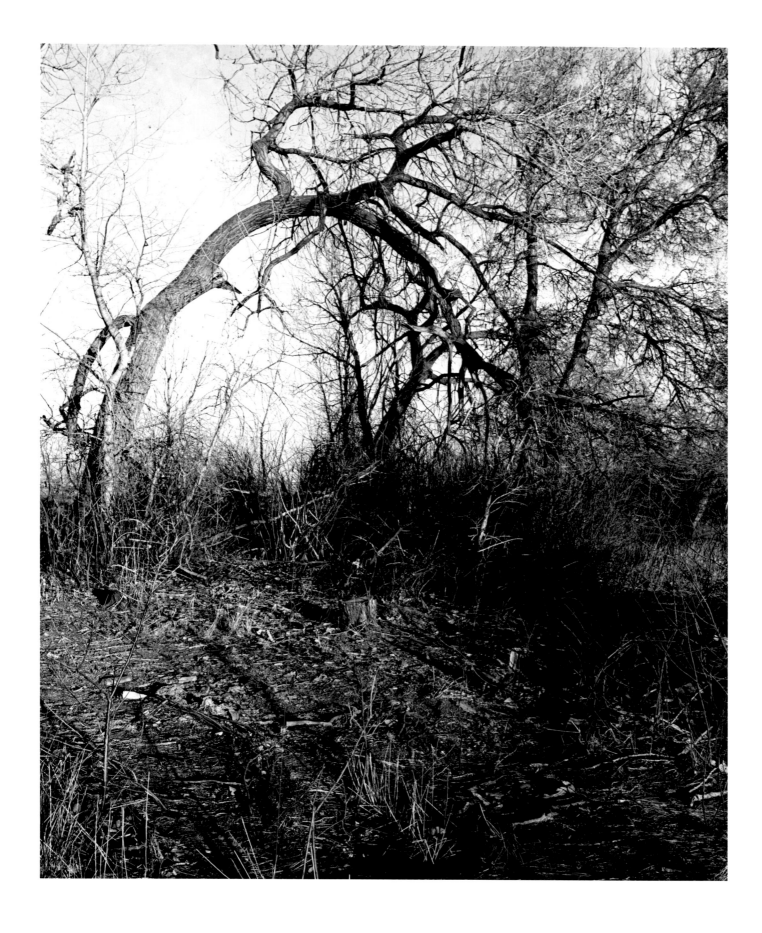

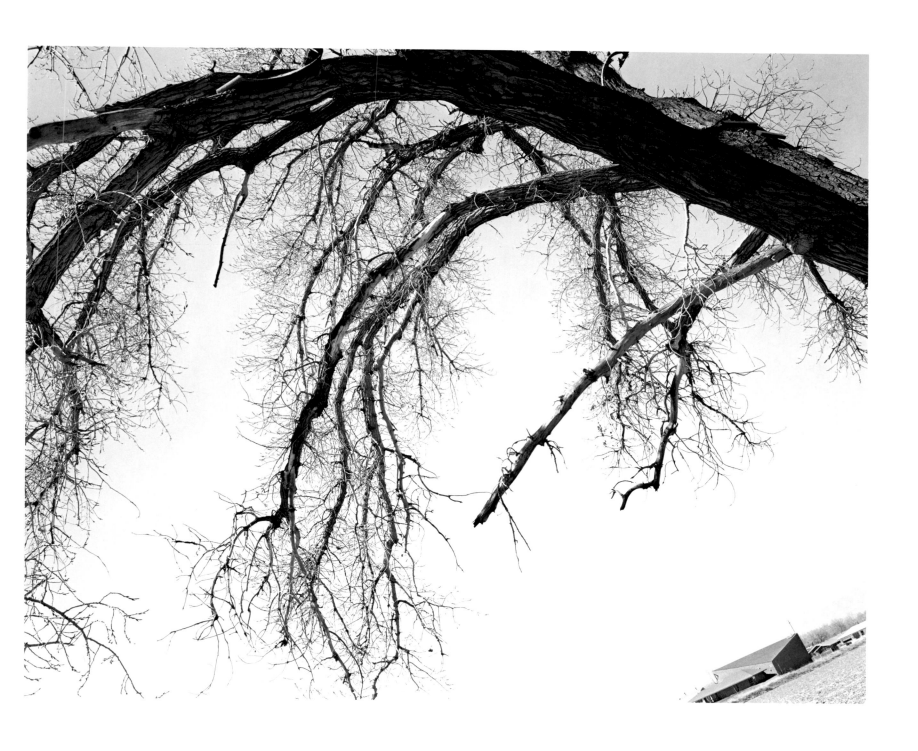

Overhead, one of those not uncommon yet
indescribable skies. . . .

WALT WHITMAN, *Specimen Days,* 1882

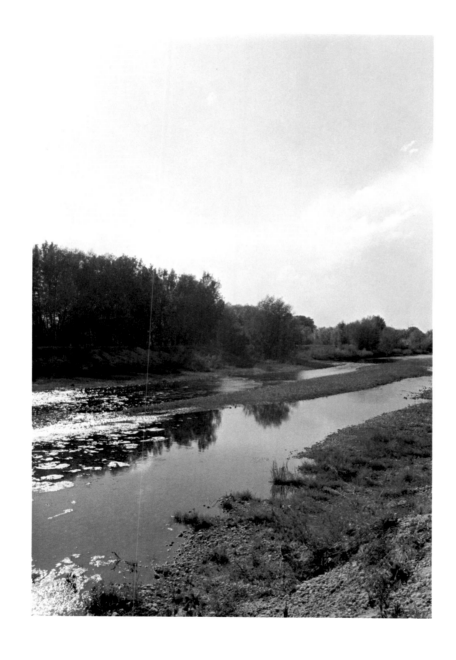

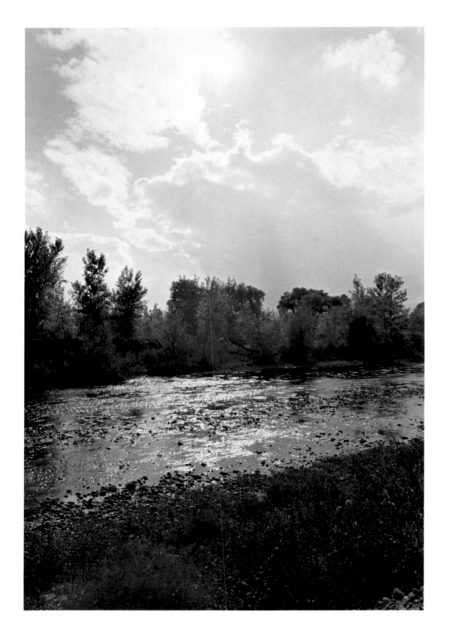
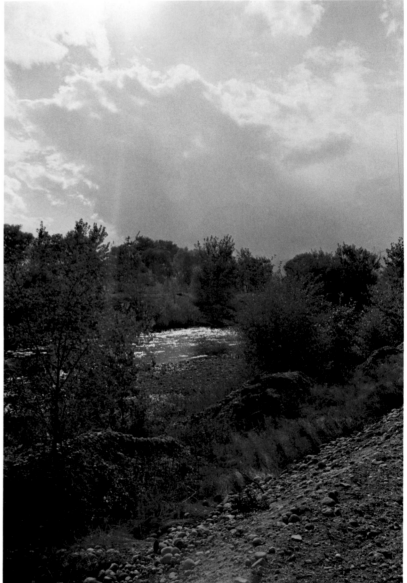

2. Farm pond about to be destroyed by earth-moving machinery. Northglenn, Colorado, 1973.

———

11. Near Peyton, Colorado, 1968. 12. El Paso county fairgrounds. Calhan, Colorado, 1968. 13. Wheat stubble. South of Thurman, Colorado, 1965. 14. Store building. Elizabeth, Colorado, 1965. 15. Russian-Serbian Orthodox church. Northwest of Ramah, Colorado, 1965. 16. Community Methodist Church. Bowen, Colorado, 1965. 17. Farmhouse, Grange Hall, and Swedish Lutheran church. The whole of Clarkville, Colorado, 1965. 18. Prairie town hotel. Colorado, 1969. 19. Arriba, Colorado, 1966. 21. Farmyard. South of Arriba, Colorado, 1969. 22. Movie theater. Otis, Colorado, 1965. 23. Boys in a pickup. Simla, Colorado, 1970. 24. Kerstin and Mrs. Leslie Ross on the Ross wheat farm. Near Peetz, Colorado, 1973. 25. North of Keota, Colorado, 1973. 26. Thurman, Colorado, 1966. 27. Genoa, Colorado, 1970.

———

29. Tract house and outdoor theater. Colorado Springs, Colorado, 1969. 30. Newly occupied tract houses. Colorado Springs, Colorado, 1968. 31. Outdoor theater and Cheyenne Mountain. Colorado Springs, Colorado, 1968. 32. "Frontier" gas station and Pikes Peak. Colorado Springs, Colorado, 1969. 33. Colorado Springs, Colorado, 1969. 35. Colorado Springs, Colorado, 1968. 36. Sunday-school class; a church in a new tract. Colorado Springs, Colorado, 1969. 37. Newly completed tract house. Colorado Springs, Colorado, 1968. 38. Along Interstate 25. Near Eden, Colorado, 1968. 39. Buffalo calf for sale. Piñon, Colorado, 1968. 40. Basement for a tract house. Colorado Springs, Colorado, 1969. 41. Frame for a tract house. Colorado Springs, Colorado, 1969. 42–45. On Lookout Mountain, next to Buffalo Bill's grave. Jefferson County, Colorado, 1970. 46. On Green Mountain. Jefferson County, Colorado, 1970. 47. Near Falcon, Colorado, 1968. 48. Colorado Springs, Colorado, 1969. 49. Pikes Peak from along Interstate 25. Near Eden, Colorado, 1968.

———

51. Adams County, Colorado, 1973. 52. North of Broomfield, Boulder County, Colorado, 1973. 53. Denver, Colorado, 1974. 54. Lakewood, Colorado, 1974. 55. Longmont, Colorado, 1973. 56. Denver, Colorado, 1973. 57. Aurora, Colorado, 1974. 59. Longmont, Colorado, 1974.

60. Lakewood, Colorado, 1974. 61. Lakewood, Colorado, 1974. 62. Lakewood, Colorado, 1973. 63. Adams County, Colorado, 1974. 64. Longmont, Colorado, 1974. 65. Burning oil sludge. Weld County, Colorado, 1974. 66. Next to Interstate 25. Adams County, Colorado, 1973. 67. Arvada, Colorado, 1974.

———

69. Sally and Kerstin. Pawnee National Grassland, Colorado, 1984. 70–72. Pawnee National Grassland, Colorado, 1984. 73. Sally. Weld County, Colorado, 1984. 74. Weld County, Colorado, 1984. 75. Kerstin. Weld County, Colorado, 1984. 76. Weld County, Colorado, 1984. 77. Pawnee National Grassland, Colorado, 1984.

———

79. Missouri River. Clay County, South Dakota, 1977. 80. Alkali lake. Albany County, Wyoming, 1978. 81. East from Flagstaff Moutain. Boulder County, Colorado, 1975. 82. Northeast from Flagstaff Mountain. Boulder County, Colorado, 1975. 83. On top of Flagstaff Mountain. Boulder County, Colorado, 1975. 84. Boulder County, Colorado, 1975. 85. Clear Creek and South Table Mountain. Golden, Colorado, 1976. 87. Near Pendleton, Oregon, 1978. 88. Near Heber City, Utah, 1978. 89. From the front porch of an abandoned one-room schoolhouse, looking into the Niobrara River Valley. Dawes County, Nebraska, 1978. 90. Looking toward the Book Cliffs. Mesa County, Colorado, 1978. 91. The Garden of the Gods. El Paso County, Colorado, 1977. 92. Scottsbluff, Nebraska, 1978. 93. Quarried mesa top. Pueblo County, Colorado, 1978. 94. Lincoln County, Colorado, 1977. 95. Along Federal Highway 287. Larimer County, Colorado, 1977. 96. Clearcut and burned. East of Arch Cape, Oregon, 1976. 97. Wasatch Range. Near Willard, Utah, 1978.

———

99. Denver, Colorado, 1981. 100. Adams County, Colorado, 1981. 101. Arvada, Colorado, 1981. 102. Denver, Colorado, 1981. 103. Denver, Colorado, 1981. 104. Lakewood, Colorado, 1981. 105. Denver, Colorado, 1982. 106. Denver, Colorado, 1981. 107. Commerce City, Colorado, 1981. 108. Denver, Colorado, 1982. 109. Longmont, Colorado, 1979.

———

111. Fort Collins, Colorado, 1976. 112. Colorado Springs, Colorado, 1979. 113. Longmont, Colo-

rado, 1979. 114. Aurora, Colorado, 1979. 115. Longmont, Colorado, 1979. 116. Longmont, Colorado, 1976. 117. Berthoud, Colorado, 1976. 118. Manitou Springs, Colorado, 1980. 119. Longmont, Colorado, 1979. 120. Castle Rock, Colorado, 1980. 121. Weld County, Colorado, 1976. 122. The South Platte River. Looking toward Denver, Colorado, twenty-five miles distant, 1979. 123. Denver, Colorado, 1979.

———

125. On Signal Hill. Overlooking Long Beach, California, 1983. 126. Looking past citrus groves into the San Bernardino Valley. Northeast of Riverside, California, 1982. 127. Santa Ana Wash, next to Norton Air Force Base. San Bernardino County, California, 1978. 128. Interstate 10. West edge of Redlands, California, 1983. 129. Long Beach, California, 1983. 130. Redlands, California, 1983. 131. Santa Ana Wash. San Bernardino County, California, 1982. 132. Edge of San Timoteo Canyon. San Bernardino County, California, 1978. 133. Abandoned ornamental cypress. Rancho Cucamonga, California, 1983. 134. At the curb of a city street. Loma Linda, California, 1982. 135. Eucalyptus alley through citrus groves. Grand Terrace, California, 1983. 136. Along Interstate 10, San Bernardino County, California, 1978. 137. Broken trees next to Box Springs Mountains. East of Riverside, California, 1982. 138. Expressway. Near Colton, California, 1982. 139. On Signal Hill. Overlooking Long Beach, California, 1983.

———

141. Boulder County, Colorado, 1983. 142. The Peetz Bench, overlooking ICBM silos. Logan County, Colorado, 1983. 143. Briggsdale, Colorado, 1983. 144. Boulder County, Colorado, 1983. 145. Boulder County, Colorado, 1984. 146. Among the last trees and lilacs surrounding a farmhouse. Everything was subsequently bulldozed. Edge of Longmont, Colorado, 1982. 147. Owl shot from a cottonwood. Pawnee National Grassland, Colorado, 1984. 148. Among the last trees and lilacs surrounding a farmhouse. Edge of Longmont, Colorado, 1982. 149. Among the last trees and lilacs surrounding a farmhouse. Edge of Longmont, Colorado, 1982. 150. Northglenn, Colorado, 1981. 151. Cottonwood. Longmont, Colorado, 1983.

———

153–157. St. Vrain Creek. Edge of Longmont, Colorado, 1986. 175. Nebraska State Highway 2. Box Butte County, Nebraska, 1978.

IN THE
AMERICAN WEST
IS HOPE POSSIBLE

ON THE PRAIRIE THERE IS SOMETIMES A QUIET SO absolute that it allows one to begin again, to love the future. Such moments are a surprising blessing because the grasslands, at least in northeastern Colorado where I walk, are weighed by the future—they are recklessly cultivated and overgrazed, and are the location every few miles of nuclear missile silos.

One summer afternoon, in the stillness which seems a part of the cloud shadows that move over the land, I stopped photographing and gave myself to thinking about a dream: what if there were a specific site here where those concerned with threats to the future could come, and in the silence of the prairie, strengthened by the knowledge that others had come here in concern before, focus their thoughts on changes needed to safeguard life. Perhaps the spot could be marked by a stone with a few words, perhaps a stone in dry ground above an arroyo with a little water, or on a hill in a stand of poplars planted for the wind, for birds, for the gold of fall—a place to which we could bring the harmony of our prayers.

It even occurred to me, in the expansive way of hope, that such a place would be better if it were approached the ninety miles from Denver on foot, by a path. I knew that between Denver and the grasslands there were now corporate farms, patrolled and fenced, but the dream was so sustaining that I tried to hold to it.

———————————

Part of our difficulty is the extreme to which things have gone. Important qualities common to life through much of history are now almost lost. What does the texture of our experience in suburban America, for example, share with the daily circumstances of those who lived in rural nineteenth and early twentieth-century America? Imagine walking in summer a hundred years ago down a street in a small town in western Nebraska. You might hear almost nothing, or just the wind, or a wagon and children and a dog. It is a scene nearly beyond our reach—farther from us than walking the moon, radios crackling. In the town whole lives were passed, hour after hour, year after year, in quiet. The lives included joys and sorrows that we know, but the context in which these were felt was fundamentally different from ours.

Thoreau in the 1840s took comfort in being able to escape even what he sensed were the noisy intrusions in small towns. In his essay "Walking" he celebrated the fact that he could "easily walk ten, fifteen, twenty, any number of miles, commencing at my door, without going by any house." He wondered "what would become of us if we walked only to a garden or a mall?" He was innocent,

of course, of the degree to which the question would be forced, of the fact that eventually no one would be able to find one square mile in America free of the imprint of man.

The sadness expressed about this condition by writers such as Edward Abbey, Edward Hoagland, and Peter Matthiessen, and understood by everyone who has known open country, is equaled at only a few points in the American experience—at the end of the nineteenth century, most notably, when Indians realized that they were defeated for the rest of their lives. There can never be again, for example, as there was for the Oklahomans who lost their farms in the Depression, a California to which to escape.

What is frightening in this loss is the corrosive, alienating bitterness toward which it has led. In the movie *Five Easy Pieces* (1970) there is a sequence that has come to synopsize it: The protagonist, driving north from Los Angeles to Puget Sound, picks up two young women hitchhikers and asks where they are going. They reply Alaska, where it is "clean," and explain, with barely controlled rage, that things in the lower forty-eight appear to them to be "shit." They reiterate the word, and when the film is shown to university audiences now the students sometimes repeat it as a litany of their own disgust. Who hasn't, after discovering a favorite mountain cut clear, or garbage on the beach, or a hawk torn from a cottonwood by gunfire?

———————————

Though distress over such things is shared now in a general way by many, its severity is due to the fact that the cause is always particular, worse than any torment by statistics. As Henry Beetle Hough, the late editor of the *Vineyard Gazette*, said not long before he died, he was sorrier about the destruction of Martha's Vineyard than about the apparent fate of the world. We feel worst about losing the specifics of home.

The issue is not just that land developers have unbalanced the ecology and made much of the geography ugly. What strikes so painfully is that, at least in the perspective of our brief lives, they have destroyed the places where we became, and would like to continue to become, ourselves. When I was fifteen, for example, I was hired in the summer to help take campers on horse pack trips through Rocky Mountain National Park. The landscapes I saw that season were for me formative, and have remained vivid in remembrance partly because of the hushed isolation in which we encountered them; it was unusual to meet anyone at all on the trail for days at a time. Twenty years later, however, it had become unusual to follow a major trail for more than five or ten

minutes—minutes, not days—without meeting long lines of hikers. Officials referred to the place as an "urban" park, and in fact I discovered eventually that there was more privacy in City Park in the middle of Denver than in walking the high peaks. From City Park I could see the back range, white, and I could recall the days I had spent there—the dry clatter of granite, the alpine flowers, the cries of pikas. It remained there in memory, though if I went closer it disappeared.

There are many such stories, and the end of them all is that, by the mid-1970s, every last secret place was finished. And one's tenderness and hope were lessened. As a boy it never occurred to me, for instance, to take a gun camping for safety (I had slept outside more than a year by the time I was twenty, from Arizona to Montana). Then, however, as the urban population increased and elements of it went on mindlessly criminal forays into the countryside, carrying a gun became commonplace. Some people—pacifists, whom I respect—refuse to carry guns, but I myself would not now camp overnight most places in the West without one, particularly if I were responsible for the safety of a woman or a child. It is a reasonable precaution against the only dangerous wild thing left, people. Having the gun, however, and always remembering the reason for it, deeply mars the experience.

There are so many events that used to bring pleasure and don't any longer. Encountering animals, for example. I remember the joy I knew the first time I saw a cougar, and later the same summer, a marten. And the satisfaction I felt when I realized I was with deer, in rimrock or sunny pines or in a canyon at daybreak. Now if I see deer, as I occasionally do along the Platte, it saddens me. Where are the wretched things to go?—in all directions there are highways, and the risk of attracting guard dogs.

Mention of such concerns to a generation of new immigrants (the population of Colorado grew by thirty percent in the 1970s), who are understandably impressed by the remaining sight of the Rocky Mountains, on smogfree windy days, brings puzzlement to them. And thus worse to me. To have grown up in Colorado and to be middle-aged now is to be old.

And sometimes angry. I think of one gray morning in October when I returned to a spot on the prairie where our West Highland terrier had been caught the previous day in a trap set for coyotes, a hellish device camouflaged in the middle of a public dirt road (legally, as it turned out). Kerstin, my wife, had been injured in freeing the dog, and I was determined to remove whatever other traps there were nearby; I carried a pair of bolt cutters to do the job.

Can good be made of the anger I feel? Can I be saved from that anger? Can it by some alchemy be transformed to the quality that one critic found in Philip Levine's poetry—a "constructive bitterness"? Might we even somehow learn the hope of the plains Indians who, photographed as if they were lunatics, danced the Ghost Dance, their final celebration of their dream of the land's restoration? The ceremonies were often held, judging by the images we have, in scrappy pastures right at the edge of their enemies' contempt.

———————————

Part of our disillusionment is a feeling common to people at any time. Keats expressed it: "To think is to be full of sorrow."

It is also a fact that there are more important issues than the loss of the West, threats that could make its fate minor.

And it is true, with respect to the landscape, that exceptions seem occasionally to mitigate its ruin. When I walk in Southern California, in its wonderful verdancy, I am sometimes reminded of how defiant life is—under the gleaming leaves of eucalyptus trees, for instance, leaves that rustle like paper, and hide mocking birds and lizards and aromatic seeds. It is always the larger juxtapositions, though, that call short one's relief. If you climb firebreaks up through the chaparral above the Los Angeles basin, for example, you are still likely to hear, eventually, the scream of a hawk, surely among the great primal sounds of nature; if, however, the air is polluted, and the cry is superimposed over the noise of dirt bikes and gunfire and the metronomic backup signal from some far-off landfill machine, then the cry will seem, in its acidity, only human.

Philosophers and writers have sometimes said we have to do without hope. The hawk apparently does not need it, and, in the absence of nuclear war, we would presumably hang on in some form without it, animated by our root unwillingness to die. On the evidence, however, hope is necessary to the survival of what makes us human. Without hope we lapse into ruthlessness or torpor; the exercise of nearly every virtue we treasure in people—love, reason, imagination—depends ultimately for its motivation on hope. We know that our actions come to little, but our identity as we want it defined is contingent on the survival of hope.

It might be thought, I admit, that insofar as the landscape is separable from people, hope for it is of lesser importance than hope for human beings; our Judeo-Christian tradition inclines us to this prejudice. I was reminded, however, in a late essay by Henry Beetle Hough of how interrelated these hopes can be. At the end of a discussion of the apparently final deterioration of Martha's Vineyard, the formerly (and, I think, finally) hopeful man repeated two lines from a poem he did not identify except as being by Swinburne, noting that he had taken the lines out of context: "There

is no help, for all these things are so / And all the world is bitter as a tear." The lines were so disturbing in their expression of defeat that I looked them up, and discovered their source to be a verse entitled "A Leave-taking," not about the passing of a landscape but about the death of a loved woman. I remembered that Hough's wife, with whom he had shared his affection for Martha's Vineyard, had died not long before, and it was clear the path by which he had come to be thinking of the poem as he wrote about the land. The two—the person and the place—were bound.

Though not as emotionally absolute as the loss of a person, the loss of one's home is so serious, I think, intertwined as it is with the rest of life, that it cannot be borne without learning, somehow, eventually, undoubtedly imperfectly, a faith. That is why we have to begin to conquer our bitterness over the loss of the West.

For generations little may change in the American political and economic system, at least without the impetus of some disaster, several of which are easily imaginable, but their occasion and consequences are uncertain. What does seem clear now, though, is that our government is not presently open to the fundamental reconstruction that would allow correction of the worst failures in our stewardship of the land. In part this is because there is no longer—if there ever was—a center of values, other than material ones, to which a majority subscribe, and in part it is because our political system has been corrupted (bought) by the economic system. Altering that economic system is, moreover, unlikely in the absence of catastrophe, since most Americans are convinced that it offers them opportunity, and thus that capitalism and democracy are appropriate to each other. (I believe that for most people the chance at wealth is illusory, that capitalism and democracy are in many ways antagonistic, and that there is a desirable affinity to be nurtured between democracy and socialism.)

Because our politics and economics aren't likely to change in the near future, I hold no hope that the American West, even significant parts of it, will remain open. The region's central, defining characteristic—space—cannot be retained in anything like its original sense because, in accordance with our system of values, it is not as important as the chance to amass wealth.

Consider the current overpopulating of the Southwest. However much we might wish to continue welcoming all economically disadvantaged people to the United States, uncontrolled immigration from Mexico—a country Edward Abbey has correctly identified as potentially our hemisphere's India—has so seriously exacerbated the ecological crisis in the American Southwest that most who know that crisis firsthand oppose allowing the immigration to continue. But it has been permitted to do so, mainly because wealthy leaders of the American Right prefer that the United States absorb Latin overpopulation rather than let it foment revolution that might endanger investments in Latin America, and because illegal immigrants make up a cheap labor pool in the United States. We have sold a region of our country into further ecological imbalance in order to protect and increase the income of a few.

Or consider our national park system. At present it is mostly a reflection of nineteenth-century interests, amounting in the main to a collection of anomalies, geegaws in the glass cabinet of a Victorian parlor. What we need now and for the future is a system of parks that would allow us to encounter not what have always been geographic oddities—caves, geysers, petrified trees, waterfalls—but what were large-scale typicalities—shores, forests, mountains, canyons, and prairies. To a small degree, we have set aside such places (often the most valuable parts of parks established for other reasons), but not in nearly enough size to convey to visitors the central fact of the undisturbed American landscape—its proportion to us, its grandness. And it is virtually impossible now to win approval for such parks because their creation would contravene economic priorities, witness the futile efforts over many years to create even a tiny park of representative tall grass prairie in Kansas. The land is worth too much for the public to own. Capitalism may not be mentioned in the Constitution, but it is in fact our state religion, and we are ardent in living by it.

So, when I have the strength to be honest, I do not hope to experience again the space I loved as a child. The loss is the single hardest fact for me to acknowledge in the American decline. How we depended on space, without realizing it—space which made easier a civility with each other, and which made plainer the beauty of light and thus the world.

Admittedly not everything dies outright by crowding. What almost always perishes, though, is a loveliness that sustains our desire for life to go on and on. Think of the tens of thousands of horses penned across the suburban West, imprisoned in bare, cramped lots where they wait their lives for baled hay tossed from a station wagon. I have seen such horses standing at night in the glare of an adjoining shopping center, and wished that their lives would be short.

Resignation must be in some measure a necessary preface to hope. I don't feel much resignation, as is obvious from the foregoing, except for brief times—when I'm able to photograph—but I see it and its value in others. Peter Matthiessen lightens his walk through

the ecologically damaged Himalayas, as described in *The Snow Leopard*, by noting again and again Buddhist prayer flags, bright in the wind; Edward Hoagland, who has acknowledged that "the age of animals is ending" and that he cannot write about them anymore, nonetheless retains a commitment to write about the complexities of human interaction with the land, a commitment that requires the energy of hope; Edward Abbey, who has been forced to console himself with the thought of a time in hundreds of years when the dams on the Colorado will wash out and the canyons reform, has nonetheless never stopped ridiculing enemies with great old wisecracks ("He's so dumb he couldn't pour piss out of his boot if the directions were on the heel"). Each writer has given up more, I think, than he ever thought he could, but each is still looking, still writing.

For what is it reasonable still to dream?

In the short run—from the perspective of our lives—changes for the better in the man-altered landscape are likely to be small. Maybe, for example, we can reduce some of the noise we make. The sound of dirt bikes and all-terrain vehicles, for instance, is a frantic and monotonous snarl common to large areas of the semi-rural West, and could be reduced by legislation. At least economic resistance to such a change might be relatively slight, and the hardship the noise causes is more and more widely felt.

In the longer perspective of a hundred or two hundred years, assuming the country lasts, a variety of difficulties might be eased. This could happen through the engine of selfishness, as people realize that their welfare is threatened by others taking short views. When whole cities begin to die for want of water, for instance, taking with them both profiteers and their idle fellow citizens, there will be a call for tighter restrictions on the use of whatever water is left. Pressure will similarly grow for land-use legislation (something which is now weak or nonexistent through the West, governed as most of it is by Republican legislatures), as landowners who are now unconcerned discover that the value of their holdings is being destroyed by sewage, chemicals, erosion, and the other consequences of excessive and anarchic development.

Eventually there will even be improvement in air pollution. After forests and lakes die, and a great many people suffer respiratory disease, the ongoing price—literally computed, no doubt—will begin to seem too high. Finally, an overwhelming majority of people will personally know victims of emphysema, lung cancer, and other pollution-related sicknesses, and will, in fear for themselves and their families, force a change.

It is hard to remember how the Southwest looked with the skies

clear, but I like to imagine the time when it could appear that way again, not only for the cessation of suffering it would mean, but for the painters who would see it and bring it to us. How direct and unqualified their celebration could be, as it was for artists like John Sloan, John Marin, and Andrew Dasburg in New Mexico in the first half of this century, and later, Peter Hurd. For the new artists the experience could each day be as Kenneth Clark wrote: "Facts become art through love, and in landscape [painting], this all-embracing love is expressed by light." How blessed seem those pictures where the reference is easy, where it reminds us of an incontrovertible and unambiguous beauty that is there at any season or hour, out any door.

Our encounter with the land may also improve as people simply grow tired of their own and others' degraded behavior, weary enough to modify economic and behavioral rules. Hunting is an example. At present, so-called wild animals are "managed," so that those of interest to hunters—who spend more money than bird watchers—are herded, artificially fed, medicated, and protected from predators. Whole ecological systems have thus been thrown off even further from whatever might remain of their original balance by alliances of game departments, hunters, and commercial interests that promote deer- and elk-hunting (now done with spotter planes, all-terrain vehicles, CB radios, and semiautomatic rifles). Any reduction in this industrial malformation and maltreatment of the surviving animal world would be an enormous gift. Just to be free of the sight of the "harvest," as it is nicely called, would improve autumn. Not to see, for example, as I did once, several men step out of a jeep, and, firing from the road, shoot the legs from a fawn before killing it.

It is possible to hope for even subtler changes. The nature of the buildings we live in, for example, may be altered as we learn respect for the environment. Economic justifications are now given for structures that defy the climate, disregard the original configuration of the geography, and in some cases require the wholesale destruction of adjoining regions for materials (as is presently happening, where I live in Colorado, with the mining of gravel for the manufacture of concrete to build cities). But at some point many of us, if given any chance at all, will gladly pay for a place of which it can be said, in Edward Thomas's words, "the house is kind / To the land that gave it peace."

And there are changes in geography that will cost nothing except honesty. Someday, for instance, we will go back to naming places as they are. It is probably too much to hope for the frankness that gave early Colorado place-names like Lye and Oil Can, but it was those hard names that neutralized skepticism about the sweet ones like Maybell and Pleasant Plains, and this lesson in the value of

candor may yet be learned. At least there will come a time when we stop naming places for lake shores that aren't there, and attaching to names eastern suffixes like "glen" and "green." And if we call places by names that are accurate, we may ultimately find it easier to live in them. "The mind rests only on the stability of truth," Samuel Johnson said; rest and stability are aspects of home. Perhaps after we reach it, we may even learn again to compose songs based on names, treasured words made right by observation and history, songs like the ballad "The Rivers of Texas," listing the places where the singer courts his beloved—by the Pecos, Nueces, Wichita, Brazos, Nacogdoches, Sabine, Trinity, Guadalupe, Angelina. . . . "Give me your hand," he invites—"There's many a river that waters the land."

As much as I hope that future generations may enjoy these small and fragmentary changes, I must admit that the adjustments would not guarantee a respectful relation to the land. I take comfort, for that reason, in hope for a change not requiring large sums of money, and for the most part not in need of a majority vote—a reshaping that will come about, I think, as the result of the needs and efforts of individuals: a recognition and enrichment and preservation over the centuries of specifically sacred places. The final goal will remain that all places be recognized as holy, but, as a step on the way, locations of particular intensity will more and more be held dear.

Each of us already knows such places, exceptional in the peace and insight they bring. Until fairly recently, for instance, graveyards could be counted among them. It was understood that in living on earth as breathing compounds of dust we are part of what is eternal, and so marking the location of the dust in gravesites served as a reminder of that consolation. It also afforded others a place to celebrate, with flowers or just attention and memory, the caring of previous lives.

I think of the grave of a man I knew on the plains. He was the editor of a small-town newspaper until, during the thirties, the town withered, leaving eventually just his shop and two houses in the middle of the prairie. He stayed on, operating a tiny post office that served a hundred square miles of farms and ranches. In 1978 he died and was buried in the town's cemetery, an acre by then not easily distinguishable from the rest of the grasslands. His gravestone reads "Clyde L. Stanley—Keota, my home for 63 years." However terse that is with the honesty of a last thing, it is compelling in its passion. He must have thought about the words for a long time to conclude so unequivocally what mattered most, remembering I suppose the blizzards he'd watched through the front windows, the smell of sage after summer rains, the conversations he'd had with generations of neighbors. . . . The place—that was who he was, by his love for it.

Sometimes one doesn't even have to visit a location to take heart from it. I once bought a vase that had been made from clay dug on Tillamook Head, a promontory on the northern Oregon Coast, and fired there in a primitive kiln in the forest on the mountain's slope. Though I have several times walked the headland, I will never find, in its dense growth, the clearing where this beautiful object was made; though when I touch it, I can imagine the site of its origin. Nothing, not even the lashing storms of winter, nor the thought of the storms we ourselves bring, disrupts the quiet of the place I know is there, with its faint smoke drifting through conifers.

If there is anything lacking in such places, lovely though they are, it is a community of observers. By the paradoxical mathematics of beauty, they are, like songs, more ours if we share them. But this is difficult in our time because relatively few people care, and because those who do are thinly dispersed. Calling such places to public notice can, as well, risk their destruction by vandals.

There are some activities now, though, that seem prophetic. A group of photographers is, for example, paying new attention to places that have been venerated by Native Americans. The reward to the photographers is not only the satisfaction of giving us truthful pictures, but the experience of being, with all their attention, there. Rick Dingus described in a letter an afternoon when, while working in the desert, he waited out a cloudburst "in a cave with Coyote painted on the ceiling. Bear, Turtle, Bird, Plumed Serpent and others were there too. Lightning crashed, the ground shook with thunder, water dripped into the catch basin carved near the Serpent. Then the storm passed, with the sun back out, and the wet earth drying, clean-smelling, regenerated." He has discovered that he can share some of these experiences with Indians: "We talked about my dreams and his, the stories connected to the place. All of this related not only to where we were but to where our time is—where it came from and where it is going."

The photographic work being done at these sites is also important, of course, because the places are unavailable to the majority of us. Even those locations to which we might make our way by long travel are now mostly being destroyed or, in order to save them, closed. They ought to be barred to us, I think, once we have learned from their example, both so that Native Americans can use them without distraction, and so we will be compelled to develop our own places of respect and harmony. Only insofar as

we are forced by our need will we realize that there are things more appropriate to mountain tops than climbing registers, that there are trees it is right to touch only as if they were human, and that there are prairie draws as true to the opening of the 23rd Psalm as any green valley in Judea.

I'm encouraged by artists brave enough to attempt the creation of sites similar to those developed for worship by earlier cultures. Though some of the "earth works" done in the 1970s were extensions of commercially inspired aestheticism common in painting and sculpture, others originated in sources far removed from the usual frivolity of marketable "art." I haven't visited them, but pictures suggest that Walter De Maria's "Lightning Field" and Nancy Holt's "Sun Tunnels" are creations of a serious order, as is James Turrell's current Roden Crater project. Each is located in a spot that is inherently awe-inspiring by virtue of the sweep it affords the eye—over a plain, across salt flats, and from within a volcanic cone, respectively—and by the silence of isolation. Each has been, or will be, brought to focus by the addition of humanly shaped objects that relate the spot to a wider context—to clouds, to the sun and the constellations, to the cosmos as a whole.

Someday not only will there be more places that encourage a harmony with nature, but there will be, I think, new sacred sites originating in the principal religious traditions of our culture, Judaism and Christianity, the correction of which seems to me imperative because their abandonment is impossible (one cannot walk away from the center of one's culture and survive; Judaism and Christianity embody insights that are unique and, at least in my experience, true). Years ago, when I found myself with time to spare in Cologne and Aachen in West Germany, I decided to visit several churches, recommended in a guidebook, that had been built by an architect of whom I had not heard, Rudolph Schwarz (I later discovered a startlingly heartfelt testimony to him by Mies van der Rohe). One church, located in an otherwise drab suburb, was said in the guidebook to call to mind—as Schwarz had mysteriously permeated the structure with natural light that seemed to have no source—the Eastern Orthodox definition of a church: a building, analogous to the mother of Christ, containing the uncontainable. To my wonder, it proved to be so. This church, St. Christophoros in Cologne-Neil, was unlike any modern American religious building with which I was familiar. At the back of the chancel was the barest sketch, in otherwise blank concrete, of the risen Christ; to the side of the pews there was another, equally simple, of an angel, her face turned toward worshipers and her finger raised to her lips for silence.

My memory of Germany, which is otherwise of a mostly lost geography, is transformed through the recollection of my visits to a half-dozen churches designed by this one man. Recalling them helped suggest to me, when I returned to America, that not just churches, but whole urban and suburban landscapes might be revealed as sacred if we brought to them a measure of the same passionate regard that Schwarz had brought to his specifically religious commissions. It was, in a way, why I started photographing, to see if I could find, by pictures, an emotional equivalent to the churches. The goal was in many ways naive, however, and over the years I have found myself looking for churches in America of the quality of Schwarz's in Germany. Working on Colfax in Denver or Pico in Los Angeles, I sometimes think that if they are here they are small, even anonymous on the outside, focusing inward, holding a stillness removed from, but redemptive of, the street.

On the Japanese island of Shikoku there is, as described by Oliver Statler in *Japanese Pilgrimage*, a footpath that follows the thousand or so miles of shore line, linking shrines celebrating events that occurred during a walk there by the Buddhist saint Kobo Daishi (774–835 A.D.). Pilgrims say that they are accompanied by him as they travel; the route eventually leads back to the start and thus to a central aspect of his wisdom.

Part of the trail, according to Statler, now runs along freeways. Unpleasant as that may be, the walk next to cars and trucks apparently does not carry with it, however, the threats of violence—shouts, things thrown, Dobermans lunging against fences—that it would along highways such as those leading to the grasslands of northeastern Colorado.

These obstacles to peace exist, however, because of who we are, not what the land inherently is. Perhaps someday America will have trails like those found in Japan, or England, where public paths commonly cross private land, or Sweden, where any citizen at all can walk to within sight of any house. Pilgrimage routes in America come easily to mind—walks to clapboard churches on the high plains, to adobe chapels in the Sangre de Cristo mountains of New Mexico, to locations along the Rio Grande that have served as painters' motifs, to sites on the Northwest Coast that inspired the poetry of Theodore Roethke—though the paths for which I hope most are between places as yet unrecognized by us, to mountains celebrated by novelists who haven't yet written, and along streets in cities loved by filmmakers whose work we haven't yet seen. By that time travelers might enjoy a community of spirit with each other and with residents nearby who, strengthened through the privilege of living there, would trust visitors. Eventually—why not hope?—there might even be retreats, as on

the route encircling Shikoku, where part of the welcome offered would be to share a community's practice of silence. Or its calendar, where a painting or sculpture might be brought out only once a year, or where things might be said at appointed times as they had been said for hundreds of years.

The circular pilgrimage route in Japan leads to an emotional understanding that I want very much to come to know, especially as I am an American, the dangerously empowered legatee of Western, linear ideas of time and progress. I think of a circular walk I would like to make along the Platte River, west from the Missouri River to the Rockies, and then, by another pioneer trail like the Smoky Hill, back to the Missouri again; I would like to walk prairie grass with the setting sun at my back for a while, day after day. Not that at my age it would convince me to go east to live, but it might encourage me, wherever I must live, to think of that place as home.

Most of my hopes are for the amelioration of problems—a more conservative pattern of land use, a reduction in air pollution, a more prudent consumption of water, a lessening of animal abuse, a more respectful architecture. When I think about the possibility, however, of a landscape enriched by specific places to which we have responded imaginatively and with deference, I find myself thinking that we might be permitted to call it improved. Samuel Johnson wrote once of a place he visited called Hawkstone Park in which he found the geography so untamed that "the ideas which it forces upon the mind are the sublime, the dreadful, and the vast," compelling, in "the horrour of solitude, a kind of turbulent pleasure between fright and admiration"; for a visitor there, "his walk is an adventure and his departure an escape." Johnson contrasted Hawkstone with another estate, a garden set below mountains, a scene in which there was "grandeur tempered with softness." I remember sensing for the first time, the summer I was eighteen, the pull of those two kinds of geography. I was working for the Forest Service in the San Juan Mountains of southwestern Colorado—on precipitous, timbered slopes, and often in storms. Late on Saturday afternoons we would leave that setting for a few hours in town. It was a long trip, down thousands of feet through warming air, eventually leading to a point from which we could see our two-block-long destination, situated in the center of an ideal ranching valley, gold in last light. The community promised a milk shake, a haircut, and a movie (always a western), all of them wonderful, but the overlook would hold us for a moment, even in our youthfulness, by its serenity.

Many times and places since then I have tried to photograph the

quality in that scene, having slowly been brought to realize that however much I loved what I saw of the western American wilderness, to have loved it raw best, lifelong, would have required a misanthropy that I couldn't have borne. Like many, I have come to hope to find a valley, in sight of peaks but gentler than they are, and to be permitted to make the valley even more itself, better consonant with a harmony in nature that seems finally more true than nature's violence. To try to do this is, I know, in consideration of our history, to embark on another failure, but I believe that our weakness is at least understood, and that we may hope to be forgiven.

If most of the larger possibilities we have considered are beyond the span of our lives, for what is there to hope within their span? If as individuals we can improve the geography only slightly, if at all, perhaps the more appropriately scaled subject for reshaping is ourselves.

The evidence is cautionary. Those little reforms that I have managed in myself and that for the moment seem more or less in the right direction have been slow and late: for a half-dozen years as a young man I was a hunter; for many more years I enjoyed photographing cattle on the plains, diverted by what seemed their part in an attractive myth, never thinking of what they did to the land or of what we did to them; I also used to take pleasure at the sight of the graceful sprays from center-pivot irrigation systems, machines that were in fact mining irreplaceable aquifers. What, I wonder, am I not seeing now? What in this essay will I wish in five years, in embarrassment, to revise? If only I knew.

I do know, nonetheless, people who have grown, if not to sainthood, to become better than they were, and better than I am. Against the weakness of my own anger I see their achievement —an opposition to evil made steady by their provisional truce with the part of it they cannot change. It appears often to be a victory requiring a whole life. We recognize their success in an evenness of voice, a serenity of hand, a kindness in small things that require patience.

When I have hope that we may improve a little, each of us, it is often after some personal contact with the land. By gardening, for instance. Our back yard has a common mixture of vegetables and flowers—zinnias, cosmos, squash, tomatoes—but as the places we enjoyed in the mountains have been lost, the garden has become a substitute for some of them, particularly for the space of the mountains' quietness.

There is, too, the common satisfaction of walking, which can sometimes be as unalloyed as that of working in the back yard, but more often leads into the diversity of modern life. Among the best descriptions I know of the rewards of exploration on foot is a small journal entitled *Of Walking in Ice* by the filmmaker Werner Herzog. In it he records a hike he made in winter from Munich to Paris, as a kind of sacrament for the health of a friend. Along the way he notes the frightening oddities of our landscape ("low-flying airplanes overhead all day, one of them coming so close that I think I saw the pilot's face"), he observes the coldness of our society's positivism ("How I long to see someone kneeling before the roadside crosses"), and he experiences a sense of isolation and confusion ("If I actually make it, no one will know what this journey means"). There are, however, moments of gain: "The mice rustled very lightly in the flattened grass. Only he who walks sees these mice." He had recorded a little earlier that a new compass "does not have my friendship yet," but, after studying the way the mice tunnels lie exposed between grass and snow, he realizes that "friendship is possible with mice." It is an observation worthy of Kafka, as befits our age, but more significantly, worthy of St. Francis as well. It is synoptic of what we can enjoy by walking—a kind of friendship with things, made possible by a pace that allows regard for the least conspicuous miracles.

Art, too, is a source of pleasure to be taken in the landscape. Making art—being able to say what one sees that is whole—is an enormous relief, as if one had been held dumb by an impediment of speech, and then abruptly cured, enabling one to say, and thus understand better, what it is that is most important.

Studying the art of others helps too. When we discover, in a landscape toward which habit has made us uncaring, a Hopper sky or Cezanne rocks, the terrain is suddenly compounded into something fresh and larger. Even minor art—songs, for instance—can reawaken our affection for places, and our belief in the certainties they offer. I cherish a ballad—half funny, half sad—describing a man who gets a letter from the East asking why he works on a ranch for low pay, speculating he "must have gone crazy out there"; the man answers to himself in the refrain, "You've never seen spring hit the Great Divide." It reminds me of my season there, and, in the loveliness of the song, the place and I both seem—I don't know how—safe.

Finally, centrally, there is the joy to be found in a landscape experienced with family and friends. There are days that become, in the urgent and hushed sharing of a wonderful place with someone else, as much as I expect to know of the world for which I dream. To hear one's name, and the invitation, spoken with the assurance you will together see the same gift—"look."

I write this on a year of retreat in a small Oregon town next to the Columbia River where it enters the Pacific. Because of the river's size—it is three and a half miles wide—and the ocean, and the town's location on a hill, it is a place of extraordinary beauty, though even it has ghosts. From my desk at an attic window I can see the riverfront that used to be, when we first came here twenty-five years ago, lined with working docks and canneries, but where now there are mostly rotting pilings and empty buildings, the salmon having been decimated by overfishing and by the destruction of their habitat. On the main street, where trucks used to pass carrying a single enormous log, they now carry twenty-five or thirty spindly ones to be chipped for composition board, the whole Coast Range having been cut bare of first growth.

For a century, Scandinavians came here as fishermen, loggers, housewives, and cannery workers, and this morning on the radio there is Finnish music, call-in requests from old people; many in the town are not, even after a lifetime, wholly assimilated. They are loyal to their adopted country, but have held something back, something perhaps beyond their power to give.

It occurs to me that I wasn't entirely accurate to claim that our disinheritance now is especially severe or out of character with our past. Many who came west did not, after all, want to stay once they saw it. Or like the immigrants to this town, they learned that their coming had imposed on them an injury. How else explain the carefully tended birch trees where alders are native?

America was not settled only by those following a dream of profit. Just as often, our forebears' motive was to escape some nightmare of hunger or stultification or violence, and they would always love, with a sudden intensity against which they could never fully guard themselves, the geography where they were raised—the flowers, trees, birds, clouds, and lay of the land. Ours has never been, really, just a country of easygoing transients. There has always been a counter tradition of learning to make the best of exile, of building from recollections of what was prized and torn away.

ROBERT ADAMS

Most of the foregoing essay first appeared in The North Coast Times Eagle, *Astoria, Oregon, in 1986.*

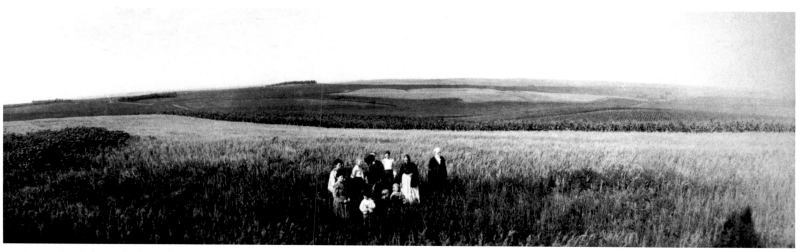

Members of the Hickman family on the South Dakota prairie in the late nineteenth century
(photograph by Robert Adams's grandfather, Charles Hickman).

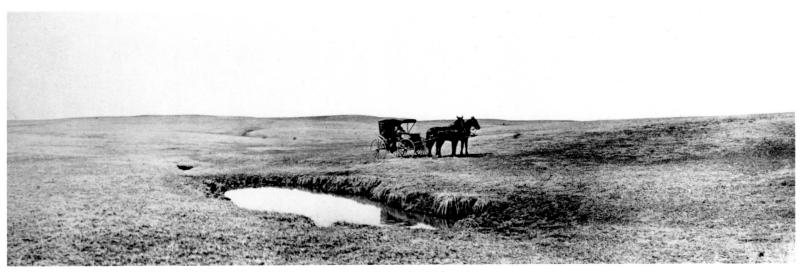

A member of the Hickman family in South Dakota in the late nineteenth century (by Charles Hickman).

1937—Born on May 8 in Orange, New Jersey, to J. Ross Adams (1907–), an actuary, and Lois Hickman Adams (1909–), a speech pathologist. Ross Adams was raised in and near small towns in western Missouri; his father, James T. Adams, was a farmer and seed salesman. Lois Hickman was raised in Sioux City, Iowa; her mother, Edith Fogg Hickman, had when young been brought from Maine to the Nebraska prairie (where as a child she was sufficiently frightened by Indians to burn and permanently scar her arm with a well rope so that she could be identified if she were kidnapped); Lois Hickman's father, Charles Addison Hickman, grew up in Ohio, was for a short time a divinity student in New Jersey, and then became, more happily, the first electrician in Iowa, as well as an amateur historian, craftsman, and photographer.

1939—Adams's father takes him on his shoulders for his first trips through the woods. "They're some of my earliest memories, together with recollections of picnics on which my mother later took my sister and me."

1940—Family moves to Madison, New Jersey, to a house on a hill overlooking the Great Swamp. —His sister, Carolyn, is born.

1942—Accompanies his father during these years on weekly Sunday hikes. —Enjoys baseball, playing in open fields, and helping his father with carpentry projects.
—Begins to experience chronic bronchial problems, suffering pneumonia twice.

1947—Family moves to Madison, Wisconsin.

1948—Active in outdoor programs of the Boy Scouts (becomes an Eagle Scout) and, with his family, the Methodist Church. His mother, who would later become a speaker for the American Association for the United Nations, emphasizes to her family the unity of religious and social concerns.

1949—Stricken with polio in back, left arm, and hand, but is helped to substantial recovery by the affectionate care of his family, particularly his mother.

1950—Suffers from increasingly severe asthma. —To escape hay fever, he spends late summer with his mother and sister in the small town of Eagle Harbor on the Keweenaw peninsula in Upper Michigan.

1951—Again goes to Eagle Harbor; this time Adams and his father also cross to Isle Royale. —Allergy problems force him to miss first half year of high school.

Hickman ancestral home (log) in Ohio, nineteenth century (photographer unknown).

1952—Adams's father secures work in Denver, Colorado, to make it possible to move west for his son's health. —The family settles in Wheat Ridge, a suburb of Denver.

"I remember how desolate it seemed, coming from Wisconsin. In the spring almost nothing good appeared to happen—just more wind. Only slowly did I learn to anticipate the coming of doves up from Mexico, the blooming of chicory, . . . hundreds of wonderful things did happen." [Lecture, Museum of Modern Art, New York, 1978]

—Works during the summer as a dishwasher in a Boy Scout camp in the mountains.

1953—With his father makes the first of five raft trips through Dinosaur National Monument.

"Photography is like rafting—the same sense of possibilities and of tangible peace. And, if you're lucky, of good company." [Interview, *Landscape: Theory*, 1980]

—Works in the summer for a boys' camp in Rocky Mountain National Park teaching crafts, making horse pack trips through the Park, and climbing mountains. Narrowly escapes injury in a climbing accident on a snow field. —With his sister as co-enthusiast, he begins in the fall to visit the Denver Art Museum. With friends at school, discovers the pleasures of reading.

1954—Studies architectural drawing for a year under a demanding but inspiring high school teacher.

1955—Graduates from high school and then works during the summer for the U.S. Forest Service near Telluride, Colorado. —Attends

Colorado University in Boulder for one year. —Hunts for the last time. —His sister gives him a copy of *The Family of Man*.

1956—Hikes with friends into Havasupai Canyon, an Indian community within Grand Canyon. —Works during the summer on a trail crew in Glacier National Park in Montana. —Enters the University of Redlands in California, where he spends the next three years earning his B.A. in English. —Abandons intention of becoming a minister.

1957—Makes with friends the first of several brief trips along the northern coast of Baja California. —On a raft trip on the Colorado River, he is washed overboard and trapped in a faulty life preserver. His father rescues him. —Takes courses in Shakespearean tragedy and modern literature from William Main, an unorthodox and charismatic teacher whose views have been shaped by those of Reinhold Niebuhr.

1959—In an essay published in a student journal, he suggests that Stephen Daedalus, in James Joyce's *Ulysses*, failed because he could not reconcile his worship of beauty with his belief that God is immanent, "a shout in the street." —Writes an honors paper on freedom in Sophoclean tragedy, describing freedom as a paradox, the willing affirmation of what is unavoidable. —Graduates in English at Redlands and then begins postgraduate study in English at the University of Southern California.

1960—Marries Kerstin Mornestam, a naturalized citizen (her family had moved to Los Angeles from Sweden in 1948) whom he had met at Redlands, and with whom he shares strong interests in the arts and in nature. —They spend the summer in a farmhouse on a hill overlooking Michigan's Keweenaw peninsula. —Adams's parents give him a copy of *This Is the American Earth*.

1961—With Kerstin spends the first of several summers on the northern Oregon coast, at first in a weathered building that had been at various times a gas station, church, and bar; days are spent walking the beach, and evenings reading.

1962—With his father and a friend he travels down Glen Canyon, the last year the water runs free. —Begins teaching as an assistant professor at Colorado College, Colorado Springs. Emphasizes Leopold Bloom's acceptance of the world

that Stephen Daedalus rejects, acceptance typified by Bloom's comic reflection, "Aesthetics and cosmetics are for the boudoir, I'm out for truth." —Finds disturbing the changes in Colorado that have occurred during his time in California.

"I came back to Colorado to discover that it had become like California. . . . The places where I had worked, hunted, climbed, and run rivers were all being destroyed, and for me the desperate question was, how do I survive this? Edward Hopper's paintings had already given me a clue, though I didn't fully understand it." [Interview, *Landscape: Theory*, 1980]

1963—Buys a 35mm reflex camera, and begins taking black and white pictures, mostly of nature and architecture.

1964—Reads photographic literature, especially complete sets of *Camera Work* and *Aperture*, at the Colorado Springs Fine Arts Center. —Myron Wood, a professional with a deep commitment to documenting Colorado, teaches him photographic technique.

1965—Publishes "Freedom in [Joyce Cary's] *The Horse's Mouth*" in *College English* (March 1965), describing the painter Gully Jimson's "vision of the imagination" as a vision of love, but realized with comic imperfection; ends by quoting Kierkegaard's journals: "What does being a poet mean? . . . it means being related to the ideal in imagination only, so that one's own personal life is more or less a satire on poetry and on oneself." —The University of Southern California awards him a Ph.D. in English. —Buys a Sinar view camera and returns to Colorado, where he photographs Hispanic cemeteries along the southern Colorado border, but soon turns to scenes on the eastern Colorado prairie. —Buys a truck and an Airedale. "Major steps toward the good life."

1966—Buys a print from Ansel Adams of "Moonrise, Hernandez, New Mexico."

1967—Begins teaching one-third time in order to photograph more. —His pictures are often rejected for publication and exhibition, and are, to his discouragement, often returned destroyed as well.

1968—Travels in the summer to Germany and Scandinavia with his parents and Kerstin, finding especially memorable the new churches

Lois and Ross Adams, 1945 (by James Adams).

Adams on a hike near Madison, New Jersey, 1946 (by Ross Adams).

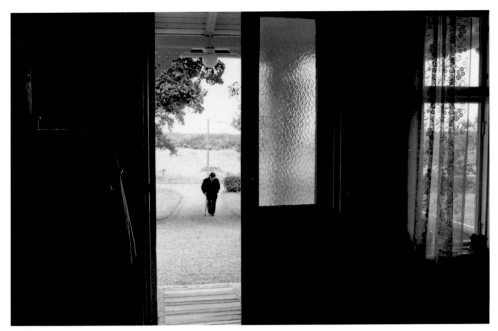

Kerstin's grandfather, almost blind, walking toward his house in Öglunda, Sweden, 1968.

in and near Cologne by Rudolf Schwarz, the Forest Cemetery in Stockholm by Gunnar Asplund, and two weeks spent on the ancestral farmstead of Kerstin's family.

"Göteborg, June 12: *No highway billboards, no television ads, few suburbs.* . . . Gränna, July 10: *Coffee and rolls, 10:30A.M., on the terrace of the Gyllene Uttern restaurant [the location of a memorable scene in Ingmar Bergman's* Wild Strawberries]. *Sunlit clouds. Lake Vättern couldn't be more beautiful.* Öglunda, July 12: *The old family house is centered beneath big trees. Behind it, a wooded hill from which one can see Lake Vänern forty miles away. Nearby—hay fields, farm wagons, cherry orchards, stone fences, one dirt auto road lacking a straight kilometer, a stone church (next which Kerstin's grandmother is buried; she was born on the farm adjacent to this one), a lake, flocks of blackbirds.* . . . Öglunda, July 15: *We brought Kerstin's grandfather, dressed in a brown vest and coat and black Homburg, from the home at Axvall to his farm here for the day. He can just see the outline of large objects, so he walked very cautiously until he arrived. Then he said he did not need more help, having lived here all his life, and that he would like to walk by himself, which he did—down the gravel drive, then to the barn, and finally back up and around the house. It was a slow walk (neither Kerstin nor I could help looking on), and interrupted by many pauses of a minute or more when he would carefully listen. To me, the sound was of the wind through the*

trees—the day was blowing and overcast—but there were obviously sounds only he could hear. It was one of the most moving sights I have ever seen." [Notes]

—In the fall, begins to photograph the new suburban landscape along Colorado's Front Range.

"A suggestion I'd read by Dorothea Lange was uppermost in my mind. She had called for the building of a file about 'the life of the American people in the 1960s, with particular emphasis on urban and suburban life.' It should, she said, 'be concentrated on what exists and prevails.' " [Lecture, International Center of Photography, 1977]

"*A documentary on ETV: Dorothea Lange, with photo in hand, talking to herself—'Am I fooling myself? Is it really a picture?' If she was uncertain about her pictures, I can surely admit that I am about mine."* [Notes]

1969—Travels east with Kerstin in June to try to find an audience for the pictures of the new Western landscape, having been given the possibility, depending on work sent ahead, of an appointment with someone at the Museum of Modern Art in New York. The trip is difficult (the two stay at the YMCA), but the interest and kindness of John Szarkowski, Director of the Department of Photography at MOMA, are a decisive reward. When the museum later buys four prints, Adams feels an enormous relief at the confirmation it gives, and returns to work with renewed commitment.

"To the east of the interstate highway are railroad tracks, gas tanks, and a prefabricated metal shed. To the west, a roadhouse (closed), a military salvage lot, a car wrecking yard, and a cafe. Extending beyond along the freeway are billboards advertising whiskey, real estate, and ice. There is, however, another aspect to this spot, one that can be set forth only in riddles. Stuart Davis, when he described his goal as a painter, talked of it: 'I am,' he said, 'not looking for something newer and greater. Everything new and great already exists—has always existed. We need to make our connection with it.' " [from the text for a photo essay, unpublished, about a truck stop named Eden]

1970—Teaches in the spring for the last time at Colorado College, leading a seminar on literature and film, stressing the importance of work by Virginia Woolf, Yasujiro Ozu, and Jean-Luc Godard. —Represented in *New Acquisitions* exhibition at the Museum of Modern Art in New York. —Publishes *White Churches of the Plains*, his first monograph. —In the fall begins a year in Denver so that Kerstin can earn a master's degree in library science at Denver University. —Pictures are rejected for a third

At the mouth of the Columbia River in Oregon, 1967 (by Kerstin Adams).

time by Aperture. —Maintains an active schedule of shooting while in Denver.

"Whatever power there is in the urban pictures is bound to the closeness with which they skirt banality. For a shot to be good—suggestive of more than just what it is—it has to come perilously near being bad, just a view of stuff."

—"Through the quiet of our [vacation] days in New Mexico I found myself thinking that there will be a precise moment when the last print will be burned or carted out with the trash or fade beyond recognition. If I remember this, I think I can keep my vision straight."

—"The praise I like to hear most is that the photographs make people think of taking pictures themselves. It implies it looks easy, which it should."

—"I who never dream had two dreams last night. At first I was on a seiner headed down the Columbia River from Astoria, Oregon. It was one of those still, gray, summer afternoons, with fog over the sea. I was on deck next to the cabin, and after a while someone touched me on the shoulder and motioned me into the galley, where I sat and drank coffee with others. No one spoke, but there was an indescribable sense of brotherhood. Later I dreamed I was standing on a street in Taos in the 1880s, though the sense was of openness, as at Acoma or on the Hopi mesas. The sunlight was intense and the adobe white, as if I were in a single picture that combined O'Sullivan's skies and Strand's walls. And like a print, it was quiet." [Notes]

1971—Publishes "Pictures and the Survival of Literature" in *The Western Humanities Review* (Winter 1971), suggesting that some forms of literature are being replaced by visual arts because they can better "reveal again the holiness, beyond complaint, in the surface of life." —First individual exhibition, the Colorado Springs Fine Arts Center. —Moves to Longmont, Colorado, where Kerstin begins work as a reference librarian. —Exhibition *Photographs by Robert Adams and Emmet Gowin* at the Museum of Modern Art in New York. —As the Vietnam War enters extreme stages, Adams and his wife consider emigrating to Europe, and take steps to make that possible.

1972—For a year works two days a week as an editorial assistant at The Colorado Associated University Press in Boulder.

1973—A Guggenheim Fellowship facilitates shooting and lab work that result eventually in the book *Denver*.

"Along West 6th Avenue, brand new houses are being pried off their foundations and trucked away to make room for more highway lanes. As in Boulder, where I recently saw new houses being cut in half for the same purpose, and the sod of each new lawn being fastidiously rolled up again."

—"Came on the following by A. R. Ammons: 'have I prettified the tragedies, the irrecoverable losses: have I glossed over the unmistakable evils; has panic tried to make a flower: then hope distorts me: turns wishes into lies . . .' So I ask myself." [Notes]

—Represented in exhibition *Landscape/Cityscape* at the Metropolitan Museum of Art in New York. —Finds and enjoys the writings of Edward Abbey and Edward Hoagland.

1974—Publishes *The Architecture and Art of Early Hispanic Colorado* and *The New West: Landscapes Along the Colorado Front Range*.

1975—Represented in the exhibition *New Topographics: Photographs of a Man-Altered Landscape* at the George Eastman House, Rochester, New York. —Western Heritage Award from the National Cowboy Hall of Fame for the *Architecture and Art of Early Hispanic Colorado*. —Begins shooting landscapes that eventually appear in his monograph *From the Missouri West*. —Spends several weeks in Neahkahnie, Oregon, on the first of a number of breaks over the years to treat the effects of nervous exhaustion.

1976—Gives lecture, "Beauty in Photography," at St. John's College in Santa Fe and at Rice University in Houston. —One-person exhibition, Castelli Graphics, New York. —Begins shooting night landscapes that eventually appear in *Summer Nights*. —Photographs on the northwest Oregon coast for several weeks. —Reads extensively works by and about Samuel Johnson.

1977—Publishes *Denver: A Photographic Survey of the Metropolitan Area*. —Gives a lecture at the International Center of Photography, New York.

—"I adopt as my teacher the Japanese writer Kafu, who wrote a collection of essays about Tokyo entitled *Walking Shoes* in which there are whole chapters about individual trees, streets that do not appear on maps, scarcely noticed hills . . . he even has a full chapter on vacant lots."

—"The pictures prove nothing. One has al-

At the back window of the Adams Colorado Springs home, 1967.

Kerstin on a hike with Sally as a puppy, 1981.

ready seen in one's own life the pictures' justification, Form, or one hasn't. The pictures are just reminders." [from the Lecture]

—Sees and responds strongly to the exhibition *Cezanne: The Late Work* at the Museum of Modern Art in New York. —Photographs during the pilot segment of the AT&T centenary project to document the American landscape; makes a ten-day trip along the Missouri River in late winter, but loses much of the work by mishandling the film in the cold.

"Cables freeze and break; the lens in the finder chips."

—*"Along the Missouri River near Yankton, South Dakota: Mud, wind, beaver-cut saplings. an eagle, broken light over walls of trees, the crack of bank ice . . . It was almost possible, except for the red plastic shotgun shells underfoot, to imagine meeting Bodmer."* [Notes]

1978—Exhibition *Prairie* at the Denver Art Museum.

"Kerstin would have made a perfect ranch wife—tan, tall, straight, soft-spoken, gentle, quiet, never a complainer (unlike me), always alert to animals and the beauty of the sky. . . ." [Notes]

—Represented in the exhibition *Mirrors and Windows: American Photography Since 1960* at the Museum of Modern Art in New York; lectures there in connection with the exhibition.

"As I understand my job, it is, while suggesting order, to make things appear as much as possible to be the way they are in normal vision. My

goal is to suggest the potential not of some piece of camera gear, but of our eyes."

—*"Most photographs would never be taken except for an impulsive enjoyment, a delight that is notably free from big ideas."*

—*"Mark Tobey said that one ought 'to name one's master's name. What have you got,' he asked, 'if you've just got yourself?' So, here's to O'Sullivan. . . ."* [Notes]

—Photographs during the main segment of the AT&T documentary project, working in Wyoming, Utah, California, and Colorado.

"West of Grand Junction, Colorado—October: *Alone down a silent road in sagebrush country this morning. Hot; no sound of wind or bird or insect. There had earlier been an oil company helicopter, its beating noise suddenly audible behind rimrock to the east; it came low and fast, and was almost at once gone over a hill to the west. Then the silence returned, absolute."* [Notes]

—Reads with deep respect the books of Henry Beetle Hough, editor of the *Vineyard Gazette* of Martha's Vineyard, Massachusetts.

1979—Exhibition *Prairie* is shown at the Museum of Modern Art in New York.

"New York City was a surprise. People seemed to like the pictures. . . . On Sunday the Gallery [Castelli Graphics] hosted a party at Marvin Heiferman's loft, and though I had dreaded it, I enjoyed it. . . ." [from a letter to Nick and Bebe Nixon]

—Photographs for six weeks in late winter on northern Long Island for a documentary pro-

ject sponsored by Apeiron, a photographic workshop.

"In a sand pit at the edge of woods near Riverhead: Suddenly four feral dogs, large crosses, appear above me at the edge of the pit. At first none move back, though when I pick up a heavy stick they do, slowly, circling. The outdoor experience of a subway. Is there anything sadder?"

—*"How many motel rooms, airport terminals, road sides . . . in how many places have I been unable to do anything, just sitting there for fright."*

—*"There is a species of silver tree here that is like a temple. It occurs singly, often in little clearings. The oaks and maples are dark; the silver tree is so bright that even on overcast days it shines."* [Notes]

—Begins taking pictures that eventually appear in the monograph *Our Lives & Our Children: Photographs Taken Near the Rocky Flats Nuclear Weapons Plant.*

1980—Publishes *From the Missouri West.*
—With the help of an assistant, works in the summer to finish taking pictures for *Summer Nights*; twice in half an hour someone near Hygiene, Colorado tries to run them down.
—Awarded a second Guggenheim Fellowship.
—Finishes writing, while housebreaking a puppy, *Beauty in Photography: Essays in Defense of Traditional Values.*

"A perfect landscape will for us always include a dog—for fun, beauty, and affection. And maybe for the dog's independence of what, on the beach and prairie, interests us most—the harmony of land and sky. Dogs don't need a sense for it. For them, the world is everywhere and always whole." [Notes]

"What a landscape photographer traditionally tries to do is to show what is past, present, and future at once. You want ghosts and the daily news and prophecy. . . . It's presumptuous and ridiculous. You fail all the time." [Interview, *The Colorado Springs Sun*, 1980]

1981—One-person exhibition at the Philadelphia Museum of Art. —Publishes *Beauty in Photography: Essays in Defense of Traditional Values.*

1982—From February to April photographs in the Los Angeles basin.

"The operating principle that seems to work best is to go to the landscape that frightens you the most and take pictures until you're not scared anymore."

Photographing the Pawnee National Grassland, 1978 (by Kerstin Adams).

A partly completed wooden angel in Adams's small shop in Astoria, Oregon, 1986.

—"On the side of Reche Canyon, 3:00PM; a cloudless day with no shadows; smog is so heavy that the cars below have their lights on. Ahead of me, a rattlesnake, as thick as my forearm, warns me . . . which is how he got so old, I guess. We're each respectful, and lost."

—"Discovered yesterday there are people living in cardboard boxes in the dry wash beneath the four-level San Bernardino interchange. Imagine what it must be like there at night (I haven't the courage to go) with the trash and the little fires, the terrible noise, the car lights sweeping out from the curves, out over the dark . . ."
[Notes]

1983—Publishes an introductory essay in Daniel Wolf's *The American Space: Meaning in Nineteenth-Century Landscape Photography.*

"The end of the American Space is related, in ways mostly beyond the scope of the essay, to the two principal threats to life on earth—overpopulation and nuclear war."

—"One can measure O'Sullivan's achievement by placing his work beside that of Jackson. Jackson seems above all just to have wanted to show the great size of the West. O'Sullivan's concern was more with the relation of things. And so, ironically, it was O'Sullivan who finally recorded how large the West was. And is."
[Notes]

—Peer Award, the Friends of Photography.
—From February to April photographs in the Los Angeles basin; while Adams is there, Wil-

liam Main, his cherished teacher living in Red-lands, dies.

"Glaring, silver-solid sky. Under eucalyptus, be-low cords of leaves, there are pigeons and rats; on bottlebrush, chili-red flowers; on one of the eucalyptus, pink trumpet blossoms."

—"Everywhere there is security fencing, much of it topped with razor wire."

—"Sunrise and sunset last for hours, turning leaves orange and green-black."

—"A man comes from his house and abruptly looses five vicious dogs toward me where I am working in a field across the street. I hit the lead dog in the chest with a rock and the pack turns; the man never speaks."

—"On many streets there is hardly a house with-out a pair of Dobermans."

—"Found a curious thing yesterday in Latti-

Adams at the mouth of the
Columbia River, 1986 (by Kerstin Adams).

more's New Testament: *When Jesus restores sight to a blind man, the first things the man sees are what he takes to be moving trees; only after-wards does he discover they are people . . ."*
[Notes]

—Detained by a railroad detective while work-ing at the edge of Fontana. Becomes the target of stone throwers next to the Kaiser steel plant.
—In October, the Adamses' West Highland Terrier is caught in a coyote trap while she walks with Adams and his wife on a public dirt road. "I would give nearly anything to shut down the fur industry. It is degenerate."
—Begins taking darker, sometimes skewed, landscapes, planning at one point to group them under a title related to the American Indians' Ghost Dance.

1984—Publishes *Our Lives & Our Children: Photographs Taken Near the Rocky Flats Nuclear Weapons Plant.* —Detained by suburban Denver police, apparently on suspicion of being a child molester because he was photographing near a school at closing time. —Enjoys the motion pictures of Bill Forsyth.

1985—Publishes *Summer Nights.* —Exhibition *Albert Renger-Patzsche /Robert Adams* at Kunst-verein München, West Germany. —Begins a year of retreat in Astoria, Oregon.

1986—Meets William Stafford, and with Ker-stin prepares a group of calligraphed and illus-trated broadsides of Stafford's poems. —Pub-lishes *Los Angeles Spring.* —In the fall returns to Colorado, and begins a series of 35mm pho-tographs of landscapes he has enjoyed lifelong. The projected title: *Notes for Friends.*

1987—Receives the Charles Pratt Memorial Award. —Works to develop public interest in establishing a peace park on the Colorado grasslands. —Works to promote the outlawing of steel-jaw leghold traps.

1988—Publishes *Perfect Times, Perfect Places.*

1989—Retrospective exhibition *To Make It Home: Photographs of the American West, 1965–1986* at the Philadelphia Museum of Art.

"After reading poems by Philip Levine and look-ing at his picture on the back of the book I try to imagine what he would be like if he were sitting across the room. I think he would not look like he does in the picture, because he would be several persons at once. He would certainly not be as clear as the poems."
[Notes, 6/80]

AWARDS

1973 National Endowment for the Arts Photographer's Fellowship.
John Simon Guggenheim Memorial Foundation Fellowship.

1975 Award of Merit, American Association of State and Local History.

1978 National Endowment for the Arts Photographer's Fellowship.

1979 Colorado Governor's Award in the Arts.

1980 John Simon Guggenheim Memorial Foundation Fellowship.

1983 Peer Award, The Friends of Photography.

1987 Charles Pratt Memorial Award.

EXHIBITIONS

SELECTED ONE-PERSON EXHIBITIONS

1971 Colorado Springs Fine Arts Center.

1976 Saint John's College, Santa Fe; Rice University, Houston.

1977 Sheldon Memorial Art Gallery, Lincoln.

1978 Robert Self Gallery, London; *Prairie*, Denver Art Museum.

1979 Werkstatt für Photographie der VHS Kreuzberg, Berlin; *From the Missouri West*, Castelli Graphics, New York; *Prairie*, The Museum of Modern Art, New York, and the Baltimore Museum of Art.

1980 *From the Missouri West*, Fraenkel Gallery, San Francisco; Atlanta Gallery of Photography.

1981 *The New West: Photographs by Robert Adams*, Philadelphia Museum of Art; *Cottonwood*, Castelli Graphics, New York; Pierce Street Gallery, Birmingham, Michigan.

1983 Milwaukee Art Museum; *Robert Adams: Prairie*, Yellowstone Art Center, Billings.

1984 *Our Lives & Our Children: Photographs Taken Near the Rocky Flats Nuclear Weapons Plant*, Moravian College, Bethlehem, Pennsylvania.

1985 *Summer Nights*, Fraenkel Gallery, San Francisco; Northlight Gallery, Tucson.

1986 *Summer Nights*, Denver Art Museum, California Museum of Photography at Riverside, and Goucher College, Towson, Maryland.

1987 Portland Art Museum, Oregon.

1988 *Perfect Times, Perfect Places*, Fraenkel Gallery, San Francisco.

1989 *To Make It Home: Photographs of the American West 1965–1986*, Philadelphia Museum of Art.

SELECTED GROUP EXHIBITIONS

1970 *New Acquisitions*, The Museum of Modern Art, New York.

1971 *Photographs by Robert Adams and Emmet Gowin*, The Museum of Modern Art, New York.

1972 *Fe de Nuestros Padres*, Colorado State Museum, Denver.

1973 *Landscape/Cityscape*, The Metropolitan Museum of Art, New York (catalog).

1975 *Fourteen American Photographers*, Baltimore Museum of Art (catalog); *New Topographics: Photographs of a Man-Altered Landscape*, International Museum of Photography at George Eastman House, Rochester, New York (catalog).

1976 *Aspects of American Photography*, University of Missouri, St. Louis (catalog); *Six American Photographers*, Thomas Gibson Fine Art Ltd., London.

1977 *Photographs by Robert Adams & Myron Wood*, Colorado Springs Fine Arts Center; *The Target Collection of American Photography*, The Museum of Fine Arts, Houston (catalog); *The Great West: Real/Ideal*, University of Colorado, Boulder (catalog); *Contemporary American Photographic Works*, The Museum of Fine Arts, Houston (catalog).

1978 *Additional Information: Photographs by Ten Contemporary Photographers*, University of Maryland; *Certain Landscapes*, Castelli Graphics, New York; *Amerikanische Landschaftsphotographie 1860–1978*, Neue Sammlung, Munich (catalog); *Mirrors and Windows: American Photography Since 1960*, The Museum of Modern Art, New York (catalog).

1979 *Venezia 1979*, Venice, Italy (catalog); *Photographie Als Kunst / Kunst Als Photographie*, Weiermair Gallery, Innsbruck, Austria (catalog); *American Images: New Work by Twenty Contemporary Photographers*, Corcoran Gallery of Art, Washington, D.C. (catalog).

1981 *American Landscapes*, The Museum of Modern Art, New York (catalog); *Biennial Exhibition*, Whitney Museum of American Art, New York (catalog); *Photography: A Sense of Order*, Institute of Contemporary Art, University of Pennsylvania (catalog); *New Landscapes, Part II*, The Friends of Photography, Carmel, California (catalog).

1982 *Selection from the Strauss Photography Collection*, Denver Art Museum (catalog); *Slices of Time: California Landscapes 1860–1880 and 1960–1980*, Oakland Museum (catalog); *20th Century Photographs from the Museum of Modern Art*, The Seibu Museum of Art, Tokyo (catalog).

1983 *Colorado Biennial*, Denver Art Museum (catalog); *An Open Land: Photographs of the Midwest, 1852–1982*, Art Institute of Chicago (catalog); *Personal Choices*, Victoria and Albert Museum, London (catalog).

1984 *Three Americans*, The Museum of Modern Art, New York.

1985 *Western Spaces*, Burden Gallery, New York; *Albert Renger-Patzsch / Robert Adams*, Kunstverein München, Munich; *American Images: Photography 1945–1980*, Barbican Art Gallery, London (catalog).

1986 *Artists in Mid-Career*, San Francisco Museum of Modern Art (catalog); *Ansel Adams and American Landscape Photography*, Australian National Gallery (catalog).

1987 *Nuovo paesaggio americano / Dialectical Landscapes*, Museo Fortuny, Venice, Italy (catalog); *Road and Roadside: American Photographs, 1930–1986*, Art Institute of Chicago.

1988 *Another Objectivity*, Institute of Contemporary Arts, London (catalog).

BIBLIOGRAPHY

WORKS BY ROBERT ADAMS
(in chronological order)

BOOKS

White Churches of the Plains: Examples from Colorado. Introduction by Thomas Hornsby Ferril. Boulder: Colorado Associated University Press, 1970.

The Architecture and Art of Early Hispanic Colorado. Boulder: Colorado Associated University Press, 1974.

The New West: Landscapes Along the Colorado Front Range. Foreword by John Szarkowski. Boulder: Colorado Associated University Press, 1974.

Denver: A Photographic Survey of the Metropolitan Area. Boulder: Colorado Associated University Press, 1977.

Prairie. Denver Art Museum, 1978.

From the Missouri West. New York: Aperture, 1980

Our Lives & Our Children: Photographs Taken Near the Rocky Flats Nuclear Weapons Plant. New York: Aperture, 1983.

Summer Nights. New York: Aperture, 1985.

Los Angeles Spring. New York: Aperture, 1986.

Perfect Times, Perfect Places. New York: Aperture, 1988.

To Make It Home: Photographs of the American West. New York: Aperture, 1989.

SELECTED WRITINGS

"Pictures and the Survival of Literature," *Western Humanities Review,* Winter 1971.

Review of *Wisconsin Death Trip* by Michael Lesy, *The Colorado Magazine* (Historical Society of Colorado), Fall 1974.

Review of *The West: An American Experience* by David R. Phillips, *The Colorado Magazine,* Spring 1975.

Introduction, *A Texas Dozen: Fifteen Photographs by Geoff Winningham,* The Cronin Gallery, Houston, 1976.

Untitled essay in *Contact Theory,* New York: Lustrum Press, 1980.

Beauty in Photography: Essays in Defense of Traditional Values. New York: Aperture, 1981.

"Photography and the Collector," *Selections from the Strauss Photography Collection.* Denver Art Museum, 1982.

Introduction, *The American Space: Meaning in Nineteenth-Century Landscape Photography,* edited by Daniel Wolf. Middletown, Connecticut: Wesleyan University Press, 1983.

Introduction, *Nicholas Nixon: Photographs from One Year.* Carmel, California: The Friends of Photography, 1983.

Review of *Dorothea Lange: Photographs of a Lifetime, Times Literary Supplement* (London), April 6, 1984.

Review of *Berlin-Kreuzberg* by Michael Schmidt, *Camera Austria,* No. 14 (1984).

Review of *The Work of Atget: Modern Times* by John Szarkowski and Maria Morris Hambourg, *Times Literary Supplement* (London), August 2, 1985.

Letter to the Editor, *Views: The Journal of Photography in New England,* Fall 1985.

"The Achievement of Edward Weston: The Biography I'd Like to Read," *EW 100: Centennial Essays in Honor of Edward Weston.* Carmel, California: The Friends of Photography, 1986.

Review of *Ansel Adams: An Autobiography, Times Literary Supplement* (London), May 16, 1986.

Review of *The Pond* by John Gossage, *Creative Camera* (London), July 1986.

Review of *An Enduring Grace: The Photographs of Laura Gilpin* by Martha Sandweiss, *Aperture,* No. 110 (1988).

INTERVIEWS

With Thomas Dugan. *Photography Between Covers: Interviews with Photo Book Makers.* Rochester, New York: Light Impressions, 1979.

With Ralph Gibson. *Landscape: Theory.* New York: Lustrum Press, 1980.

With Vidie Lange. *Ocular,* Spring 1980.

With Michael Köhler. *Camera Austria,* No. 9 (1983).

SELECTED COMMENTARY ON ADAMS'S WORK

Baltz, Lewis. Review of *The New West. Art in America,* March/April 1975, pp. 41, 43.

_____. "Robert Adams: Our Lives & Our Children." *Artspace,* Fall 1984, pp. 52-53.

_____. "Konsumterror." *Camera Austria,* No. 18 (1985) pp. 16-26.

Constantini, Paolo. *Nuovo paesaggio americano / Dialectical Landscapes.* Milan: Electa, 1987.

Fisher, Hal. "Robert Adams Landscapes." *Artweek,* March 15, 1980, pp. 11-12.

Foster, Hal. Review of the exhibit *From the Missouri West. Artforum,* April 1979, pp. 69-71.

Goldberg, Vicki. "Bankrupt Landscapes, Newly Rich." *American Photographer,* August 1981, pp. 32-34.

_____. "Lost Landscapes: Two Versions of America's Eden." *American Photographer,* June 1987, pp. 36, 38.

Green, Jonathan. *American Photography: A Critical History, 1945 to the Present.* New York: Abrams, 1984.

Grundberg, Andy. Review of *From the Missouri West. Art In America,* May 1981, pp. 21, 23.

_____. "The Point of Photography." *The New York Times Book Review,* November 29, 1981, pp. 35-36.

_____. and Julia Scully. "Currents: American Photography Today." *Modern Photography,* April 1981, pp. 108 ff.

Heiferman, Marvin. *Contemporary Photographers.* New York: St. Martins, 1983.

Jeffrey, Ian. *Photography: A Concise History.* London: Thames and Hudson, 1981.

Johnson, Barry. "Beauty With a Capital B." *The Oregonian,* December 6, 1987, p. 15.

Jussim, Estelle, and Elizabeth Lindquist-Cock. *Landscape as Photograph.* New Haven: Yale University Press, 1985.

Lifson, Ben. "Robert Adams: Notes Toward a Supreme Landscape." *Village Voice,* February 26, 1979, p. 71.

Murray, Joan. Review of *The New West. Artweek,* March 8, 1975, pp. 11-12.

Newhall, Beaumont. Review of *The New West. The Colorado Magazine* (Historical Society of Colorado) LIV/1(1977) pp. 81-82.

Ratcliff, Carter. "Route 66 Revisited: The New Landscape Photography." *Art in America,* January/February 1976, pp. 86-91.

Sobieszek, Robert A. *Masterpieces of Photography From the George Eastman House Collections.* New York: Abbeville, 1985.

Szarkowski, John. Foreword to *The New West.* Boulder: Colorado Associated University Press, 1974.

We had a remarkable sunset one day last November. I was walking in a meadow, the source of a small brook, when the sun at last, just before setting, after a cold, gray day, reached a clear stratum in the horizon, and the softest, brightest morning sunlight fell on the dry grass and on the stems of the trees in the opposite horizon and on the leaves of the shrub oaks on the hillside, while our shadows stretched long over the meadow eastward, as if we were the only motes in its beams. It was such a light as we could not have imagined a moment before, and the air also was so warm and serene that nothing was wanting to make a paradise of that meadow. When we reflected that this was not a solitary phenomenon, never to happen again, but that it would happen forever and ever, an infinite number of evenings, and cheer and reassure the latest child that walked there, it was more glorious still.

The sun sets on some retired meadow, where no house is visible, with all the glory and splendor that it lavishes on cities, and perchance as it has never set before—where there is but a solitary marsh hawk to have his wings gilded by it, or only a musquash looks out from his cabin, and there is some little black-veined brook in the midst of the marsh, just beginning to meander, winding slowly round a decaying stump. We walked in so pure and bright a light, gilding the withered grass and leaves, so softly and serenely bright, I thought I had never bathed in such a golden flood, without a ripple or a murmur to it. The west side of every wood and rising ground gleamed like the boundary of Elysium, and the sun on our backs seemed like a gentle herdsman driving us home at evening.

So we saunter toward the Holy Land, till one day the sun shall shine more brightly than ever he has done, shall perchance shine into our minds and hearts, and light up our whole lives with a great awakening light, as warm and serene and golden as on a bankside in autumn.

HENRY DAVID THOREAU, from the essay "Walking," 1861

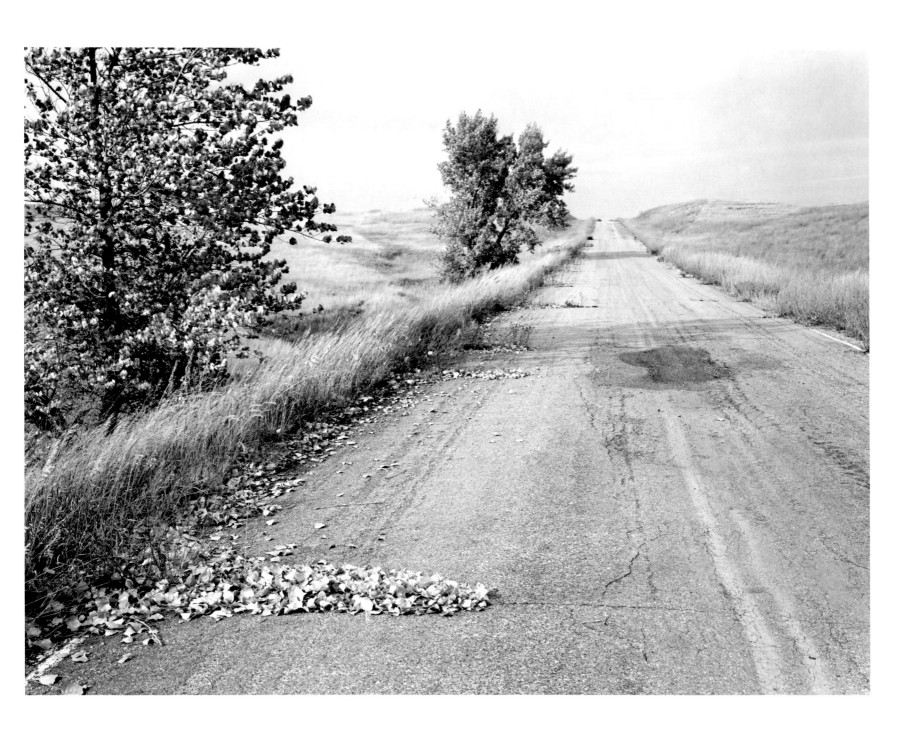

Library of Congress Catalog Number:
88-72206.
Clothbound ISBN: 0-89381-351-6
Paperbound ISBN: 0-89381-384-2
Book design by Wendy Byrne. Jacket Design
by Peter Bradford Associates. Duotone
negatives by Robert Hennessey, Middletown,
Connecticut. Composition by EyeType, New
York, New York. Printed and bound in West
Germany by H. Stürtz, Würzburg.
The staff at Aperture for *To Make It Home* are
Michael E. Hoffman, Executive Director;
Stevan A. Baron, Vice-President Production;
Bettina Henzler, Production Assistant;
Steve Dietz, Vice-President, Editorial—Books;
Lisa Rosset, Managing Editor.

Aperture Foundation publishes books,
portfolios, and a periodical of fine photography
to communicate with creative people
everywhere. A complete catalog is available
upon request from Aperture, 20 East 23 Street,
New York, New York 10010.

TEXT CREDITS
Page 20: Robert Adams, *Prairie*, 1978: 28:
Robert Adams, *The New West,* 1974; 34: Robert
Adams, 1977; 50: Robert Adams, *Denver,* 1977;
58: Lewis Baltz, *Camera Austria,* 1985; 68:
Robert Adams, "In the American West, Is Hope
Possible" 1986; 78: Robert Adams, *From the
Missouri West,* 1980; 86: Robert Adams,
Introduction, *The American Space,* 1983; 98:
Robert Adams, *Our Lives & Our Children:
Photographs Taken Near the Rocky Flats Nuclear
Weapons Plant,* 1983; 110: Robert Adams,
Camera Austria, 1983; 124: Robert Adams, *Los
Angeles Spring,* 1986; 140: Robert Adams, "In the
American West, Is Hope Possible" 1986; 152:
Walt Whitman, *Specimen Days,* 1882.

The poem on page 9, "The Obbligato," was
published in *In Good Times* by Origin Press
©1964 by Cid Corman. Reprinted by
permission of the author. Quotations from
Robert Adams on pages 166 and 167 are taken
from an interview with Ralph Gibson
published in *Landscape: Theory*, edited by Carol
di Grappa, © by Lustrum Press, New York,
1980. Reprinted by permission of Ralph
Gibson. The lines of poetry quoted on page 169
are from *Tape for the Turn of the Year* ©1965
by A. R. Ammons, published by W. W. Norton
& Co., Inc. Reprinted by permission of the
publisher. The descriptive copy on the jacket
and cover, by Terry Toedtemeier, Adjunct
Curator of Photography for the Portland Art
Museum, is a revised version of the essay first
published in "Perspectives 10," ©1987 by the
Oregon Art Institute. Reprinted by permission
of Terry Toedtemeier.